TIMOTHY HYMAN is a painter and w[...]
and on modern painting, at universi[...]
the USA. In 1993 he received a Leve[...]
Research Fellow at University Colle[...]
his widely praised monograph on B[...]
reviews to the *Times Literary Suppler*[...]
his major exhibitions include 'Carnivalesque' (2000) and the Tate's Stanley Spencer
retrospective (2001). Trained at the Slade, he has had seven London solo exhibitions,
and his work appears in many public collections, including the British Museum, the
Arts Council Collection, the Los Angeles County Museum and the Museum of London.

Thames & Hudson world of art

This famous series provides the widest available
range of illustrated books on art in all its aspects.

If you would like to receive a complete list
of titles in print please write to:

THAMES & HUDSON
181A High Holborn
London WC1V 7QX

In the United States please write to:

THAMES & HUDSON INC.
500 Fifth Avenue
New York, New York 10110

Printed in Singapore

Timothy Hyman

Sienese Painting
The Art of a City-Republic
(1278-1477)

183 illustrations, 73 in colour

 Thames & Hudson world of art

*Dedicated to Gabriel Josipovici, writer
and Gulammohammed Sheikh, painter
— both lovers of Siena*

First published in the United Kingdom in 2003 by
Thames & Hudson Ltd, 181A High Holborn, London WC1V 7QX

www.thamesandhudson.com

British Library Cataloguing-in-Publication Data
A catalogue record for this book is available from the British Library

ISBN 0-500-20372-5

Printed and bound in Singapore by C. S. Graphics

Contents

Introduction 'An Art Born Amidst City Streets'

Above the gate, inside the walls, below the towered hill, across the chessboard expanse of fields, towards the curving horizon – any account of Sienese painting will be full of spatial indications. No other art has engaged so imaginatively with the experience of moving about in one's own city, of hovering above it, of surveying the panoramic landscape beyond. In no other painting tradition do we find architecture represented with such a tender intimacy, figures juxtaposed against the deep space of street or interior with such a freshness of compositional invention.

As a distinct school, Sienese painting spans roughly two centuries: from 1278, when Duccio begins work for the Commune, to 1477, when Francesco di Giorgio abandons the city-republic for the ducal court of Urbino. In the early trecento, three strongly individual masters emerge in Siena: first Simone Martini, then the Lorenzetti brothers – Pietro and Ambrogio. Their painting will be, in Hayden Maginnis's phrase, 'an art born amidst city streets', and their shared language will tend towards an urban vernacular – an idiom of the everyday, closely parallel to the built vernacular all around them.

Siena is created out of a small repertory of building types, most of them already in place long before Duccio began his *Maestà* for the Cathedral. The monumental reservoirs such as Fontebranda (begun in 1193), the stretches of city wall, the gates, the towers, nearly every house or church: all are of the same 'burnt sienna' brick, establishing an architectural vernacular of extraordinary flexibility across the entire city. It would be easy for Ambrogio Lorenzetti to assemble his *Well-Governed City* out of typical fragments; or, a hundred years later, for the painter of the *St Anthony* series to recreate a typical Sienese palazzo. This Sienese Gothic vernacular comes to represent the identity of the city, a kind of mother-tongue, for the masters of the 1320s, allowing them to shape from the streets an art of depiction and observation, a new urban realism. But in the 1420s the same architectural idiom is deployed by Sassetta and his generation with

16–24

82–9

156

a very different inflection: to signpost the lost glory of the republic, and their hope to restore it.

That Siena is so unified in its visual impact, that its buildings and public spaces all speak the same language as its paintings, can only be understood in the context of its system of government. For almost seventy years, between 1287 and 1355, Siena was under the continuous rule of 'the Nine Governors and Defenders of the Commune', which even in its own time became known as *il Buon Governo* (the Good Government). Elected by lot, nine citizens took office for two months, each holding the chairmanship for one week, living together in virtual confinement in the Palazzo Pubblico. Their two months ended, they would have to wait at least another twenty before becoming eligible again. The system ensured that, over a five-year period, several hundred different individuals would have the leading role in the state. It was, the historian William Bowsky writes, 'a highly complex administrative structure in which the vast majority of the citizens participated'; Siena under the Nine, he concludes, 'came close to the ideal of a balanced communal government'.

What did the Nine 'defend' the Commune against? Against war, certainly, since peace alone guaranteed that the roads stayed open and that trade flourished. But above all, they defended the fragile state against the domination of any small class or group. In the 1270s, tensions had developed between *i Grandi* (the magnates – the landowning families who by now were often bankers as well) and *il Popolo* (not so much 'the people' as merchants and manufacturers, including some of the smaller traders). In 1277 the *Popolo* made a decisive move, naming fifty-three powerful families who would henceforth be excluded from most key offices. Lawyers were similarly ineligible. All these exclusions were inherited later by the Nine, whose rule has been described as a 'plebeian oligarchy', in sharp contrast to the more naked oligarchy of Florence, for example, where power lay almost entirely with the magnates and the major guilds. Nevertheless, the Nine still needed to keep the support of Siena's great banking and landowning families; the system was a difficult compromise, under constant threat of strife and dissolution. It was a civic society, where politics and art were inseparable, and where scarcely any major artistic commission came from a private individual.

In my first four chapters, the republic's civic ideal rises to near fulfilment, with Ambrogio Lorenzetti celebrating the 'Good Government' as a return of the Golden Age. Almost immediately, the Black Death follows, and chapter 5 surveys its aftermath, a

long era of confusion and tyranny, in which the greatness of Sienese painting also fades. But in chapters 6 and 7, the republic is recreated – and with it, a new constellation of Sienese painters appears, consciously reviving the imagery of the trecento city. Then, in my final chapter, all is swept away: the communal culture transformed into aristocratic humanism, the vernacular lost to the new conventions of classicism, and the painting of Siena so utterly changed as to lose almost all relation to its earlier achievement.

The Image of the City
Sienese painters seem to have imagined their city as an object one might hold in one's hand, a cramming-together of towers and loggias, cupolas and roof-ridges, enclosed by a wall, entered by a gate. Across two centuries, their landscapes and narrative panels would be studded with intricate, sharply faceted little constructions of this kind. When Duccio shows Christ tempted by Satan's offer of dominion over 'all the kingdoms of the world', 1, 2 we are presented with no less than seven of these ideated city-signs. Colour is graded with marvellous precision: each plane cuts another crisply, in such a way that the city becomes crystalline, ideal, charged with a more than terrestrial light.

The beautiful little panel known as *City by the Sea* is recognizably 3 of the same idiom, the light again falling from above to catch each

2 **Duccio (and collaborator?)**, *The Temptation*, predella panel from the *Maestà*, 1308–11. New York, Frick Collection.
Christ, Satan and two angels loom above a panoramic landscape in this small panel cut from the back predella of the *Maestà* (see ill. 18 for a reconstruction). The dark brick roads leading in under the city gates are painted in transparent burnt sienna – a pigment refined from the reddish clay out of which the city itself is built. Modulated with white, burnt sienna also provides the graded pinks of the roof tiles.

3 Attributed to Sassetta,
c. 1425 (also attributed to
Ambrogio Lorenzetti, c. 1340
and Simone Martini, c. 1310),
City by the Sea. Siena, Pinacoteca.
This mysterious little panel, less
than half the surface area of
Duccio's *Temptation*, is pair to the
equally poetic *Castle by a Lake*
(ill. 107). The city has sometimes
been identified as the port of
Talamone, Siena's only access
to the sea. Were these two
landscapes cut from a painted
reliquary cupboard, or from the
panoramic background of Sassetta's
Arte della Lana Altarpiece (see
p. 138)? Or were they part of the
imagery of Sienese castles, made
for the *Sala del Mappamondo* in the
Palazzo Pubblico (see p. 62)?

107

4 **After Ambrogio Lorenzetti**,
*The Resuscitation and Healing of
Suppolino*, Cortona, Biblioteca
Comunale.
A seventeenth-century
watercolour, recording a scene
from one of the lost fresco cycles
of *c.* 1335 by the Lorenzetti
brothers in the church of Santa
Margherita, Cortona. Joanna
Cannon and André Vauchez have
made clear how important these
Cortona murals were; their
architectural complexity probably
influenced the early artistic
formation of Sassetta. Further
new discoveries will continue to
be made; most recently, a major
thirteenth-century fresco cycle
in the cathedral crypt, as yet
unpublished.

crenellation. Together with its companion piece, *Castle by a Lake*,
this miniature world has been characterized as the earliest 'pure
landscape' in all Western art, and was long thought to have been
painted around 1340 by Ambrogio Lorenzetti. Yet the delicate
grey-green harmonies, the refinement of atmospheric light, the
fragile attenuated towers – all this has led Keith Christiansen and
several other scholars to identify *City by the Sea* instead as an early
work by Sassetta, dating from the 1420s. Attributions have been
made to other fifteenth-century painters, including Giovanni di
Paolo and the Master of the Osservanza; more recently Thomas
de Wesselow has made a persuasive case for the youthful Simone
Martini, working about 1310.

I can think of no other key work in the whole of Italian painting
whose date and authorship remain so widely contested. It points
both to the continuity of Sienese pictorial language and to how
little we securely know. Probably less than ten per cent of Sienese
painting survives; six lost fresco cycles are documented for
Ambrogio Lorenzetti alone. While trecento Siena has been
well served by such writers as John White, Chiara Frugoni, Eve
Borsook and Hayden Maginnis (and the political context brought
vividly to life by William Bowsky), the quattrocento city of
Sassetta and Giovanni di Paolo remains more elusive. Important

4

work has been done by Henk Van Os, Keith Christiansen, Carl Strehlke and others, yet in the absence of any detailed political history, no scholar has been able to show convincingly the context in which the new generation of Sienese painters appeared so suddenly in the 1420s.

I want here to confine questions of attribution and dating rather to the sidelines; the more urgent issue seems that of critical evaluation. The reputation of both the Lorenzetti brothers has risen dramatically over the past fifty years, and Ambrogio's image 82 of the city has now entered into general currency. But the fifteenth-century Sienese remain relatively little known. Although the pictorial cycles of this period – the Master of the Osservanza's 155–9 *St Anthony*, Giovanni di Paolo's *St John the Baptist*, Sassetta's 142–7 *St Francis* – stand to me among the supreme achievements of all 116–30 Italian painting, these artists have usually been marginalized, downgraded as 'provincial' or 'conservative' beside their Florentine Renaissance contemporaries.

I will explore in my epilogue why Sienese painting – and especially its second flowering in the fifteenth century – had to wait so long for recognition. We need to keep in mind that, as John White puts it, 'the patent on the history of art was taken out in Florence': Vasari's sixteenth-century *Lives of the Artists* has cast a very long shadow. Vasari built his compelling narrative around the progress of Florentine artists towards the 'Renaissance' – towards systematic perspective, anatomical mastery, the revival of classical forms. But for Sienese painters we need to construct an altogether different account. When I first visited Siena as a young English art student in the 1960s, the concerns of Sienese painters – intensity of flat colour, spatial experimentation, narrative, the representation of the city – seemed to converge astonishingly with those of my contemporaries. A few weeks later, back in London, I encountered Sassetta's seven *St Francis* panels, which have remained for me, across more than thirty years, the most rewarding pictures in the National Gallery. I have found my own conviction of the 'relevance' of Sienese painting shared by many fellow artists – in London and New York, in Baroda and Bombay – and it is partly with them in mind that I have embarked on this account. I have wanted to understand better the relation between, say, Sassetta and Ambrogio Lorenzetti; between the individual and the collective; but also between the Sienese painter of seven hundred years ago and the artist of the present.

Chapter 1 Duccio and the Religion of the Commune

5 Siena, with the Cathedral in the foreground, and, to its right, the nave of the enormous 'New Cathedral', never to be completed. Beyond, the Campo, with the tower of the Palazzo Pubblico. To the left, we can make out the stumps of the stone towers of the nobility, cut back by the Commune. Top left, the church of San Francesco, and to the right, a stretch of the city wall, enclosing market gardens.

The Italian word *comune* indicates a self-governing community, whose citizens have wrested power from bishop or feudal lord to form their own city-state. Among the many such 'communes' and independent city-republics in medieval Italy, Siena had evolved, by the time of Duccio, to become the most radical of all in its political culture. According to William Bowsky, 'the fertility of Siena's administrative experimentation' remained unmatched elsewhere. The basis of the early medieval city's prosperity had been its site on the Via Francigena, the great road between Northern Europe and Rome; Siena had become a chief halting-place for the

hundreds of merchants and pilgrims passing back and forth each day. But Siena's own myth of origin told of three hilltops, occupied by three ever-warring tribes. According to this myth, true Sienese identity began at the moment when the three tribes decided to nominate the lowest area between the hills, a marshy 'meadow', as a place of neutrality and peace – *il Campo*.

To walk down into the Campo of Siena is to enter upon a space immediately expressive of communality. Its shape has been seen as an amphitheatre, a scallop shell, an open hand, the cloak of the Madonna, a fan. It is certainly a stage, enhancing the presence of all who step upon it; in the words of an eighteenth-century citizen, 'our piazza has been created with so magnificent and so beautiful a symmetry that anyone, at the first glance, can tell whether the person he seeks is there.' The Palazzo Pubblico (sometimes translated as 'Town Hall', though 'Palace of the Commune' would be closer) occupies the proscenium on which all the sight-lines converge; it was begun in the 1290s, the tower some thirty years later. Within the arena, everything curves – even the vertical of the tower, so tall it seems to bend, especially when lit against the

6 The 'stage' of the Campo, with its nine compartments, fanning out from the Palazzo Pubblico, powerbase of the Nine. All roads meet in this sacred-civic space, where not only weapons were banned but also the suckling of babes and the eating of figs. The city still revolves around it; at the time of the *Palio*, it becomes a racetrack. The triple-arched colonetted windows of the Palazzo Pubblico would become a vernacular all over the city.

7 The Palazzo Tolomei was built in 1270–72 to serve as clan fortress for the most dangerous aristocratic family in Siena. Claiming descent from the Ptolemies of Egypt, the Tolomei controlled their neighbourhood to the north of the Campo, already in 1246 documented as the *Contrada Ptolemicorum*. Their landholdings were scattered all over the republic's territory. Engaged in constant street fighting with the rival Salimbeni clan, they were also heavily implicated in a rebellion led by disgruntled butchers in 1318 under the cry 'Death to the Nine!'

night sky. The ensemble appears designed exactly to fill the visual field; the orange-pink oval of the Campo perfectly tailored to sight, a brimming vessel.

The Expanded Icon

When Duccio (c. 1255–1319) began work on the *Maestà* he was already in his fifties and the Nine had governed Siena for over twenty years. The young master is first documented in 1278, painting twelve wooden boxes (now lost) to hold the Commune's accounts. Thirty years later, he had become the city's leading painter, his *Maestà* both high altarpiece for the Cathedral and part of the Commune's wider programme to promote and strengthen Siena's civic identity.

In 1260, on the eve of the Battle of Montaperti between Siena and Florence, it was proposed that the city should be 'laid at the feet of the Queen and Empress of Everlasting Life, the Glorious and Ever-Virgin Mother of God'. The keys of Siena were ceremonially brought to her image in the Cathedral, a painting known as the *Madonna with the Large Eyes*. And the following morning, 'those in the camp looked across to the town and seeing a shadow like a mantle encompassing the city walls they fell to their knees with tears of thanksgiving believing it to be the mantle of the Holy Virgin protecting their city.' The subsequent rout of the Florentines confirmed this special relationship between Siena and the Virgin. It has been estimated that, in the two hundred years covered here, at least half of all commissioned Sienese paintings were images of the Madonna. The Cathedral, with its five altarpieces each dedicated to one of her feast days, would become the centre of this civic cult: from Duccio's *Maestà* to Sassetta's *Madonna of the Snow*, the development of Sienese painting could 112 be told through her image alone.

Duccio's *Maestà – The Virgin and Christ Child Enthroned in Majesty* 16–24 *with Angels and Saints* – would be the magnificent fulfilment of his own art, but also the consummation of a visual tradition seven centuries old, the finest product of Byzantium's long influence on Italian painting. About Duccio's early training there has always been speculation; that he worked in Assisi (perhaps as assistant to Cimabue); or, more romantically, that he voyaged to Constantinople and imbibed the Byzantine tradition at its metropolitan source. There are elements in his art which so faithfully reproduce Byzantine prototypes as to suggest very close personal contact. Otto Demus and others have accepted Vasari's tale that 'Greeks' were summoned to Florence around 1255, 'for no other purpose than the revival of painting'. On balance, it seems likely that Duccio did indeed at some point receive instruction directly from a Byzantine master. In Northern Europe, Byzantine forms had been swept away with the emergence of a new style centred on the French court – the art we now call 'the Gothic'; in Italy, however, Byzantine art exerted a renewed influence. From the surviving panels in the Siena Pinacoteca we can piece together a fragmentary history of artistic development as the icons of the Eastern Church were transformed to fulfil the very different functions of the Western altarpiece. We might call Duccio's *Maestà* an expanded icon.

In the 1260s, an identifiable Sienese painting was taking shape: a dialect of Byzantium, much less refined, but robust and vigorous.

8 Attributed to Guido da Siena,
Reliquary Shutters of Blessed Andrea Gallerani (outer shutters), c. 1275. Siena, Pinacoteca.
These shutters (sometimes attributed to Guido's contemporary, Dietisalvi di Speme) were made for the church of San Domenico. Although never fully canonized, Blessed Andrea (d. 1251) became the object of a popular civic cult, and his image recurs in many Sienese paintings, from Simone Martini to Vecchietta (see ill. 168).

9 Attributed to Guido da Siena,
Reliquary Shutters of Blessed Andrea Gallerani (inner panel), c. 1275. Siena, Pinacoteca.

The *Reliquary Shutters of Blessed Andrea Gallerani* have been ascribed, along with most of the anonymous works of this epoch, to the rather shadowy figure of Guido da Siena (active c. 1260–90). Gallerani was a banker and pious layman; the outer shutters show him, rosary in hand, greeting a group of pilgrims, two of whom wear the scallop-shell badge of St James of Compostela, while the buildings behind probably represent Siena's hospital of Santa Maria della Scala, where he founded a confraternity active in good works. The facial types are strongly individuated, and the image gains some of its freshness from its new iconography, invented for a local figure who had died barely twenty years before. Inside, we see Gallerani again, now kneeling in fervent prayer within the Hospital. A rope is tied to a beam, with the noose around his neck; if he nods off, he will hang. The beam, though elaborately depicted in dark silhouette, is

8–9

suspended in mid-air; or rather, it is as though the gold 'sky' above the gabled building also doubles as an interior wall.

In Guido's little *Annunciation* panel a characteristically earthy colour harmony is established: the figures in browns and greys and dark reds, suspended against the planes of olive green and salmon pink. The pink (which I think is burnt sienna) moves from near-white on the left of the tall building to deep reddish brown on the right. This may indicate a rounded tower, but the effect is one of absolute flatness, creating around the Virgin the warm glowing aureole in which her golden halo is embedded. Behind the rushing angel, between wing and back, we glimpse the pink again; while the graded yellow ochres of the angel's wing feathers play chromatic scales on a gold-ground theme.

Guido is famed mainly for a large panel of the Madonna and Child. Since both the heads were later repainted by Duccio (or at least, in his manner), we need to imagine a broader cast of feature if we are to recreate Guido's masterpiece in all its harsh, almost crushing majesty. The mantle of this colossus – she would stand almost twelve feet tall – falls in angular straight lines, its blue expanse held down by the surrounding red and brown. Some art

11 **Guido da Siena**, *Maestà*,
c. 1275 (?). Siena, San Domenico.
The inscription below seems to
give the painting's date as 1221,
which would establish Siena rather
than Florence as fountainhead of
the earliest 'modern' painting. But
in fact '1221' commemorates the
death of St Dominic, whose altar
stood below Guido's massive image
in the vast brick interior.

historians believe Guido and his contemporaries were influenced above all by Coppo da Marcovaldo, a Florentine painter working in Siena after having been captured at Montaperti, whose inflection of Byzantine linearity was even tougher than Guido's.

Duccio would have grown to maturity in a Siena where every major commission was carried out in this shared style. But we know that his own achievement would be to give Sienese painting an almost opposite stamp – that warmth of colour and rhythmic subtlety which would thereafter become its hallmarks. His earliest

12 **Duccio**, *Rucellai Madonna*, 1285. Florence, Uffizi. Commissioned for the Dominican church of Santa Maria Novella in Florence, the *Rucellai Madonna* may have been inserted into a niche frescoed by the Florentine artist Cimabue, often thought to have been Duccio's master. The design has been linked to a French Gothic stained-glass window known as *Notre-Dame de la Belle Verrière* at Chartres Cathedral.

13 **Duccio**, An Angel, detail from the *Rucellai Madonna*, 1285.

surviving large altarpiece, the *Rucellai Madonna*, was made not in Siena, but in Florence. In 1285, a confraternity based in the Dominican church of Santa Maria Novella 'assigned to Duccio di Buoninsegna, the painter of Siena, a certain large panel for painting with the most beautiful picture'. He was 'to adorn it with the image of the Blessed Virgin Mary and her omnipotent son and other figures, in accordance with the wishes and pleasures of the said commissioners, and to gild it, and to do each and everything which will contribute to the beauty of the said panel.'

Only since the 1989 restoration have we become aware just how magnificently Duccio met this demand for 'beauty'. The panel is three feet taller even than Guido's, yet the Virgin is less overwhelming within this large expanse and the angels are rendered weightless in almost unnameable hues: rose-greys, soft lavenders, bluish greens. Caressing the throne with their long fingertips, they seem to have just delivered the Virgin to us – or to be preparing to lift her away. Hayden Maginnis points out how the lower angels' haloes fit behind the throne, while the upper ones carve into it. When we look closely, we see that the Virgin illuminates her own throne: gold striations move from the centre outward, the sides of the throne remaining in darkness. Paradox is built into this language: the Virgin is allowed full materiality (as in her powerfully modelled knee), yet the natural laws of space and gravity are suspended. It is, in Maginnis's phrase, a 'habitable ether'.

In its spatial complexity, its coloristic refinement, its emotional intimacy, the *Rucellai Madonna* is unprecedented in all Italian painting. It immediately makes all earlier masters appear primitive by comparison. This visionary image, celebrated ever since Vasari as the primary work leading to what we now call the Renaissance, was for centuries thought to have been painted by the Florentine Cimabue, in nineteenth-century Britain, for example, Lord Leighton entitled his own first academic success *Cimabue's Celebrated Madonna Carried in Procession*, with Cimabue himself and his boy-assistant Giotto proudly accompanying the *Rucellai Madonna* hand in hand. The supposed Florentine pedigree of the *Rucellai Madonna* and its royal reception formed the foundation myth for Vasari's entire Florentine edifice. Since the 1930s Duccio's authorship has been universally accepted, but few art historians have gone on to draw the obvious conclusion: that Duccio was at least as important as Cimabue to the 'New Painting' of the 1280s, and hence in determining the subsequent direction of all trecento art.

14 **Nicola Pisano**, *The Nativity*, *c.* 1265–68. Siena, Cathedral. This marble panel on the monumental pulpit of Siena Cathedral has some of the compression of Late Antique and Byzantine ivories. The figures were originally highlighted with gilding. Generations of Sienese painters would continue to learn from Nicola's reliefs, as would the sculptor Jacopo della Quercia in the fifteenth century.

Pisans and Parisians

In the years between Duccio's *Rucellai Madonna* and his *Maestà*, a single enormous enterprise dominated Sienese cultural life: the completion of the New Cathedral. In 1265 a famous sculptor was summoned to Siena to build a massive free-standing pulpit of the kind he had already created in Pisa. Nicola Pisano (*c.* 1210–84) was also known as Nicola d'Apulia, and his early formation was almost certainly in that South Italian culture of revived classicism centred on the court of the Emperor Frederick II. What Nicola brought north to Pisa, and then to Siena, was a new synthesis: the imagery of Christian Byzantium, now reinfused with figures much closer to pagan Rome. In *The Nativity* from the Siena pulpit, Mary is a classical goddess surrounded by virtual quotations from antique sarcophagi. To her left, two Roman matrons clasp hands, enacting the Visitation; the shepherds are dressed in Roman tunics, while their sheep, clustered around the Virgin's bed, have surely strayed in from some Virgilian pastoral, or from Jason's quest. At upper right, above the shepherds, intrudes the large head of a Roman emperor, his beard and hair well-drilled in true lapidary fashion. Yet the effect is never dryly antiquarian; this is one of the most moving and tender Nativities in all Italian art.

14

Nicola worked alongside a group of gifted assistants, among them an adolescent prodigy, his son Giovanni (*c.* 1248–*c.* 1319). After many wanderings – certainly in Italy, and probably also among the Gothic cathedrals in France – Giovanni was invited to Siena again, this time as *capomaestro*, designing both the sculpture and architecture of the Cathedral's west front. He would remain in the city for twelve years, from 1284 to 1296. His swaying prophets and sibyls, craning their necks and waving their scrolls

from high on the Cathedral's cliff-face, had a long-term influence on Sienese artists. When Duccio returned from Florence, he found Giovanni Pisano in charge of the Opera del Duomo (Cathedral Works). The two are documented in 1295, serving together on a committee to determine the site of a new communal fountain. French Gothic elements seem to have entered Duccio's work around this time, and it is possible that contact with Giovanni also inspired a journey into France. In 1296 a certain 'Duch de Siène' is recorded in Paris, in a street where many painters were living, and there is a similar reference for the following year. Duccio's tiny *Madonna of the Franciscans* was probably part of a portable shrine, and may date from the turn of the century. Its patterned background is strongly reminiscent of the work of contemporary Parisian miniaturists such as Honoré. Of all his Madonnas, this is the most courtly in feeling – the three diminutive friars bowing down in almost cinematic sequence,

15

15 **Duccio**, *Madonna of the Franciscans*, c. 1300. Siena, Pinacoteca.

the lowest kissing her foot. The panel's beauty of composition survives the severe damage to its surface; intimacy, wit, and a kind of tapering elegance are the keynotes of this little devotional masterpiece.

French influence would remain an important factor in Sienese culture. Back in 1260, the Battle of Montaperti had been celebrated as a victory of Emperor over Pope – of Ghibelline Siena over Guelf Florence. Yet the long-term consequences proved disastrous for the city. Sienese bankers had formerly held a virtual monopoly of papal financial services all over Europe (including the levying of 'Peter's Pence'); now Florence was rewarded instead with more and more of the papal business. In 1269 the Guelfs gained power in Siena, and initiated a long-term alliance with Florence, with the Pope (in Rome, and from 1309 in Avignon), but above all with the French, both in Paris and in Naples. Although this 'weak-partner' role continued as official Sienese policy under the Nine, popular sentiment remained Ghibelline and anti-papal. Duccio and his successors worked in a republic that was already in both political and economic decline.

The Maestà

Duccio's fourteen-foot image of the Virgin in Majesty – the *Maestà* 16 – is perhaps the most unreproducible of all the world's great paintings: if you lose the scale, you lose almost everything. Standing before it, we experience the Madonna as an immense spreading mantle filling the visual field, while the surrounding saints become contracted, a multitude who attend at the periphery. The blue of her robe, although subtly modelled in layer upon transparent layer, reads above all as a flat silhouetted shape – a deepest infinite midnight blue, large enough to lose ourselves in. Suspended against the pale non-colours of white and gold, this very dark blue creates unparalleled effects of dazzle and pulse, almost of hypnotic trance; it is as though we are being invited to worship not so much the Madonna as the Blue.

To either side of the throne, across the entire surface, there extends a play of exquisite flickering pattern, of richly embroidered fabrics, of geometric division and repetition. The marble platform is almost obliterated by the press of draperies, while above, the flatness of tooled-gold haloes breaks into the illusory space and swallows the angels' wings. The hirsute visages of Peter, Paul and John the Baptist are embedded within the beardless mass of nearly identical young male and female saints and angels; the overall effect is of a softened, dreamy and 'feminine' world – 'a private idyll of

16 **Duccio**, *The Virgin and Christ Child Enthroned in Majesty with Angels and Saints*, central panel of the *Maestà*, 1308–11. Siena, Museo dell'Opera del Duomo.

17 **Duccio**, The Christ Child, detail from the *Maestà*, 1308–11. Gold leaf and paint create a crisp conjunction, encouraging the artist to design in terms of shape and linear outline. Close-up, one marvels at Duccio's ability to integrate so complex a surface – made up of elaborate stencilling and incised haloes, as well as finely cross-hatched tempera modelling. Across the centuries the greenish (terra verde) underpainting has become much more visible.

the nursery' in Hans Belting's phrase. All around the throne the angels' tender laying-on of hands frames the central hand-play of mother and child. The Madonna's expression has probably been sweetened in restoration, but the gaze of the Christ Child is grave. As we move closer in, we see how this figure, his pale violet drape scratched through to the gold ground so as to create the tiny four-pointed stars, is also resolved in elaborate surface pattern, in a kind of abstraction.

Duccio's complex altarpiece – in which the image of the Madonna was only one component – represented an enormous undertaking for the artist and his assistants, at least three years in the making. A contract dated 3 October 1308 stipulated that Duccio was 'not to accept or receive any other work... until the

18 Reconstruction of the reverse of **Duccio**'s *Maestà* after John White.
The narrative begins on the predella, with scenes from Christ's life prior to his entry into Jerusalem – the episode that commences the main Passion narrative above, filling the two central tiers. The topmost level depicts Christ's further appearances after his Resurrection.

17

said panel should have been made and completed'. John White believed the carpentry of the entire altarpiece must have been carried through first, creating a vast, double-sided freestanding structure of pinnacles and pediments, roughly fifteen feet in each dimension; and he invites us to 'sense how marvellous and intricate a thing it was before a single brushstroke had been laid upon it'. Recent scholarship suggests instead that the panels were painted piecemeal, and only assembled at the end. Yet White's account does vividly convey the artisanal achievement – the sizing, gessoing and scraping that preceded the charcoal drawing; the stylus that incised lines into the gesso; the processes of laying a red bole ground beneath the gold leaf and embossing. It is sobering to realize that half the outlay for this altarpiece might have been on gold leaf, with another large amount for carpentry, transport and candles – and perhaps only a quarter on the actual pigments and labour.

The *Maestà*, like all the other panel paintings explored here, is executed in egg tempera: a patient accretion of small marks, of rhythmic hatchings and stipplings that build up an image far more slowly than the sweep and dash we have become accustomed to in oil. The tempera mark might be more 'impersonal'; but the best tempera painter may be the one with the most delicate touch, who creates the most fluid and integrated transitions between forms. Within these criteria, Duccio's *Maestà* remains unsurpassed.

By the middle of 1311, the altarpiece was ready. On 9 June, we hear of trumpeters, pipers and a castanets player being sent out at noon to meet the procession that would carry this enormously heavy object from the workshop up into the Cathedral:

At this time the altarpiece for the high altar was finished, and the picture which was called The Madonna with the Large Eyes... *was taken down. Now this Madonna was the one which harkened to the people of Siena when the Florentines were routed at Montaperti...And on the day [the* Maestà*] was carried to the Duomo the shops were shut, and the bishop conducted a great and devout company of priests and friars in solemn procession, accompanied by the Nine, and all the officers of the Commune, and all the people, and behind came women and children with great devotion. And they accompanied the said picture up to the Campo, as is the custom, all the bells ringing joyously, out of reverence for so noble a picture.*

The new picture is declared by the chronicler to be 'far more beautiful and devout and far larger' than its predecessor:

'everything is ornamented with fine gold; it cost three thousand florins'. Duccio's Madonna had inherited the role of civic protectress; she was as much a magical entity as a work of art, and the rhymed inscription on the throne may be more akin to a sorcerer's spell than to an artist's signature:

MATER S[AN]C[T]A DEI
SIS CAUSA SENIS REQUIEI
SIS DUC[C]IO VITA
TE QUIA PINXIT ITA
[Holy Mother of God / Be thou the cause of rest to Siena / Be life to Duccio / Because he has painted thee thus]

A description of 1435 identifies the *Maestà* raised up under the dome on a marble altar covered with a red cloth, flanked by perpetually burning candles and canopied above. There may have been curtains, drawn back to reveal the image only on feast days, or at specific liturgical moments: for example, when the priest, standing before the Madonna with his back to the congregation, elevated the host. Perhaps we need to have this sense of the *Maestà* as sacramental backdrop in order to grasp Duccio's shifts

19 **Duccio**, *Scenes from the Passion of Christ*, reverse of the *Maestà*, 1308–11.
Duccio's Passion narrative draws on texts from all four gospels, as well as from the Acts of the Apostles. The narrative unfolds from left to right in a zig-zag, up-and-down, sequence. We are invited to read the narrative not only as a linear progression, but also as a system of cross-references. Christ is consistently dressed in blue and red; at the Transfiguration and again, after his Resurrection, his robes are gilded.

in scale; the priest roughly the same size as the angels and saints, but the Madonna a giantess, and the format pressing upwards at the centre, as though to reinforce her swelling before our eyes.

Narrative and Predella

On the reverse of the same wooden panel as the *Virgin and Child Enthroned*, Duccio painted the Passion in twenty-five small scenes. This narrative was hardly ever viewed by the general public; it served as focus for the worship of the Cathedral clergy, who sang their offices in the enclosed choir behind the altar. The *Maestà* was removed from the high altar in 1506, and in 1776 the central panel was sawn down the middle, so that we now encounter the main front and back panels of the *Maestà* as two separate works shown facing one another, each commanding a very different response. The polarity is partly one of colour: if the Madonna is predominantly white, gold and blue, the reverse is chiefly red and gold. The Madonna elicits contemplation, stillness, silence; but to turn to the Passion narrative is to shift to the other side of the brain, where images demand to be followed in sequence, to be entered into empathetically and dramatically.

19

31

21 **Duccio**, *The Entry into Jerusalem*, detail from the *Maestà*, 1308–11.
The central Passion narrative opens with a scene of unprecedented spatial complexity. The vertical panel conveys the steep climb up the road between stone walls (the nearer one penetrated by an open door) and into the city through the deep gate. The biblical event – the fulfilment of Zechariah's prophecy, 'Lo, your King comes to you; triumphant and victorious is he, humble and riding on an ass' – is fused with Duccio's compelling observation of the contemporary world.

Artists of the fourteenth and fifteenth centuries were, I believe, fortunate to work on complex structures, where two such different aspects of imagery could be united in a single composite object. The iconostasis of the Eastern Church consisted mainly of single portrait-icons, but included also a row of saint's narratives – the 'festival tier'. Early Tuscan painters were constantly experimenting with new formats: they inherited from Byzantium the *vita icon*, a full-scale saint standing surrounded by little scenes from his life; but they also pioneered genres where icon and narrative were (as in the *Maestà*) kept more discrete. From the trecento onwards, the typical Italian altarpiece would have two parts: the large-scale cult image, which serves to identify and make present the mediating saint or holy figure, beckoning the worshipper into the space before the altar; and the small-scale narrative sequence, telling the particular story relevant to the cult, which informs and nourishes prayer. Typically, this narrative came to be placed on the narrow strip that runs along the base of the altarpiece, seen best by the worshipper kneeling close by. Many of the most memorable and compelling Sienese paintings are from predellas of this kind.

In the *Maestà*, a double-scaled double-sidedness is essential to its meaning. The Virgin is enthroned within a metaphysical realm; little scenes from her life on earth are added above and below, but they only serve to underline her timeless state. Yet the reverse of the *Maestà* is *all* little scenes – all time, all narrative, all incarnation. Christ moves through a social world whose urban character is constantly emphasized: the central Passion narrative starts with the Entry into Jerusalem and ends on the road outside 21 Emmaus – another entry into another city gate. We might think 20 of this narrative sequence alongside other settings of the story – Bach's *St Matthew Passion*, or, closer perhaps in its cinematic unfolding, Pasolini's *Il Vangelo secondo Matteo* (The Gospel According to Matthew). In Duccio's narrative the locations are immediately established: the same green room appears three times, in the Washing of Feet and the Last Supper, and again as Christ tells the disciples one of them will betray him; at which point Duccio suddenly 'cuts' in mid-panel to an entirely different colour world, a bleached exterior where Judas conspires with the Pharisees. Then, after the Agony in the Garden and the Arrest – both scenes horizontal in format – there follows the marvellous spatial invention of a staircase joining two rooms: Christ upstairs, 22 questioned by the High Priest Annas, while below, huddling by the fire, Peter makes his first denial, pointed out by a maidservant

22 **Duccio**, *Christ before Annas*
(above) and *Peter's First Denial*
(below), detail from the *Maestà*,
1308–11.
'And as Peter was below in the
courtyard, one of the maids of the
high priest came; and seeing Peter
warming himself, she looked at
him, and said, "You also were with
the Nazarene, Jesus." But he denied
it, saying "I neither know nor
understand what you mean."'
(Mark 14: 66–8)

with a superbly expressive gesture. In the next panel, standing
outside, he denies knowing Christ two more times; and in the
upper scene we see the cock crow. Then, as the narrative moves
onto the upper tier, the Roman and Jewish judiciary take over;
Christ is questioned, flogged, condemned; almost lost in the
crowd he carries the cross.

In by far the largest image, placed at top centre, Christ is
crucified. But what then occurs, after all that crowding and
multiplication, is a kind of emptying out. Only a few figures appear 19
in each of the concluding scenes; the sense is of epilogue, or
elegiac finale. Now the gold ground – confined to a narrow band
in the city interiors – pours in, asserting its dematerializing power.
Throughout, the Passion narrative has driven Duccio on to create
extraordinary colour-equivalents for dramatic moments. In the
last panel before the narrative moves onto the uppermost level,
two disciples meet a stranger on the road. He is dressed as a
medieval pilgrim, wearing a hair-shirt and a scallop-shell pouch,
carrying a staff, hat on back. The two hands point towards the
gate. The disciples will go into the city with him, and we know
that in Emmaus, at the moment when they recognize him as
the risen Christ, he will disappear. The conjunction of two
evanescent colours – white city compressed against gold ground –
marvellously embodies this 'disappearance'. It is as though the
historical Jesus were slipping out of the narrative, to become
'ethereal' once again.

When we turn to the predella below these scenes, the urban
theme is also strongly present, especially in *The Temptation* with 2
those seven little cities we have already encountered. Three scenes
further to the right, the image is divided between city and country.
Seated on the rim of Jacob's Well, Jesus pursues a strange dialogue 23
with the Samaritan woman, eventually revealing himself (in John's
text) as the Messiah. Both are silhouetted against the expanse of
flat gold. The disciples, meanwhile, watch from the city of Sychar –
a more compressed variant of the gate in the *Entry into Jerusalem*.
In the adjoining panel, *The Healing of the Man Born Blind*, Christ 24
and the disciples are inside the city walls – the first time in
Sienese painting that the street begins to be explored spatially.
Each window and door is differentiated, often left slightly ajar,
as though cautiously beckoning us to enter. The convention
employed here is known as 'continuous narrative': it is the same
man who first has his eyes touched, and then, having washed them
in the pool, casts his staff away and turns towards the light. The
conjunction of white and gold – the bare white wall, and the long

23 **Duccio**, *Christ and the Woman of Samaria*. Predella panel from the *Maestà*, 1308–11. Madrid, Thyssen-Bornemisza Collection.

vertical shaft of gold leaf – is deployed once again, but here to create the equivalent of the healing miracle, the sudden breaking-in of sight.

The *Maestà* was painted for a city audience, commissioned by a city-state. The contemporary Tuscan hilltown settings may well have been stipulated in Duccio's brief (and a younger master, perhaps Simone Martini, hired as a kind of 'architectural specialist'). To what extent might these 'anachronistic' settings have been influenced by medieval drama? From the eleventh century or earlier, sacred plays are known to have been performed in many Italian cities. In Siena in 1257 we hear of

24 **Duccio**, *The Healing of the Man Born Blind*. Predella panel from the *Maestà*, 1308–11. London, National Gallery.
Unmistakably the work of two different artists, figure and townscape each speak a very different language. John's account of the miracle includes Christ's declaration 'I am the light of the world'; to the right of this panel was the dazzling *Transfiguration*.

a *Play of the Marys* and a *Crucifixion* being staged in the Campo; and also of a Palm Sunday procession through the city, the bishop leading the townspeople through one of the gates to meet an actor garbed as Christ. So a fourteenth-century Sienese painter might indeed have witnessed the Passion unfolding against the background of a local street. Such performances, together with the vivid sermons of Franciscan friars keen to bring home the sufferings of Christ to their urban audiences, must have given further impetus to the new tendency so striking in Duccio's successors, the depiction of biblical history as though it were contemporary event.

'From Greek, Back into Latin'

According to Vasari, it was Giotto (c. 1267–1337) who
first 'abandoned the rude Byzantine manner and revived the
modern and good style of painting'. A century before, Poliziano
had put into Giotto's mouth the boast: 'I am the man who
brought painting to life when it was dead'; and writing earlier
still, in the late fourteenth century, Cennino Cennini saw Giotto
as having 'changed the profession of painting from Greek, back
into Latin, and brought it up to date'. Yet Duccio's *Rucellai* 12
Madonna predates Giotto's *Ognissanti Madonna* by perhaps 25
as much as twenty years. Seeing them side by side now in the
Uffizi, it is by no means clear that the younger artist had made
any advance in terms of *quality*. Indeed, in beauty of colour or
subtlety of touch, Duccio is arguably the superior painter. But
there is in Giotto a greater rationality and clarity, so that he
seems to repudiate those 'paradoxical', dreamy or ethereal,
overtones so evident in the *Rucellai Madonna*. What results is
a Mother and Child more natural, more accessible, closer
to humankind.

To set Giotto against Duccio must, I think, have been
commonplace even in the 1300s. Artists often emerge in
contrary pairs – like Dostoevsky or Tolstoy, Picasso or Matisse –
demanding not only comparison, but choice. Erwin Panofsky's
characterization of Giotto as 'epic', Duccio as 'lyrical' may be
helpful. The contrast is confirmed by the biographical record:
Giotto prudent, successful in his investments, hiring out looms
at enormous profits; Duccio disorderly, with large debts, fined
several times, accused of sorcery, refusing to go to war: in short,
the proto-bohemian to Giotto's proto-bourgeois. Already the
Sienese and the Florentines were mapping out separate artistic
territories. John White observes, regarding Duccio's *Entry into* 21
Jerusalem, that 'nowhere in Giotto's output are there such a sense
of landscape, such reflections of the pulsating, casual multiplicity
and varied beauty of the natural world'. We might speak of Duccio
as 'feminine' and Giotto as 'masculine'; of Duccio as emotionally
and spatially mobile, where Giotto remains always calm, stable,
and lucid in his construction. (To quote White again, 'no depth
was meaningful to him unless it could be measured out on level
ground'.) The grandeur and monumentality of Giotto comes
partly out of Roman sculpture. Even in Siena, the weighty plasticity
of Giotto's figures would feed into those of Simone Martini and
the Lorenzetti brothers who would achieve an extraordinary
synthesis of both 'Greek' and 'Latin'.

Yet Duccio had one close follower, Ugolino di Nerio, who in Vasari's words 'held in great part to the Byzantine style, to which he had become attached by habit; and always preferred, from a species of obstinacy, to follow the manner of Cimabue rather than that of Giotto'. Ugolino's greatest work was the huge polyptych made in 1325, several years after Duccio's death, for the Franciscans of Santa Croce in Florence (the panels of which are now dispersed, mainly between London and Berlin). Why did these Florentines choose Ugolino, rather than a local, more 'up-to-date', follower of Giotto? Probably for the same reason that Florentines would, a century later, import Flemish paintings: they wanted an emotional intensity their own tradition did not supply. In Ugolino's *Entombment* the upflung arms, the embrace, the

26 **Ugolino di Nerio**,
The Entombment, 1325. Berlin, Gemäldegalerie.

26

various postures of grief all have their precedents in Duccio, though rendered here perhaps even more dramatic and moving. It is an arresting and beautiful picture, and in many ways Ugolino vindicates his 'obstinacy'. Nevertheless, examined closely, there are awkwardnesses – a hand placed too close behind the Virgin, another under Joseph of Arimathea's beard – so that overall Ugolino is revealed as a lesser master than Duccio, as well as a more 'conservative' one.

Duccio was (as Louis Aragon wrote of Fernand Léger) the 'hinge' of the new century, his work wonderfully poised between tradition and futurity. The language of Byzantine art embodied a mystique, a timeless remoteness, essentially opposed to Siena's communal culture. Duccio's art was a difficult adaptation, by which the hierarchical style first created for an imperial court was made to serve a newly founded experiment in civic democracy. His true heirs in Siena would discover a vernacular of street scene and human sociability that breaks free of their Byzantine inheritance.

Chapter 2 Simone Martini: 'The Sweet New Style'

Of all early Italian painters, Simone Martini (c. 1284–1344) has the widest emotional and stylistic range. Across thirty years he continues to change, almost bewilderingly: secular and courtly, a witty portraitist, a master of detailed, precious description; yet also a very profound religious artist, who imagines the Christian narrative anew with compelling power.

The lower part of his *Entombment* retains something of the stillness and frontality of Duccio and Ugolino; but above and to the left, Simone unleashes an unprecedented outcry of wild emotion. A woman turns to another open-mouthed, howling; others press hands to ears, fling themselves into one another's arms, tear at their hair. Between Duccio and Simone, the conceptual shift is from Entombment to Lamentation – from calm action to shocking expression. This raw intensity of grief would not be paralleled again in Italian art until the late reliefs of Donatello. And although the panel is tiny – not much larger than this book – it registers in Berlin as the most sheerly passionate picture in the entire Gemäldegalerie.

If the colour orchestration seems oddly 'modern', this is partly due to Simone's atmospheric night sky – believed until recently to be a nineteenth-century repainting, but now confirmed as Simone's own highly original invention. The expanse of orange becomes foil to all those clustered apple greens, violets, pinks, blues and reds, each at full strength and separately contrasted, here somehow assembled into an improbable harmony. The crowd of the Louvre's *Carrying of the Cross* presents a similar bouquet of bright colour patches, but now set against a beautifully articulated cityscape where graded purples define the interior of Jerusalem's gate. Christ is surrounded by enemies, mockers, stone-throwing children, pulled at by a Pharisee, yanked forward by a rope. His mother reaches out to take the weight of the cross; a soldier pushes her away, threatening to strike her with his mace. Simone is here a superbly inventive dramatist. But as in *The Entombment*, the strangest notes are at upper left, in the flood of

27

28

27 **Simone Martini**, *The Entombment*, c. 1312 or c. 1337. One of four surviving panels from the *Orsini Polyptych*. Berlin, Gemäldegalerie.

over-large heads with glinty little eyes pouring out of the gate – an extreme expressivity bordering on the grotesque, which we will often meet with again in Sienese painting.

Both these compressed crowd scenes are uncertain in date: perhaps very early in Simone's career, reflecting his origins in Duccio's workshop; or much later, pointing to some new expressive possibility at the end of his life. Whatever their origin, they would come to be housed before 1400 in the Chartreuse de Champmol, the great court monastery and burial place of the

Dukes of Burgundy outside Dijon, which would become for a few decades a centre of European cultural life. More than any other Sienese images, they would influence subsequent Flemish and French painting; their echo is found also in Bohemia and Cologne, in Spain, and even in England.

In the French High Fashion

Simone's first documented work was completed in Siena in June 1315. It is a fresco over thirty feet long, filling one end wall of the Great Council Hall in the Palazzo Pubblico, where many hundreds would cram together to debate the policies of the Nine. Simone's wall has been described as 'almost a commentary' on Duccio's *Maestà* of four years earlier – closely related in composition, yet carrying an entirely different function and meaning. The protectress still hovers in the dark Cathedral; but now the Nine

29

16

29 **Simone Martini**, *Maestà*, 1315; reworked, *c.* 1320. Siena, Palazzo Pubblico.
The wide border of twenty roundels, with saints and prophets each holding scrolls, sets the work of justice within a biblical framework. Christ is Judge above; below, on the lower border a double-headed woman symbolizes the Old and New Law. Kneeling in front of the Virgin and Child are the same Sienese patron saints (Ansano, Savinio, Victor and Crescenzio) who had already kneeled before Duccio's Madonna.

have invited her down into the Campo to preside over the decisions of State. Her throne has been set up under a canopy – in Eve Borsook's phrase, 'a kind of reviewing stand'. (We might think of Guinevere watching the tournaments in Arthurian romances.) She wears, instead of Duccio's infinite celestial blue, an intricately embroidered gown that reads at a distance as a most elegant grey. This Virgin is almost a secular queen, whose company of angels and saints cluster about her as courtiers and bodyguards. The gaze of Simone's sacred persons is far more alert and directed than the sleepy-eyed melancholy with which Duccio's faces look

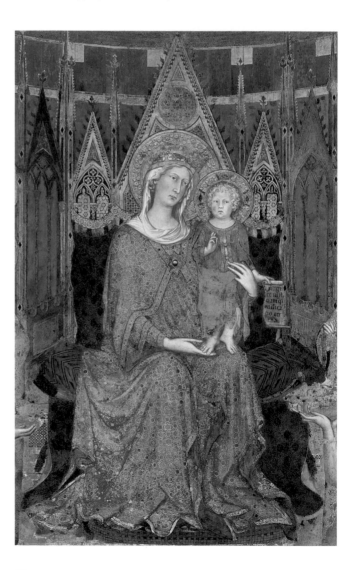

30 **Simone Martini**, The Virgin and Child, detail from the *Maestà*, 1315–20.

at us. Simone has updated Duccio's heavy throne with the pinnacles and filigree of Parisian high fashion. Above, the Cloth of Honour of the Queen of Heaven is lined with stars, edged with the arms of the Commune, and also those of the Angevins, Siena's allies in Naples.

On the scroll held up by the Christ Child, the opening words from the apocryphal Book of Wisdom appear in Latin: 'Love Justice, You who Judge the Earth'. And it is as Justice personified that the Virgin speaks to the councillors in long inscriptions on the steps – not in Latin, but in the Tuscan vernacular, and in the *terza rima* (triple-rhymed lines) made familiar by Dante:

The angelic flowers, the roses and the lilies / That adorn the plain of heaven / Do not delight me more than good counsels. / But one I see who, seeking his own gain, / Despises me and cheats my land... / And when he speaks worst is most applauded. / Watch out, whoever is condemned by this speech.

A few months earlier, Siena had been brought to a standstill when two great aristocratic families, the Tolomei and Salimbeni, battled in the streets. In her second utterance, the Virgin warns her people again:

My beloved, keep in mind / You who devote to me your honest prayers / Whatever you request, so shall I grant / Except if the powerful molest the weak, / Oppressing them with shame or hurt...

Simone's fresco has a surface area four times that of Duccio's panel, and was a very different undertaking – less expensive, faster and situated far above head height, inviting a less concentrated aesthetic scrutiny. The fresco painter would first have made a full-scale brush drawing – the sinopia – on the rough plaster. The final image would have taken shape patch by patch on the next, smoother layer, each section needing to be completed while the plaster was still wet. A typical day's work might have completed a single head (there are more than thirty in Simone's *Maestà*), most of a figure, or a larger area of landscape. Speed was important: the fresco season was usually confined to the drier months – roughly April to November; for the patchwork to grow smoothly, the team needed to be very well prepared. (The analogy to the film director preparing his 'shoot' was made explicit when Pasolini cast himself as Giotto in his *Decameron*.) Yet in practice, nearly every fresco was finalized with some further, less stable details applied dry (*a secco*). Simone worked always rather in the manner of a miniaturist, using small brushes even in his largest

31 **Simone Martini**, An Angel,
detail from the *Maestà*, 1315–20.

murals. It would have made him a very slow fresco painter;
evidence suggests he painted *a secco* far more extensively than
any of his contemporaries.

The ruinous condition of the *Maestà* may be partly a
consequence of this; it was perhaps because of technical problems
that Simone was recalled to the Palazzo Pubblico after 1320. In
this second campaign, he altered much, constantly breaking the
painted surface: a chunky imitation opal for the Virgin's brooch,
inlaid coloured glass on her throne, an actual piece of parchment
pasted to the wall for the Christ Child's scroll. The angel offering a
brimming bowl of flowers retains a hairstyle close to Duccio. Yet
her open-mouthed profile and plump chin belong to a different
aesthetic – suspended between Siena and Paris.

31

A commission such as this could only have been awarded to a
leading master, but we know nothing for certain about Simone's
early career. He may have grown up not in Siena but in San
Gimignano, a smaller hilltown some thirty miles to the north-west,
training there under a local painter, Memmo, whose daughter he
would eventually marry and whose son, Lippo Memmi, would
become Simone's chief collaborator. In the late 1290s, he was
probably apprenticed to Duccio, returning to the workshop to
assist on the *Maestà* in 1308–11. But Vasari's reference to Simone
as a 'pupil of Giotto' may point to more complex origins: perhaps
a period of working in Assisi. It seems likely that at some time
before 1315 Simone was active in a French cultural milieu –
whether in Paris, at the papal court in Avignon, in the service of
the Angevins in Naples, or, more exotically, in Hungary.

The *Altarpiece of St Louis of Toulouse* was probably made for the
church of Santa Chiara in Naples, where the Angevins were

32

buried. It has been described as a 'dynastic icon', and its patterned splendour masks the murky events on which it is based. Simone's painting was nominally commissioned to celebrate the canonization of Louis in 1317; in reality, it was intended to legitimize the usurper King Robert, by showing his saintly brother giving him the crown. Stripped today of most of its jewels, the altarpiece remains an astonishing object, nearly ten feet high, its original frame intact. The huge seated figure seems archaic in its frontality, until we notice the sly off-centredness of Simone's design. His brown sackcloth smothered beneath his crimson jewelled cope, the Franciscan prince stares impassively out. At the

32 Simone Martini, *Altarpiece of St Louis of Toulouse*, c. 1317. Naples, Museo di Capodimonte. Simone's great altarpiece has remained exceptionally intact, complete with frame and predella. Some scholars believe it was originally in San Lorenzo Maggiore in Naples. This Louis is not the famous crusading French king, but his Angevin nephew, a prince who in 1286 renounced any claim to his father's throne of Naples and became a poor Franciscan friar with Spiritual tendencies – only to be created, unwillingly, Bishop of Toulouse.

33

33 Simone Martini, King Robert II of Naples, detail from the *Altarpiece of St Louis of Toulouse*, c. 1317.
Louis's younger brother Robert snatched the throne of Naples from his young nephew, supported by the Avignon papacy, who also saw to it that Louis was canonized. Robert's villainous profile is surely drawn from life, one of the earliest likenesses in European painting. Simone's depictions of Petrarch's Laura and of Cardinal Orsini (both now lost) are the earliest portraits recorded in Italian art.

top, angels reward him with a celestial diadem; but below in a strange left-handed gesture, he gives away his earthly crown to a diminutive Robert who kneels to receive it. In the predella scenes below, Simone pioneers a new spatial intimacy in the architectural settings for Louis's miracles. But any note of 'realism' is overruled by the double heraldic framing: first the panel, bordered with closely packed fleurs-de-lys (emblems of the French royal house) punched into the gold ground; then the frame itself, the same flowers greatly enlarged, modelled in deep relief, each a separate golden star blazing against the deep night-blue – as though, like the Angevin dominions, poised to expand ever outward.

The Montefiore Chapel and Franciscan Narrative

In the years just before his *Maestà*, Simone had started work on a major commission to create an entire chapel in the church of San Francesco in Assisi. He may have returned there from Naples, to complete this single most ambitious undertaking of his career. The church where St Francis lay buried had been at the centre of the 'New Painting' for over thirty years. Cimabue and several Roman masters had each made their contribution, and the transition 'from Greek, back into Latin' was even more evident in the fresco cycle of the *Life of St Francis* in the upper church, perhaps completed around 1295. Whoever the artist was (and many art historians now rule out Giotto) he was certainly familiar with the Late Antique mural cycles surviving in the basilicas of Rome. The Upper Church at Assisi might be described as French Gothic, adapted to display Roman wall paintings.

34–9

St Francis (1182–1226) had founded what was originally a lay order in 1209 with a call to radical poverty:

Povertade e nulla avere,
E nulla cosa poi volere,
Et omne cosa possedere
In spirito di libertade.
[Poverty is to have nothing, / And to desire nothing, / And to possess all things, / In the spirit of freedom.]

His call was extraordinarily successful; there were already ten thousand friars at his death, and he was canonized only two years later. Yet Francis had died estranged from his own order, already a great ecclesiastical institution. A split would soon develop among the Franciscans, between the Spirituals, who maintained that Christ and his disciples had no possessions and were opposed to expenditure on buildings or works of art, and the Conventuals,

who had become one of the richest corporations in Europe, building the huge double church at Assisi as their power centre. The Spirituals were persecuted as heretics; around the time Simone was working in Assisi, Pope John XXII issued from Avignon a series of papal bulls denying the poverty of Christ. For their *Life of St Francis*, the Conventuals nevertheless opted for fresco, a less costly medium than mosaic or glass. This was the first monumental picture cycle to relate, not the hallowed biblical images, but the story of a modern Italian. As Paul Hills has observed, 'Christ had taught by parables, yet narrative had long taken a subordinate place, compared to the transcendent symbols of Christian art. The Franciscan movement re-established the value of narrative rich in human incident.'

Francis's influence was bound up with his choice of language. His *Canticle of the Sun* (or *Of All Created Things*) was the first great poem in the Italian vernacular, reflecting a new acceptance of the natural world, of 'Brother Wind' and 'Sister our Mother Earth'. To employ the language of the common people and of the street was part of Francis's challenge to the authority vested in medieval Latin, in Church and Law. The earliest surviving document in Italian is an account book written in 1211 by a Sienese merchant. By the early 1300s, Dante (a member of the Franciscan lay or 'third' order) was composing the defining work of literary Italian, the *Commedia*, later known in English as the *Divine Comedy*. At the outset Dante needs Virgil's guidance to find his way out of the 'dark wood'. But Dante's own linguistic 'way' would be Tuscan, not Latin. As Gabriel Josipovici points out, 'Latin for Virgil was his vernacular; to write in Latin in thirteenth-century Italy would therefore be in a sense a betrayal of Virgil.'

Thus the paradox appears: that just at the moment when the poets of the *Dolce Stil Nuovo* (Sweet New Style) were choosing to write in their native Tuscan, the 'New Painting' was being created largely out of the forms of Roman antiquity. There is a real convergence between Francis's use of the vernacular – his rediscovery of the gospels as the narrative of the common people, in the common tongue – and the vernacular emphasis in the Siena of the Nine, with its aspiration towards a just commonality. (The first vernacular Sienese constitution was produced in 1309–10, just as the Commune began to occupy the Palazzo Pubblico, and while Duccio and his assistants were labouring on the *Maestà*.) But could these essentially demotic values, either the Franciscan or the Communal, ever be satisfactorily embodied in a painting idiom based on so authoritarian an art as that of Imperial Rome?

To step up from the darkness of the Lower Church at Assisi, into Simone's Montefiore Chapel, is to enter an altogether separate world. Elaborate Gothic tracery, coral-and-cream inlaid marbles, and stained-glass windows all conspire with the painted narrative to create, in Borsook's phrase, 'a shimmering casket'. Just as Simone had made his Francophile 'commentary' on Duccio's *Maestà*, so at Assisi he designed an ensemble whose aesthetic could hardly be more opposed to the simplicity and 'poverty' of the *Life of St Francis* upstairs. In Italy, the word *Francescano* (Franciscan) is still used by decorators to denote a paint surface without shine or gloss. But Simone's walls are all shine and gloss; and to anyone attuned to the message of Francis, they may seem at first something of an intrusion.

34, 37

The chapel is dedicated to a French saint, Martin of Tours, often seen as the fourth-century forerunner of Francis: both first experienced their calling when they offered their cloak to a beggar. Simone sets his opening scene outside a city gate. The beggar's grasping gesture in the sinopia is transformed into the more vulnerable and poignant crossed arms of the fresco. The

35

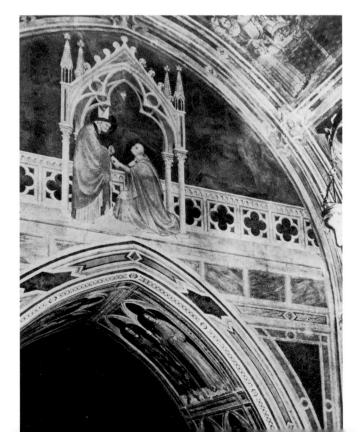

34 **Simone Martini**, *Cardinal Gentile da Montefiore Kneeling Before St Martin*, c. 1317–20. Assisi, Lower Church of San Francesco, Montefiore Chapel.
The donor, Cardinal Montefiore, was a worldly Franciscan and (while Papal legate in Umbria) a zealous persecutor of the Spirituals, before being employed in Buda by the Angevins. It was he who successfully diverted the rival claimant to the throne of Naples (Robert's young nephew) by fixing him up with the crown of Hungary. Montefiore died in 1312, leaving a large sum to the church of San Francesco in Assisi, where Simone probably began painting his chapel soon after.

35 **Simone Martini**, *St Martin Shares his Cloak with a Beggar*, *c.* 1317–20. Assisi, Lower Church of San Francesco, Montefiore Chapel.

The greenish sinopia underdrawing was uncovered in restoration work on the much damaged final fresco. The city behind St Martin (Amiens) relates closely to the cityscapes in Duccio's *Maestà*. Sassetta's image of St Francis giving his cloak to a poor knight (ill. 119) offers a parallel narrative.

36 Simone Martini, *Christ Appears in a Dream to St Martin*, *c.* 1317–20. Assisi, Lower Church of San Francesco, Montefiore Chapel.

37 Simone Martini, East wall of the Montefiore Chapel, with *The Investiture of St Martin* and *St Martin Renouncing the Sword*, *c.* 1317–20. These were probably the last scenes to be completed. Painted, like most frescoes, above head height, they become part of the decorative unity of the wall with its heraldic and diapered marbles. The profile of the Emperor Julian, perhaps derived from a Roman cameo, links both scenes. On the right, above his head, coins pass from hand to hand – soldiers' pay, refused by Martin. At Assisi, this was especially apposite: a Franciscan should never handle money.

following night, Martin, like Francis, is vouchsafed a dream. But in contrast to St Francis's austere chamber in the Upper Church, Simone's St Martin lies in luxury, the bed thrust into the foreground, marvellously realized in sheet and bolster and curtain. The complex tonal shifts of the plaid counterpane, rising up from a foundation of strongboxes, are exquisitely graded in pinks, greens and yellows. Beside this virtuoso description – a draper's catalogue raised to the visionary – the little head and hand of the haloed saint seem marginal; as does even Christ himself, wearing the beggar's half-cloak and surrounded by angels who watch tenderly over the sleeping youth.

We see Martin next invested by the Emperor Julian with the sword and spurs of knighthood – a fine opportunity for Simone to stage a tale of chivalry, with no expense spared. If Simone himself

36

38 **Simone Martini**, A Hawker and an Armourer, detail from the *Investiture of St Martin, c.* 1317–20.

39 **Simone Martini**, Musicians, detail from *The Investiture of St Martin, c.* 1317–20. The peculiar hat worn by the piper has been convincingly identified as Hungarian – evidence that Simone may indeed have joined Cardinal Montefiore's retinue in Buda. The whole group of musicians, and especially the singing trio so wittily compressed into the right edge, marvellously combines observation and invention. Their motley dress creates a very distinctive colour world – in Paul Hills's phrase, 'as natural and as strange as a tabby-cat's coat'.

was a knight (the 'Symone Martini, milite' who in 1317 was awarded an annual grant of fifty ounces of gold by King Robert) then this scene may well be an authentic reconstruction of his own court ceremony at Naples. His interest in the precise cut and hang of costume, in the way different fabrics respond to light, is everywhere evident. Perhaps echoing the flickering colour patches thrown by the stained glass, the flute-player's hat changes before our eyes from green to crimson. Among the beardless young men who throng the court, two on the left, bearing armour and a hawk, are deliciously contrasted in their gently smiling gaze: the musicians on the right are equally vivid, the frowning singer especially finely observed. In the companion scene, the saint goes into battle armed only with a cross; the army's tents and houses are compressed, so that Martin can turn into the emptied landscape to confront the hairy, visored barbarians approaching from across the stream.

39

38

These are the scenes we encounter first and most legibly as we step into the confined space, and they establish an essentially secular and wealthy milieu. True, if we look up, two further tiers piled above depict Martin as bishop and miracle-worker, but even here, incidental detail seems to outweigh any religious impetus.

St Francis had placed at the centre of the religious life a smiling sweetness and joyousness, and the charm of his personality is here paralleled by Simone's charm of composition and storytelling; he achieves a 'Sweet New Style' of his own, whose effect is partly to challenge the Roman authority of the frescoes upstairs. With hindsight, we can recognize that Simone's Assisi frescoes would provide one foundation for the brilliant retelling of Francis's life, in supremely non-authoritarian mode, painted by Sassetta a century later.

116–30

Simone in Siena 1328–33

The city Simone returned to was now rapidly growing – from an estimated 30,000 inhabitants in 1275, to at least 50,000 by 1340. The new religious orders – chiefly Franciscans and Dominicans – had settled on the outlying spurs of the city, moving among the urban poor in the newly built streets. Their mission would generate a new iconography of popular religion. Blessed Agostino Novello, Prior General of the Augustinian order, had died in 1309 and was probably known to Simone at least by sight. In 1324 the Commune allotted a large sum to celebrate his life. For this very

40 **Simone Martini**, *Altarpiece of Blessed Agostino Novello*, c. 1328. Siena, Pinacoteca.
Ascribed to Simone only in the twentieth century, this altarpiece was painted for the church of Sant' Agostino in Siena. In his *Confessions*, St Augustine told of his conversion through the example of St Anthony, and both these saints look down on Agostino from their roundels. In the dark foliage all around him, little birds are perched; one is at his feet, perhaps echoing the familiar image of St Francis.

local cult, Simone, the most sophisticated artist of his day, suddenly performs in what is almost the idiom of a folk tale. Agostino stands book in hand at the centre of a *vita icon*, a giant figure looming above the trees, ear cocked, alert to the angel's advice. He is flanked to right and to left by the modest domestic miracles he performed after his death, set in the Sienese localities where they had so recently occurred. In one scene, a small child in a grey-and-red striped robe has dropped from a high balcony through a loose wooden slat – the distraught mother watching him fall headlong – when suddenly there swoops down from the left, trailing clouds and deftly catching the slat in mid-air, Blessed Agostino, and the boy is set on his feet, right as rain. The relatively blank architectural screen of Duccio's *Healing of the Man Born Blind* has now become a living street, to be entered into as a spatial tunnel. We feel Simone carving his way back into space inch by inch, not without awkwardness, but with a kind of revelatory intimacy. The exquisitely graded pinks are an intensification of Duccio's palette, more emotionally charged: the street becomes an almost fleshly matrix, from which the miracle is born.

40

41

24

41 **Simone Martini**, *Agostino Saves a Falling Child*, detail from the *Altarpiece of Blessed Agostino Novello*, c. 1328.
Simone has gone to great pains to recreate the street – the balcony's carpentry, the grain of the wood, the recession of the roof tiles. Through a door, just below the falling child, we glimpse an interior staircase. The overlapping of the further side of the street, set against the dark loggia, marks a new spatial discovery.

42 **Simone Martini**, *Agostino Heals a Child*, detail from the *Altarpiece of Blessed Agostino Novello*, c. 1328.

Outside a grey wall and towered gate another child lies, head bleeding, savaged by a wolf. But again from on high there appears behind the tower the head and shoulders of Blessed Agostino, silhouetted against the golden sky, his attendant clouds hovering jaggedly at the top; and again the child Is restored, to kneel alongside the other witnesses. Two further miracles, equally touching, involve a broken cradle and a fall from a horse, set in the familiar *crete*, the desert-like hills just outside Siena. In each the convention of continuous narrative – by which the falling horseman can be set just to the right of the same horseman saved – is employed with such a naive directness as to seem today almost comical; while the way Blessed Agostino flies in will inevitably carry overtones of Superman. We almost hear the 'whoosh' as he appears.

But if these street miracles show Simone at his most 'popular', *The Annunciation* completed some eight years later, is his most

42

43

43 Simone Martini and Lippo Memmi, *The Annunciation* (central panel), 1333. Florence, Uffizi. The brothers-in-law merged their workshops for this major commission. Lippo's own paintings have sometimes been derided as bland, or lacking in tension; but he was always a flawless craftsman, and some of the credit for the outstanding quality of this altarpiece is certainly his.

exalted and exquisite masterwork. It stood on the altar of St Ansano in the Cathedral, to the left of Duccio's *Maestà*. We may need to block out the insipid flanking saints (probably by his collaborator, Lippo Memmi) as well as the flimsy nineteenth-century frame, in order to experience the full power of this wonderful confrontation. Simone has here eschewed all concern for deep space or plausible setting. The gold ground is itself a force, carving out a dramatic void between the two figures, scooping an extraordinarily expressive shape from the Virgin's shoulder. The angel is life-size, yet rendered immaterial, dissolved in gold-and-white damask, whose blue shading confers a phantasmal sheen. From the open mouth of the angel comes a diagonal shaft of embossed speech: 'Hail Mary Full of Grace', the

44

44 Simone Martini and Lippo Memmi, The Angel Gabriel, detail from *The Annunciation*, 1333. The radiant flesh of the forward-pressing head is painted in tiny marks, with the dark contour of neck and chin set against astonishingly elaborate punch-marked and incised gilding – rivalling the complexity even of Duccio's surfaces. Simone's ornamental aesthetic contrasts with the starker approach to human depiction of Giotto and his Florentine successors.

opening words of the recently instituted *Ave Maria* prayer. Yet Simone's real subject is not the angel's salutation, so much as Mary's response. According to St Luke's gospel, 'she was greatly troubled at the saying, and considered in her mind what sort of greeting this might be'.

Simone's picture is marvellously and profoundly centred upon fear. As Gabriel alights in fluttering movement, his plaid cloak still swirling behind him, the Virgin is made literally to 'shrink'. Placed within sight of Duccio's enthroned Madonna of twenty years earlier, Simone's blue-mantled figure silhouetted against the gold was both an echo and a rupture; the still icon transformed into narrative, the hieratic divinity swept up into dramatic action.

The Guidoriccio and Barna Controversies

Long seen as a key work of Simone's, and among the most famous of all Sienese paintings, the thirty-foot-long fresco in the Palazzo 45

45 North wall of the Great
Council Hall, or *Sala del
Mappamondo*, in the Palazzo
Pubblico, Siena (present state).
Above, *Guidoriccio at the Siege of
Montemassi.*
Formerly given to Simone Martini,
the attribution of this fresco is
now widely questioned. It was
painted in barely ten sessions (in
contrast to Simone's own slow
fresco technique). Below are the
circular grooves left by Ambrogio
Lorenzetti's lost World Map from
which the room derived its name,
and the pre-existing fresco
uncovered in 1978. The two saints
in niches were added by Sodoma
in the sixteenth century.

Pubblico shows a richly caparisoned knight riding alone through a
vast landscape, silhouetted against a deep blue sky. It is a design of
great poetic charm that evokes an already waning chivalric world.
As with so much of Sienese art, however, its air of fairy tale is
bonded to acute observation: we really do come across such
hilltops crowned with towers all over southern Tuscany. The
date 1328 identifies the rider as Guidoriccio da Fogliano, the
Sienese general who in that year secured the town of Montemassi.
The attribution to Simone seemed to rest securely on two
documented payments made to him in 1330 and 1331 for
journeying to, and depicting, various Sienese fortress towns; but in
the late 1970s, another fresco was uncovered lower down on the
same wall – which has become ever since a kind of puzzle and
palimpsest. It seems clear that the new fresco is earlier than the
Guidoriccio; and, although both are connected to the same ongoing

46

project – the depiction of the strongholds of the Sienese territory – they are too incompatible in scale and format ever to have been seen on the same wall at the same time. The town itself, and especially the stockade, is realized with much greater delicacy and tonal conviction than the rather schematic equivalent elements in the *Guidoriccio*. Sometimes attributed to Duccio (it would be his only fresco) or to Simone's father-in-law Memmo, it seems to me closer in spirit to the generation of Simone himself.

I want to avoid rehearsing here all the complex arguments, some of them highly technical, by which Simone's authorship of the *Guidoriccio* has been challenged or supported. At the most extreme, the *Guidoriccio* has been written off as an eighteenth-century medievalist pastiche; others believe parts have been repainted (hence certain anachronistic details) and that only the rider himself is authentic. Among the most interesting approaches is Thomas de Wesselow's recent attempt to reconstruct the entire history of the wall. One strand of his argument focuses on the ambiguity of the horseman, which had been remarked on even before the discovery of the new fresco: as White put it in 1966, 'Who can say exactly where the charger walks or glides; over or on the landscape, or on the frame'. What de Wesselow shows is that the rim of Ambrogio Lorenzetti's rotating World Map of 1345 was actually part of the *Guidoriccio* design: the position of the

46 Unknown Sienese painter (Simone Martini in collaboration with Lippo Memmi?), *Fortress Town with Figures*, c. 1331(?). Siena, Palazzo Pubblico.
The decorative scheme of the Great Council Hall was designed to create a kind of national topography – with Simone's Virgin surveying '*la mia terra*' ('my land') from the south wall. De Wesselow suggests the *Fortress Town* may commemorate a peace agreement between Siena and a feudal rival, the Aldobrandeschi, in 1331 at their fortress of Santa Fiora. A ladder of open gateways leads up through the palisade and into the castle keep.

47 **Unknown Sienese painter** (attributed here to Lippo Memmi and assistants), *The Crucifixion* and other episodes from the Life of Christ, *c.* 1335. San Gimignano, Collegiata.

horse makes more sense when floating, as it were, above or upon the turning world. In other words, the *Guidoriccio* was probably painted *after* the map was already in place and therefore cannot be by Simone who had died a year before its installation. A possible date for the painting's execution is 1352, when the aged Guidoriccio died and received a hero's funeral, and the most likely painter, Simone's still surviving collaborator, Lippo Memmi. These issues may never be satisfactorily resolved.

Lippo Memmi has also been the main beneficiary of another long-running controversy. Vasari wrote a brief but vivid life of 'Berna, painter of Siena', whose final works were said to be the New Testament scenes in San Gimignano, dated by him as late as 1380. This Berna, or Barna, continued as a rather shadowy presence into the 1950s, when he was thrust into the limelight by Millard Meiss in his influential *Painting in Florence and Siena after the Black Death*. Just as Vasari praises Barna's expressive vigour, so Meiss writes of his 'terrible intensity', seeing it as indicative of the experience of the plague. He dates the frescoes to the 1350s, when 'Barna was by far the most gifted painter active in Siena'. Sadly, all this has been shown conclusively to be mistaken: Vasari followed Ghiberti in mistranscribing the name; Barna never existed, and the San Gimignano frescoes are probably from the 1330s. There certainly are individual figures of great power in several of these compositions, most obviously in *The Crucifixion*. 47 The thuggish horseman, swollen with arrogance, wielding his stick; the contorted thief; the dice-playing soldiers; the two entwined spectators seen from the back, looking up at the cross – all these are memorable inventions. But the general effect as I stand before *The Crucifixion* is of a sort of dynamic chaos, an incoherence made worse by the joyless prevailing colour, a heavy puce-and-grey. One hypothesis is that it echos a lost composition by Simone, transmitted more or less clumsily by his associates under the leadership of Lippo Memmi.

Other pictures formerly attributed to Barna are now scattered among several unidentified masters. The most beautiful and mysterious is *The Mystic Marriage of St Catherine of Alexandria,* 48 whose quiet radiance and compartmental flatness seem very far from the painter of the San Gimignano *Crucifixion*. In St Catherine's words, 'I was wedded to Christ with an indissoluble tie, to him, my glory, my love, my sweetness, my beloved.' The design operates four shifts of scale: from the grand, still figures of Catherine and Christ, to the charming miniaturized scene of the Christ Child standing on the bench between mother and grandmother, to the

48 Unknown Sienese painter, *The Mystic Marriage of St Catherine of Alexandria*, c. 1340. Boston, Museum of Fine Arts. Attributions have ranged from 'Barna' and the Master of the Straus Madonna, to Donato Martini (Simone's brother). In the textual account of the Marriage of St Catherine, which originated only in the mid-fourteenth century, it was the child Jesus who accepted her as perpetual spouse. But here, the two adults touch fingertips across a gulf of gold, while below, St Michael and St Margaret subdue demons. Millard Meiss has speculated that the late fourteenth-century St Catherine of Siena may have been influenced by this image or a similar one seen in her youth.

angels battling with black devils below them, and, tiniest of all, to the embracing warriors who have cast away their swords – probably the joint patrons, whose angelic reconciliation this haunting work commemorates.

With Petrarch in Avignon: 'il mio Simon'
Simone migrated from Siena in the mid-1330s, accompanied by his wife and brother, to settle in Avignon, the 'Capital of Christianity' since the Pope's exile in 1309. Like his friend, the poet Petrarch, he may have been offered a sinecure by an Italian cardinal at the papal court. While little survives from these Avignon years, we know that he remained active as well as influential; the frescoed rooms of the 1340s in the Palais des Papes (especially the delightful fishpond of the *Chambre du Cerf*) retain something of Simone's swaying rhythms. Among his few certain late works is the quietly intense little devotional picture known as *The Holy Family*. It has been described as a 'family quarrel'; the moment when, after a 49

three-day search, the child Jesus is found at last, teaching in the Temple. Joseph takes him by the shoulder to receive his mother's rebuke. As St Luke's gospel tells us, 'his mother said to him, "Son, why have you treated us so? Behold, your father and I have been looking for you anxiously." And he said to them, "How is it that you sought me? Did you not know that I must be in my father's house?"' Christ's rejoinder took on a special meaning for the Franciscan Spirituals; the call of 'my Father's house' far outweighed any social or ecclesiastical conventions.

Mary's pursed lips, like Joseph's turned-down mouth, do seem to threaten a parental scene. But the boy, with his half-closed eyes, remains calm, and this is the note the picture strikes as a whole. Beyond any expressive interaction, gentleness and sweet harmony reigns – a stillness in which we register the perfected intervals, the precise placing of each differently punch-worked halo within the swinging arcs of the frame, the marvellously refined touch particularly evident in Joseph's face and hair.

Simone already knew Petrarch (Francesco Petrarca, 1304–74), the leading Italian poet of his generation, who had been living in Provence intermittently since childhood. From *Il Canzoniere* we gather Simone made a (lost) portrait of the poet's beloved 'Laura' before 1336. Sonnet 78, *Quando giunse a Simon l'alto concetto*, starts with the moment when that 'exalted conception' first came to the painter, while the previous sonnet, *Per mirar Polycleto*, considers the impossibility of any artist doing justice to Laura's beauty. It does, however, include the haunting line: '*Ma certo il mio Simon fu in Paradiso*' ('But certainly my Simone was in paradise'). Despite the twenty-year gap in age, there was a real artistic affinity between poet and painter: a shared lyrical grace, intimacy, musicality; perhaps also a shared nostalgia for Italy. Petrarch clearly enjoyed Simone's company. In the margins of his copy of Pliny (beside a passage about the charm of the painter Apelles and his ability to converse on equal terms with Alexander the Great) he notes: 'Thus also our own Simone of Siena used formerly to do, very joyfully'. It is from Petrarch also that we learn Simone was 'not handsome'.

Simone's last surviving work is a frontispiece added in 1342 to Petrarch's own cherished manuscript of Virgil. It included a commentary by Servius, who here is shown pulling back the veil to reveal the great Mantuan, propped against a tree, pen in hand. To the left, Aeneas looks on; and in the foreground are the peasants of the *Georgics* and *Eclogues*, half the size of their creator. Petrarch's own Latin couplets are borne aloft by winged hands:

50

49 **Simone Martini**, *The Holy Family*, 1338. Liverpool, Walker Art Gallery.

50 **Simone Martini**, frontispiece to Petrarch's copy of Virgil with a commentary by Servius, 1342. Milan, Ambrosiana Library. The author of the *Aeneid*, *Georgics* and *Eclogues* is shown in a pastoral setting. Petrarch's Latin inscription could be translated: 'Servius is here uncovering the arcana of Maro the high-speaking, so that they may be transmitted to leaders, shepherds and farmers'.

'Bountiful Italian soil you have nourished great poets / But this man has enabled you to attain the level of the Greeks'. Below the picture, another couplet reads: 'Mantua made Virgil, who shaped such song / Siena, Simone, by whose hand it is painted here'. A complete world – trees, beasts, birds and men – has been realized in whiteness: the cool blue-white of the pruning peasant, the cream of the milking herdsman, the fleece a different white again. We see the trees also rendered white, through the semi-transparent check of the veil. Probably the source of all this white was emulation of Roman marble reliefs; what results is a true convergence of Sienese and Roman, without any sense of Latinate

Ytala si elavos tellus alis alma poetis:
Sz tibi grecos redit hic atingere metas.

Seruius altiloqui regens archana maronis.
vt pateant ducib; pastorib; atq; colonis.

orthodoxy. It is a fitting last glimpse of Simone in all his delicacy
and wit.

When Petrarch wrote his sonnets – his 'vernacular fragments',
as he later called them – he was still young. His later works would
almost all be composed in Latin. But Simone's trajectory was
altogether different. Early in his career he achieved a synthesis of
the three dominant visual idioms of his day: Duccio's Byzantinism,
French High Gothic and Giotto's 'Latin'. But after 1320, he seems
to have aspired 'beyond' style, towards a new transparency of
expression, equivalent to a vernacular language. The stumpy
figures of *The Holy Family* appear awkward and unmodish beside
those Assisi courtiers of twenty years before. His chameleon
development must have been partly in response to different
demands of patronage, but if we can discern any more inward
thread, it seems to be towards a greater simplicity – a kind of
repudiation of French courtliness. Perhaps it is significant that his
most influential invention in the Avignon years was a Virgin who
suckles her child, no longer enthroned, but seated on the floor.
Over the next century, throughout Europe, these 'Madonnas of
Humility' would come to be the most popular of all devotional
images; hundreds survive from Siena alone – even if none by
Simone's own hand. The style now known as 'International
Gothic' – tightly drawn, lacking in large monumental forms, but full
of charming naturalistic and anecdotal detail – emerged some fifty
years after Simone's death. His influence, transmitted through his
works at Avignon, Assisi and Dijon, as well as by travellers passing
through Siena, had become pan-European. Such scenes of chivalric
pageantry, elaborately clothed and set, seem most at home on the
illuminated page, as in the splendid calendar imagery painted by
Franco-Flemish miniaturists such as the Limbourg Brothers. But
Simone's example is evident also in nearly every early Italian
painter; while in Siena itself, his ascendancy would wane only with
the passing of the entire International Gothic tradition at the end
of the fifteenth century.

Chapter 3 Pietro Lorenzetti: Towards a Franciscan Art

As part of the team collaborating on Duccio's *Maestà*, Pietro 16
Lorenzetti (*c.* 1280–1348) and Simone Martini would have
come to know each other well. They would have shared in the
excitement of the 1310s, of a new generation coming to fruition.
But, assuming they met again in Assisi a few years later, they
would have felt their paths diverging. If Simone pointed towards
elaboration and description, Pietro became the pioneer of a
more radical synthesis. Assimilating Giotto's stark simplicity of
construction, he utterly transformed its emotional timbre to
create, in his *Deposition* at Assisi, a composition unprecedented 59
in its dramatic condensation and tragic intensity.

The *Arezzo Polyptych* of 1320 is Pietro's earliest signed work: 52
an exceptionally glowing gold-ground altarpiece standing some
nine feet wide. Its rows of iconic saints and angels staring mostly
straight out, seeming scarcely to interact, appear at first oddly
archaic. Yet the centre is all about interaction, with *The
Annunciation* breaking as narrative into the iconostasis. Raised as
three steps, in diminishing scale, we see the Madonna in tender
play with her child; Gabriel kneeling before Mary; and higher still,
the Virgin carried by angels, rocketing upwards. To the left,
St Luke looks up from his own gospel, in which the Annunciation
story is so compellingly told; since Luke was also traditionally
taken to be a painter, this has sometimes been identified as
Pietro's self-portrait.

Mother and child are more than life-size, made to press 53
forward into our space. Both are realized with a superbly
sculptural solidity, and it has been suggested that Pietro's earliest
training in the 1290s may have been as a sculptor, assistant to
Giovanni Pisano on his figures for Siena Cathedral. Certainly
the body language of the infant taking hold of his mother's veil,
balancing on her spread hand, is beautifully observed. Mary's sari-
like white gown is a masterpiece of patterned rosettes, lined with
milky ermine, the little furry tails sewn in. Borsook writes of
Pietro's characteristic faces, of the 'narrowed eyes with long

52 **Pietro Lorenzetti**, *Arezzo
Polyptych*, 1320. Arezzo, Santa
Maria della Pieve.
Although now lacking its predella,
the restored altarpiece looks
magnificent today, set in the
beautiful Romanesque space of
Santa Maria della Pieve (where,
according to Vasari, Pietro also
completed a fresco cycle). The
whole polyptych can be seen as
an architectural construction –
the saints in their columned
niches echoing the populated
cliff-face of Siena Cathedral.

53 **Pietro Lorenzetti**, Madonna and Child, detail of the *Arezzo Polyptych*, 1320.

trailing corners'; we register in their smiling eye contact even a humorousness. This Madonna asserts not divine sovereignty, so much as intimate relationship. After the authority of Roman or Byzantine art, this new trecento figure-type may seem naive, almost childlike, in its candour of depiction. In this, as in so much else, Pietro's art would parallel the thrust of Franciscan teaching.

The Passion Cycle at Assisi
Entering the dark, cave-like Lower Church of San Francesco after the radiant preaching hall above is like a descent from head to stomach, from intellect to emotion. And if we enter as the friars did, via the cloister and the transept stairs, our first sight will be of Pietro's Passion narrative. We stand on a little balcony, rather like a theatre box, witnessing at arm's reach other life-size figures bending forward to lower the dead Christ into the tomb.

Above, on the barrel vault, are frescoes begun at least as early as 1315. Pietro's work at Assisi may well have extended

54

54 South transept of the Lower Church of San Francesco at Assisi, frescoed by **Pietro Lorenzetti** with scenes from the Passion of Christ, *c.* 1315–25. The vaults were painted first, followed by *The Crucifixion* and ending with *The Deposition* and *The Entombment*. Underneath *The Crucifixion*, at head height, he later painted the intimately scaled *Madonna and Child between St Francis and St John*.

intermittently over several years. Trecento painters often left a wall incomplete at the end of the fresco season, working on altarpieces and panels over the winter, and resuming once again in the spring. Pietro Lorenzetti would in these years have been frequently on the move between Siena and Assisi, Arezzo and Florence. His Passion vaults were probably his first fresco commission, and they present an uncomfortable ensemble, with too many figures vying for attention against complicated architectural backdrops. The elaborate depiction of Jerusalem, towering above both *The Entry* and *The Way to Calvary*, strikingly anticipates his brother's city of twenty years later; perhaps it confirms that the young Ambrogio was already working beside him.

82

If the overall effect of the vaults is too crowded to be monumental, individual scenes are often astonishingly ambitious in their spatial organization. *The Last Supper* takes place by night, inside a complex hexagonal room. The very bright illumination –

55

55 **Pietro Lorenzetti**, *The Last Supper*, c. 1315. Assisi, Lower Church of San Francesco. The hexagonal pavilion recalls Nicola Pisano's pulpit in Siena Cathedral. The blue night sky is spangled with golden stars and a crescent moon; in the next episode, *The Betrayal*, the moon will sink, as meteor showers rain down on Gethsemane.

whose source may be Jesus himself – throws up the virtuoso construction of yellow roof and red cornice in an almost exploding perspective. John lays his head across Jesus's breast; the unhaloed Judas reaches for the eucharistic bread. But behind, in a doorway, a serving man is glimpsed in lively discussion with the landlord; and this provides a transition into the kitchen, where another waiter delivers his commentary on the great events unfolding next door. 

Pietro's tall genre slice, with its smaller scale and separate spatial construction, might be likened to the marginal image of an illuminated manuscript; or to one of those low-life episodes that occur in several medieval dramas. It is a kind of choral aside, which allows another perspective on the sacred narrative, as well as conferring on it an everyday, demotic intimacy. The kneeling servant does the washing-up, assisted by his pug, while puss sleeps beside the roaring fire; all are depicted with the same affectionate attentiveness to the 'insignificant' – at one with the Franciscan emphasis on the humble experience of the common people.

Pietro moved next to the curved wall below the vaults to create an epic staging of Golgotha. The crosses are set against an 

56 Pietro Lorenzetti, detail from *The Last Supper*, c. 1315. Fireplace, shelf and wooden beams are each compellingly realized in this unprecedented genre scene; note the shadow cast by both dog and cat, a very unusual observation at this early date. One complex line of interpretation has centred around the kneeling servant, who may be using a tallith (a Jewish prayer shawl) to wipe away the Old Law. The same tallith recurs in Pietro's *Birth of the Virgin* (ill. 71).

enormous void of deep blue, with Christ, more than life-size, arching over our heads. This is the most ambitious of all pre-Renaissance crowd scenes; it comprises some fifty figures, each strongly differentiated. The hill presents a vast, crowded panorama: the familiar cast of the disciples and followers are grouped around the swooning Madonna, but they are all in turn encircled by mounted soldiery, so that, in the mêlée of horses' rumps and helmets, the haloed principal characters seem almost lost to sight. The soldiers, raised up, dominate the crowd, embodying a whole spectrum of responses – ranging from the two smiling friends on the left, their horses engaged in animated flirtation, to the dramatically silhouetted centurion, Longinus, already haloed in the moment of his conversion. One wonders whether it was Pietro or Simone who first developed that equine

57 **Pietro Lorenzetti**, *The Crucifixion*, *c.* 1320. Assisi, Lower Church of San Francesco.

58 **Pietro Lorenzetti**, detail
from *The Crucifixion*, c. 1320.

type, so spirited, so individually characterful (even if sometimes
more like a dragon than a horse); the new breed that would recur
in the imagery of Siena for at least the next hundred years.

'A Sweetly Passionate Abandonment to Feeling'
Several more fresco seasons may have passed before Pietro
embarked on the concluding wall of the transept – divided by an
altar-niche, with a window above. He crammed in *The Descent into
Limbo* and *The Resurrection* high up; but below, painting at last on a
contained flat surface, his life-size figures only a little above eye
level, he constructed the magnificently monumental groups of
The Deposition and *The Entombment*. He incorporates the vault's
encroaching curve into each composition: under the weight of
the arch, every back is stooped in sorrow.

 In *The Deposition* we follow each twist of the emaciated corpse 59
– the vertical lower legs, the diagonal thighs and stomach, the

horizontal chest, the falling arm – to the sudden drop of the
head which locks it all into place. Chiara Frugoni writes of 'an
uninterrupted line that envelops them all... the spreading grief
that flows from one to the other.' Each figure appears as part of a
mechanism of weights to be balanced against the stark geometry
of ladder and cross. Joseph of Arimathea bears most of the weight;
Nicodemus takes pliers to extract the nail that has pierced both
feet; John cradles the thighs. From the left, the Marys enact
another trio of grieving – from orange to green to red; from
standing to stooping to kneeling. These Marys, and especially the

59 Pietro Lorenzetti, *The Deposition*, after 1320(?) Assisi, Lower Church of San Francesco. Christ would stand far taller than any other figure. His white corpse was once even more dramatically contrasted to his companions, who were originally mostly dressed in blue. Applied *a secco*, this blue pigment has now flaked off. Pietro, with the corporeal realism encouraged by Franciscan meditation, has imagined the separate rivulets of blood from hands and feet joining in a complex stain. Something of the tragic drama of Cimabue in the Upper Church is here retrieved.

red Magdalene, come directly out of the blockish figures of Giotto, yet charged here with a new warmth. Only when the long-extended rhythm of Christ's body takes its final unexpected turn and the heads of mother and son merge — the living and the dead, the upright and the upside-down, the corpse's closed eyes aligned to the mother's half-closed — do we realize how far Pietro's expressivity has pushed beyond any classical decorum.

60 Pietro Lorenzetti, detail from *The Deposition*, after 1320(?) The dead Christ's halo merges with his mother's as she lays her cheek alongside his forehead and runs her hand through his long hair. Despite much repainting, the beautiful cursive rhythms of Pietro's fresco hatching are still evident in both these heads.

61 Pietro Lorenzetti, *The Entombment*, after 1320(?) Assisi, Lower Church of San Francesco. Joseph of Arimathea, Nicodemus and John the Evangelist have carried the corpse to a noble Cosmati-work sarcophagus, set in the traditional rocky landscape. Emotional intimacy is most poignant and vivid when, as both here and in *The Deposition*, it is held within a highly formal composition.

The same cast of characters reappears in *The Entombment*, with John's profile almost identically placed. The red Magdalene, chorus leader of all previous Entombments, is wonderfully reinterpreted here – her hands, no longer upthrown, but joined in desperate prayer. Yet although Pietro's actors are so individualized, far weightier and more physically present than those of Duccio or Ugolino, he avoids the overt lamentation let loose by Simone. No mouth is open; their grief is silent.

Erich Auerbach in *Mimesis*, his great book on 'The Representation of Reality in Western Literature', finds in the new Franciscan vernacular poetry an unprecedented emotional warmth: 'a sweetly passionate abandonment to feeling'. At Assisi, Pietro too moves into a new realm of feeling. The Roman and Florentine artists of the earliest trecento had sometimes seemed to remove emotion from the centre of painting's purpose. In Pietro Lorenzetti, painted narrative regains its full expressive potential, and we are made to participate in a community of grief, a true catharsis.

61

26, 27

New Majesties

With his Passion cycle completed, Pietro made one last extraordinary devotional image. Under *The Crucifixion* he allows us to glimpse his principal protagonists at eye level, engaged now beyond time in a 'sacred conversation'. John, so vivid in *The Deposition* and *The Entombment*, looks on, clasping his own gospel, as Mary and her infant stare into one another's eyes in rapt communion. With a gesture more of the common people than of the court, she commends to her son's attention Francis, their host at Assisi, buried close by. In response, the child makes the sign of blessing. John was the 'beloved' of Jesus, entrusted with the care of his mother; Francis the 'Second Christ', who took upon himself the wounds of the crucified. Together, John and Francis define a special territory of religious feeling. Both are associated with a tender, personal and loving intimacy with their incarnate God; both are traditionally 'seraphic', even 'feminized' saints. Pietro here creates a sacred imagery equivalent to Franciscan spirituality – tremulous, pietistic, yet too robust to be sickly. Mary retains the blue mantle traditional to the Queen of Heaven, but she is very much a mother actively engaged with her little boy – her grave beauty not aristocratic, but accessible to all of common humanity.

62

62 **Pietro Lorenzetti**, *The Madonna and Child between St Francis and St John, c.* 1325. Assisi, Lower Church of San Francesco. The visionary half-length apparitions rise up from behind a stone ledge, set against the infinite gold beyond. Underneath the main figures, Pietro has placed a row of images (sometimes interpreted as an altar front): the profile of a male donor in prayer, and a little gold-ground *Crucifixion*, flanked by shields whose heraldry is now indecipherable.

63 **Pietro Lorenzetti**, *Madonna del Carmine*, 1327–29. Siena, Pinacoteca.

A few years later Pietro set before us his *Madonna del Carmine* — a Virgin crowned and enthroned among angels; but also a young rustic girl embarrassed at all this attention, her elongated almond eyes flickering sidelong towards St Nicholas, while her boy reaches out to Elijah. Her pose derives from a small but powerful Madonna carved by the foremost Sienese sculptor of the day, Tino da Camaino (c. 1285–1337). Pietro and Tino were lifelong associates; in 1342, the painter would be documented buying land, as guardian of Tino's orphaned sons. The elder by some five years, Pietro may have first met Tino as a fellow assistant on Giovanni Pisano's figures for Siena Cathedral. By 1320 (when Pietro was at Arezzo, painting his strikingly Pisano-like Madonna) Tino had risen to become Siena's *capomaestro*. His little Madonna was sculpted in Florence in 1321. Its blockish forms owe much to Giotto, one of whose commissions Tino would take charge of in his absence in the 1330s. The limbs are rendered here so massive as to border

63

65

64

64 Tino da Camaino, *The Madonna and Child*, 1321. Florence, Museo Nazionale del Bargello. This figure group was carved for the tomb of Bishop Orso in Florence. Although Tino's figures can appear somewhat doll-like, they are wonderfully taut and strong. The base is inscribed *SEDES SAPIENTIAE* (Seat of Wisdom).

on brutality, the child's posture utterly unconstrained. Giotto's *Ognissanti Madonna* is a bourgeois matron. But Tino raises up a woman of the people, and something of this popular flavour remains in the tender simplicity of Pietro's youthful mother.

The *Madonna del Carmine* was originally the high altarpiece of the Carmelites in Siena. The Carmelites claimed precedence over Franciscans and Dominicans, since they were supposedly founded by Elijah himself, dressed here in the order's habit. (On his scroll is a quotation from 1 Kings 18:19 beginning: 'Now therefore send and gather all Israel to me at Mount Carmel'.) The predella begins with the dream of Sobach, Elijah's father, set in a cut-away architecture of great clarity. Pietro establishes the domestic intimacy of Sobach's bedchamber with a beautifully observed hanging towel. We then move to Mount Carmel, where the first monks inaugurate a miraculous fountain; they wear a striped habit, to commemorate the scorch marks left by Elijah's fiery chariot.

25

65 **Pietro Lorenzetti**, detail from the *Madonna del Carmine*, 1327–29.

Finally, at the papal court in Rome, the order and its new habit are ratified. These little scenes, so rich in charming detail, would strongly influence both Sassetta and Sano di Pietro a century later. Documents show Pietro in conflict with the Carmelites, refusing to let the altarpiece leave his studio until he received his final payment; the Sienese Commune voted a special subsidy, uniting its support for the religious orders with its concern for the embellishment of the city. Pietro had by now become a leading master. In 1325 he had married upwards; like his brother and Simone Martini, he lived, not in the main 'artists' quarter' (identified by Maginnis as the area just below the Via Francigena leading to the Campo, looking down on to the deep cleft of

Fontebranda) but among jewellers and goldsmiths, close to the Cathedral.

Imagery of the Journey: Dante and Blessed Umiltà
Dante's *Divine Comedy* began to be widely read soon after its completion in 1321, with copies of *The Inferno* circulating earlier. For the literate Lorenzetti brothers, Dante was the great poet of their youth; and a beautiful illuminated page now in Perugia, usually attributed to Pietro, is one of the very earliest images made for a text that would eventually inspire so many artists, from Giovanni di Paolo to Botticelli and Blake. I have already stressed the significance of Dante having composed in 'Italian' – that is, in the Tuscan vernacular – rather than in Latin. But I believe his actual imagery, his autobiographical dream narrative of a cyclic journey across a cosmological landscape, also released new possibilities in early fourteenth-century art.

66

139

The topography of the Perugia miniature comes directly out of Dante's opening lines:

Nel mezzo del cammin di nostra vita
mi ritrovai per una selva oscura,
che la diritta via era smarrita.
[In the middle of the journey of our life / I came to myself in a dark wood / where the straight way was lost.]

Not only do we recognize the 'dark wood' at the top right, but we also see Dante 'at the foot of a hill' and under its 'shoulders'. He is traversing the 'desert strand' before he encounters the she-wolf at bottom left. This landscape of the somnambulist, 'where the sun is silent', is realized in a sequence of wonderfully graceful curves, with transparent streaks swept in by the artist's brush to create a vast atmospheric space: Dante's 'great desert', set in the barren eroded hills of the *crete*. The she-wolf is usually seen as an allegory of the papacy in its aspect as a political and temporal power, which Dante (both as pro-imperial Ghibelline, and as a Franciscan tertiary) experiences as an obstruction, barring the way to salvation. Terrified and disheartened, he sinks to his knees. But at this point a figure appears behind him – Virgil, the master-poet who will act as his guide. They set off together back along the ledge in the last line of the Canto: '*Allor si mosse; ed io li tenno retro*' ('Then he moved on; and I kept behind him'). We know that this is the beginning of an epic journey that will take them to the gates of hell and down through all the circles of the Inferno. Poet and artist seem here miraculously in tune.

66 Attributed to Pietro Lorenzetti, *Dante's Path Blocked by the She-Wolf; He Encounters Virgil*, c. 1340(?) Perugia, Biblioteca Comunale.

67 Attributed to Pietro Lorenzetti (assisted by Ambrogio Lorenzetti?), *Altarpiece of Blessed Umiltà*, c. 1335. Florence, Uffizi.

68 Attributed to Pietro Lorenzetti, *Umiltà Leaves the Convent*, detail from the *Altarpiece of Blessed Umiltà*, c. 1335.

69 Attributed to Pietro Lorenzetti, *Umiltà Arriving in Florence with Her Companions*, detail from the *Altarpiece of Blessed Umiltà*, c. 1335.

Similar imagery of wayfaring along life's path, but with a female protagonist, occurs in several little panels of an altarpiece made for Florence. The *vita icon* of Blessed Umiltà, or Humility **67** (1226–1310), once stood in the church of San Giovanni Evangelista, part of the convent she founded; it was probably commissioned by the female devotee who kneels at her feet. In the first panel, at the beginning of her story, the as yet unhaloed Umiltà renounces her marriage for the life of a religious; eventually she will renounce a series of convents as well. In one extraordinarily moving image, among the most beautiful of all fourteenth-century narratives with its warm harmonies of gold and ochre, orange and brown, we see Umiltà's solitary figure at **68** the extreme margin, walking away across the water. Behind, in the convent, we glimpse her through a window as she receives a visitation from St John the Evangelist. She appears a third time in the same panel, kneeling in prayer outside the convent on a little

terrace, and gazing upon a tapering rocky hill that is something of a Sinai, a mount of God. The design has the same spaciousness, and the same streaked terrain, as the Dante miniature. Umiltà's convent is conceived as a flat plane of orange wall; the drama is in her turning her back sorrowfully upon it, before moving on, out of frame. Her journey continues in a further, almost equally compelling image, as she abandons yet another monastic house to 69 arrive with her devotees at the gate of Florence. Here she would herself become a labourer, in order to build the convent for her own new order.

These panels are by an artist who had surely seen Simone Martini's *Altarpiece of Blessed Agostino Novello*, but who composes 40 with a religious sentiment more deeply inward. At least three other panels in the series seem to be by a cooler hand; one hypothesis is that both the Lorenzetti brothers worked on the altarpiece together. In the early 1330s they seem to have completed extensive fresco cycles, now lost, dedicated to the life and 4 miracles of another exceptional woman, Margherita of Cortona. An unmarried mother who repented, Margherita became a lay Franciscan, and eventually an anchoress, establishing her cell among the rocks near the steep summit of the city. In one of her visions, Christ confirmed to her that 'Francis is like a new God'. After her death in 1297 her cult grew, although she would not be formally canonized for centuries; a new church was built around her tomb, frescoed by the Lorenzetti brothers, whose complex architectural and spatial imagery probably had a lasting influence on the young Sassetta, growing up in Cortona in the 1400s.

A New Birth
By 1335 the brothers were back in Siena, allocated a fresco each on the exterior of the Hospital. These episodes from the Life of the Virgin faced the main door of the Cathedral and were seen by every pilgrim on their way to or from Rome, though no trace remains today. Pietro's fresco of the *Birth of the Virgin*, especially, became a familiar image, echoed in many subsequent Sienese paintings. Seven years later Pietro completed a variant on panel: an altarpiece for the Cathedral, the third of the superb series that had begun with Duccio's *Maestà* and Simone's *Annunciation*. The earthy 'realistic' detail and contemporary setting of Pietro's domestic scene challenges the rarefied icons of his great predecessors. With Duccio long dead, and Simone departed for Avignon, the field was free for the Lorenzetti brothers to assert a new material emphasis in painting. Within the Cathedral's totality

both the incarnate and the immaterial could be accommodated: Pietro's altarpiece set in the main bustling body of the church; while Duccio's and Simone's held sway beyond the choir screen, in the area most charged with the numinous.

The Birth of the Virgin reads both as a triptych (echoing the tripartite façade of the Cathedral) and as a deep, unified illusionistic space — the most convincing interior space of the entire fourteenth century. The vaulted room is brilliantly projected as an extension of the frame in a perspectival construction that seems strikingly 'ahead of its time'. (Rogier van der Weyden's fifteenth-century *Altarpiece of the Seven Sacraments* in Antwerp

70 Ambrogio Lorenzetti,
The Purification of the Virgin, 1342. Florence, Uffizi
Ambrogio's altarpiece is based on Luke 2: 22–39, where the evangelist conflates Jesus's presentation in the Temple with Mary's purification. The holy figures are set within an immensely ambitious architectural construction, unparalleled in fourteenth-century art. The little garland-bearing maidens above display Ambrogio's awareness of antique sculpture.

71 **Pietro Lorenzetti**, *The Birth of the Virgin*, 1342. Siena, Museo dell'Opera del Duomo.

comes to mind, where a triptych embodies the nave and aisles of a great church.) To the left, at a smaller scale, we shift beyond the women's realm to an anteroom (very much as we passed into Pietro's Assisi kitchen) where Joachim, the aged anxious father, waits with a friend for news of the birth. Behind, we glimpse the courtyard of a Sienese palazzo, masterly in its spatial lucidity.

Anne's bed with its plaid coverlet comes straight out of Simone's *Dream of St Martin* at Assisi, but here rendered even more emphatic and weighty. Anne herself has a kind of massive tenderness, a heavy grace shared by the maid in green pouring the

36

infant's bath. Byzantine weightlessness has been transformed into three-dimensional modelled form, not without awkwardness, but with enormous charm, to create a figure-type I would liken to archaic Greek sculpture, or to those genial 'Campers' of late Léger in the 1950s. Today, encountering *The Birth of the Virgin* immediately beside Duccio's *Maestà*, we recognize Pietro's colour- world as startlingly different: dense, saturated, opaque, planar. Characteristic is his juxtaposition, in the tiles on the right, of flat olive green against flat Indian red – a vibrant contrast, but not a luminous one. The feast of the Birth of the Virgin falls on 8 September – often a very hot, thundery time of the year in Siena. The whole orchestration of this grand female assembly suggests a late-summer languor; the vermilion-robed girl whose figure is divided by the frame holds a patterned fan, the black streaks to the left seeming to register its flapping.

16

The child is the pivot, but the dominant figures are her elderly parents. Ambrogio's 1342 *Purification of the Virgin* (similarly derived from his Hospital fresco) shares this emphasis on the aged; as Diana Norman has pointed out, the Hospital's function was partly to care for the old and infirm. The key figure is the eighty-four-year-old prophetess Anna; beside her, holding the baby Jesus (who sucks his thumb), stands the aged Simeon, about to utter the *Nunc Dimittis*. Ambrogio's complex fantasy of the Temple of Jerusalem was much admired, as several versions by later artists attest, but its virtuoso architecture seems less freighted with meaning than Pietro's bedchamber. If Pietro's art is, in Carlo Volpe's phrase, 'calm and powerful', Ambrogio's will be mercurial and inventive, but seldom as emotionally rewarding.

70

By the 1330s, it must have been clear that the most innovative painting was emerging less in Florence (where Giotto's many pupils had all proved slightly disappointing) than in Siena, where the 'New Painting' of the 1300s was being radically transformed again. A convergence had occurred between the civic aspirations of the Sienese Commune and the emotional and intellectual liberation associated with the Franciscan movement. Much of the best Franciscan painting would be Sienese; much of the best Sienese, Franciscan.

Chapter 4 Ambrogio Lorenzetti: The Golden Age Returns

The *Sala della Pace*, the frescoed chamber of the Nine in the Palazzo Pubblico, is in many ways the defining achievement of Sienese painting. Ambrogio Lorenzetti (*c.* 1288–1348) was heir to thirty years of experiment in the relation of figure to architecture – by his master Duccio, his rival Simone, his brother Pietro. But his panorama of *The Well-Governed City* reaches beyond this inheritance, to create an entire microcosm whose imaginative scope has never been surpassed.

This single wall has tended to overshadow all his other achievements. Under the Nine, private patronage was almost non-existent, and with Simone Martini monopolizing the Commune's commissions, both the Lorenzetti brothers may have been forced

82

72 **Ambrogio Lorenzetti**, *A Group of Poor Clares, c.* 1329. London, National Gallery. This charming fragment from the San Francesco fresco cycle centres on the profile of a beautiful nun; she is flanked by the almond eyes of her Franciscan Sisters. It epitomizes Ambrogio's gift for social comedy, for carving out witty vignettes within the complexity of the crowd.

73 Ambrogio Lorenzetti, *The Investiture of St Louis of Toulouse*, c. 1329. Siena, San Francesco. Here is the same reluctant prince of Naples painted earlier by Simone Martini (ill. 32). His father, Charles II of Anjou, is shown to his right, grieving at his son's renunciation. But Louis's submission to the Pope may have had an additional symbolic meaning. The Franciscans of Siena had Spiritual tendencies, and had rebelled against the denial of Christ's poverty promulgated by Pope John XXII; his portrait here may mark the end of their long quarrel.

to make their youthful reputations outside Siena. Ambrogio's only certain early work is a village *Madonna* of 1319, whose frontality gives little hint of his future spatial mastery. Vasari's assertion that 'in his youth he devoted himself to letters' is already implicit in the tradition handed down by Ghiberti, of Ambrogio as a *pictor doctus* (learned painter), and 'an expert in theory'. He probably read Latin, and there are many indications that he was steeped in Dante. The artistic development of this most intellectually complex of early Italian painters is likely to have been slow. Only in his late thirties did Ambrogio emerge as an outstanding master, and virtually all his surviving work was crowded into the next decade.

The Lorenzetti brothers probably did not return from Assisi until the later 1320s, when they embarked together on a complex fresco scheme in the chapter house of San Francesco. In Ambrogio's *Investiture of St Louis of Toulouse* a new interaction of figure and architecture is immediately evident. The scene in this papal court echoes not only the fresco at Assisi, where St Francis

72

73

kneels to have his Rule confirmed, but also the more recent composition in Santa Croce in Florence (usually attributed to Giotto), where the seated friars at Arles are astonished by the apparition of Francis among them. Nevertheless, the genial social comedy Ambrogio stages is utterly unlike those solemn groupings and announces a new sensibility. Everything is arranged in a relaxed and 'natural' way within the elegantly constructed architecture: the witty back-play of cardinals' hats, the press of anonymous spectators behind the frowning king and thoughtful cleric. (All these elements would be brilliantly reworked by Sassetta a century later in his altarpiece for Borgo San Sepolcro.) 116 He delights in the way a single eye, or the merest hint of nostril and lip, appear from behind a mantle; perhaps because these overlaps and occlusions tend to emphasize chance and happenstance. To put it another way, Ambrogio's roving eye leads to a mode of composing very different from the statuesque assemblies of classical art.

The resulting danger is a diffuseness, or lack of drama: his art is least convincing in moments of high emotion. In 1332, now a fully accredited master in the Florentine guild, he completed a sequence of little narrative panels for the church of San Procolo 74 in Florence. According to Vasari, this 'life of St Nicholas in small figures... enormously increased his name and reputation'. Echoes of these little scenes would appear in the work of several later Florentine artists, including Orcagna and Fra Angelico. The pink palazzo is a virtuoso feat of spatial construction, especially the astonishing upstairs loggia – the feast viewed through a balcony from below, the L-shaped table foreshortened, the servants sliced to pieces by doors and walls. Yet for all its fascination, this space may register somewhat at the expense of the narrative unfolding within it. A little boy has wandered away from the feast to be accosted by a demon on the staircase; at lower left, he is strangled. In the downstairs room, his mother is weeping beside the bed, the small corpse stretched out on the plaid when, suddenly, two crossed rays pierce the darkness – the first reviving the boy, the second bringing him to a kneeling position. The family looks up in awe, to see, framed by the window, the hovering saint.

This domestic miracle emulates Simone Martini's recently completed *Blessed Agostino* altarpiece, yet Ambrogio's storytelling 40 is less compelling; he has needed to depict the child no less than four times. *The Miracle of the Wheat* is simpler. The expanse of dark green sea, with the high horizon broken by distant sails, is a new and poetic invention. Bishop Nicholas stands on the shore, the city

74 **Ambrogio Lorenzetti**, *Two Miracles of St Nicholas of Bari*, 1332. Florence, Uffizi.

gate skewed upwards. Angels pour from on high their miraculous wheat for the famine-stricken town into the big forecastled ships. Ambrogio is clearly interested in the processes involved: how the grain is funnelled into a smaller boat; how they row to shore.

Only a few fresco fragments of Ambrogio's *Tempest* now remain at San Francesco, but it was vividly described in the fifteenth century by the Florentine sculptor Lorenzo Ghiberti: 'For a painted story, it seems to me a marvellous thing... a storm with much hail, flashes of lightning, thunder and earthquake... It really seems that the hailstones bounce from the shields as if driven by great winds. Trees are bent to the earth and split'. When Ghiberti's pupil, Paolo Uccello, painted his famous *Flood*, he probably incorporated echoes of Ambrogio's fresco; much later, Vasari would cite the Sienese *Tempest* as the great model from which 'modern masters learned to treat such a scene'.

About a year after Simone completed his *Annunciation* for Siena 43 Cathedral, Ambrogio embarked on his own version. The reddish 75

75 **Ambrogio Lorenzetti**, *The Annunciation*, 1334. Montesiepi, Oratory of San Galgano.

sinopia underdrawing was discovered only in 1966 during restoration of the mediocre and much repainted fresco on top and was immediately recognized as one of Ambrogio's supreme achievements. In a few swift and fluidly calligraphic lines, the life-size figures are evoked with startling economy. Fear is again the keynote; as the angel enters, wings spread wide, the Virgin sinks to her knees, hugging the column and looking over her shoulder in terror. The almost abstract transparency of this underdrawing, so sheer and uncompromising, brings it close to twentieth-century taste – akin to both a cave painting and a Rembrandt reed-pen drawing.

The following year for the cathedral of Massa Marittima (one of Siena's most important subject towns) Ambrogio and his assistants made a compressed variant on the *Maestà* theme. Rediscovered in a convent attic in 1867, this *Maestà* is more boisterous than Duccio's and homelier than Simone's: a small-town Tuscan festivity, to set beside their Byzantine and Parisian

76

76 **Ambrogio Lorenzetti and assistants**, *Maestà*, 1335. Massa Marittima, Museo Civico.

Courts. Angels are swinging censers at arm's length or pelting the Madonna with flowers; others sing to guitar and lute, apparently the first angel musicians in all Italian art. The Virgin's throne has entirely disappeared, as though she is being kept aloft only by the pressure of massed haloes, over a hundred of which can be counted. Among the saints, we note the local patron saint, Cerbone, with his attendant gaggle of geese at bottom right. Mary herself has a face of great beauty; she clasps the child to her cheek in a most tender close embrace. *Caritas* (Charity) presides over the Virtues, brandishing her heart, but the most memorable figure of all is *Spes* (Hope), who gazes ardently up at the tall tower she herself has constructed.

77

77 Ambrogio Lorenzetti and assistants, Hope, detail from the *Maestà*, 1335.
Ambrogio's gift for allegorical personification, so crucial to the *Good Government*, is already evident here. The three coloured steps below the Madonna echo those described by Dante at the gate of purgatory (*Purgatorio* IX: 94–100).

In the Service of Ben Comun

By the end of the 1330s, when Ambrogio was commissioned to celebrate Siena's system of government, the Commune was an institution under threat: as Dante had lamented earlier in the century, 'The towns of Italy are full of tyrants' (*Purgatorio* VI: 124–5). There has been much debate as to the probable sources for the allegory of *Good Government*, Nicolai Rubinstein proposing Aristotle and Thomas Aquinas, Quentin Skinner suggesting

79

79 **Ambrogio Lorenzetti**,
Good Government, 1337–40.
Siena, Palazzo Pubblico.
The giant figure at right, the largest
in the entire room, is *Ben Comun*.
The Sienese variants of Romulus
and Remus are being suckled below;
on the right are soldiers and
miscreants. All look towards the
window, which today opens still
onto a vast expanse of green Sienese
territory beyond the city walls,
extending towards Monte Amiata.

78 The *Sala della Pace*, the
chamber where the Nine met in
the Palazzo Pubblico, frescoed
by **Ambrogio Lorenzetti** in
1337–40. On the far wall, the
allegory of *Good Government*;
to the right, *The Well-Governed City*;
to the left, *The Ill-Governed City*.

Brunetto Latini, as well as Cicero and Seneca. What now seems
clear is that no single author provided the text. It probably
emerged out of preliminary discussions, to which several
individuals, including Ambrogio himself, would have contributed
ideas. (In 1347, the artist is documented as having 'spoken wisely'
at one of the main Sienese councils.)

The resulting room was perfectly structured to make its
statement. The Nine entered beneath Justice – the bricked-up
arch of the doorway is still visible – and sat below the allegory
on a raised platform. The petitioners facing the nine men were
able to read off the six female Virtues seated above them: Peace,
Fortitude, Prudence, Magnanimity, Temperance and Justice;
with Hope, Faith and Charity hovering above. To either side,
they saw extended a stark choice: the 'Bad' wall on their left,
where Tyranny leads to War; the 'Good' on their right, where
the Commune creates a world in harmony.

They would have read *Good Government* from the left, with
Justice raising her eyes to Wisdom. Justice rewards and punishes,
she gives just measure. From each of her scales a cord leads down,
the two cords plaited together by a handsome figure, who bears
on her knees a massive carpenter's plane inscribed CONCORDIA. She
hands the double cord to a blue-robed man who turns to receive

78

80

it; and so it is passed along the line of gowned-and-capped (but subtly individuated) citizens, each one laying hold of it; until finally it is tied around the wrist of the noble old greybeard. The letters around him, CSCV, identify him as *Commune Senarum Civitas Virginis* ('Commune of Siena, City of the Virgin') and he is elsewhere named as *Ben Comun*. Here is a team of citizens, harnessed in the traces of Justice and Concord and flanked by all the Virtues, serving the common good – or the Good Commune.

Allegory of this kind can easily sound laughable, an enormous mixed metaphor. But in Ambrogio all is realized with a convincing

81

29

80 Ambrogio Lorenzetti,
Justice and Concord, detail from
the *Good Government*, 1337–40.
Justice, presiding over the original
entrance door, is the key figure
in this legalistic allegory, which
probably reflects ideas of
jurisprudence discussed in Siena's
university milieu. In Ambrogio's
youth, in 1321, Siena was enriched
by a sudden influx of teachers
and students from the troubled
university of Bologna, then the
greatest law school in Europe.

materiality. The angel in Justice's scales gives two kneeling
merchants a large black object resembling a hat box, recently
identified as a *staia* or bushel: an instrument of just measure in
their commerce. Concord's attribute, the carpenter's plane, is
even more practical. Commentaries have usually talked of her
'smoothing out discord'; but surely everything we know about
the Nine suggests they favoured a more robust action of any
'good government' – to make citizens more equal, to shave the
overmighty, by taxation or by other measures. The three Virtues
to the left of *Ben Comun* are finely characterized. *Pax* (Peace),
lolling on her discarded armour with more piled under her feet,
has often been viewed as the room's pivot – and hence its familiar
name, the *Sala della Pace* (Hall of Peace). Yet the vernacular
inscriptions in the frame make clear that it is from Justice, not
Peace, that all good is said to flow. The same text built into
Simone Martini's *Madonna-as-Justice* in the Great Council Hall next
door, now reappears some twenty years later in the semicircular

81 Ambrogio Lorenzetti,
Peace, detail from the *Good
Government*, 1337–40.
The four-square solidity of this
famous figure comes clearly out of
Giotto. Both artists were intensely
interested in Roman sculpture. But
Ambrogio recreates his classical
goddess with a new genial warmth
and sensuousness, her breasts
painted in concentric whorls.

inscription above the scales: 'Love Justice, You who Judge the Earth'. Finally, below the panorama of the adjoining wall, it is Justice who is praised: 'Turn your Eyes to Look on Her, You who Govern...':

Guardate quanti ben' vengan da lei
È come e dolce vita e riposata
Quella de la citta du è servato
Questa virtu ke piu d'altro risprendo
[Look how many good things flow from her / And how sweet and reposeful is life / In the city where she is served / That Virtue who outshines any other]

The Image of a Just Society

Ambrogio's famous wall must, at over forty-six feet, be among the widest uncompartmented depictions in all painting prior to the colossal nineteenth-century panoramas. What defines Ambrogio's space as 'panoramic' is its highly extended format, almost five times wider than it is high (twice the ratio of even the widest

82

82 **Ambrogio Lorenzetti**,
The Well-Governed City, 1337–40.
Siena, Palazzo Pubblico.

cinemascope), the culmination of all Siena's bird's-eye imagery. Once again, we are above the city, but we see only the right-hand segment; the city wall must continue far below and to the left, just as the vast tract of countryside under its curving horizon must imply an equally grand vista on the other side of the city. Perhaps the clearest way to conceptualize this would be as two concentric circles – the circuit of the city walls, surrounded by its territory.

The panorama has often been seen as a problematic viewpoint: it gives us a kind of omniscience, but also holds us at a distance. Ambrogio's pre-perspectival space is able to resolve this dilemma. In a manner that might seem almost magical, we are both above *and* inside the city; we see everything, yet we are also able to participate and move freely about. (We might think of the mystical condition known as 'ambient vision', with its 'circumspatial' or infinite perception; or of the demon Asmodeus lifting the roofs off Madrid in LeSage's *The Devil on Two Sticks*.) Many of the characteristic Sienese building types – the loggias, open fountains, free-standing porticos – assist Ambrogio in this

aesthetic of total disclosure, creating a cityscape that is intrinsically cut away. Could Ambrogio have known some of those passages by classical authors that describe works of art in terms of their comprehensive vision of all terrestrial existence? Homer's 'Shield of Achilles' in the *Iliad*, for example, with its representations of Peace and War; or the famous text by Pliny the Elder, where the Roman painter Statius paints

villas, harbours, landscape gardens, sacred groves, woods, hills, fishponds... figures of people coming up to the country houses either on donkeys or in carriages beside figures of... fowlers, or of hunters.

Yet what makes Ambrogio's space so much more accessible than any of his Renaissance successors, is the way near and far can be simultaneously present: at a single glance, we take in the lecturer in the city classroom together with a glimpse of the sea miles beyond. We recognize a kind of seeing truer to our imaginative experience of space (confirmed in reverie and dream) than single-point perspective can ever be. And it also takes on a moral dimension – embodying the social diversity and fluidity of the republican ideal.

Ambrogio's masterstroke is the complex construction of gate and wall at the centre, triggering powerful spatial cues: the sliver of dark wall that reaches down on the right of the nearest zig-zag plunges us back into space; the pale line of ledge behind the unguarded castellations – out of sight in the foreground, visible half way up, then lost again – leads us compellingly to a little door in the gate. The pigment used is, once more, burnt sienna, with each shifting plane perfectly graded to the most luminous range of tones. It is from the gate that we move left into the city; or outwards, along the road and down to the bridge.

Of course we can also move across the city from the left. The first ten feet or so have been insensitively reworked by a later artist; it is unlikely that Ambrogio would have included the Cathedral in a composition so markedly free of any specific local topography. The campanile is poorly observed (the artist needed only to look out from the other side of the Palazzo to register that the number of arches decreases as the tower descends) and although the wedding procession has its charms, the figures are clearly by a later hand. So Ambrogio's city really begins just to the left of the dancers, under an arch where a falcon perches and two little children are chatting, and where a group of men concentrate on some now obliterated object – perhaps a board game. The nine dancers, much larger than the figures around them, are

84

83

83 **Ambrogio Lorenzetti**, Nine Dancers and a Tambourine Player, detail from *The Well-Governed City*, 1337–40.

almost certainly emblematic; a tenth, differentiated by her dark gown, accompanies them with tambourine and song. Perhaps we should call these dancers the 'Daughters of the Nine', even though some commentators have identified them as male, their fantastical gowns suggesting a masquerade. Dancing in the street was, in reality, expressly forbidden in security-conscious and faction-ridden Siena. Yet the significance of their dance here is surely as a kind of distillation of peace. For Ambrogio (as later for Matisse) when human beings move together in a circle they spell out a fundamental image of social well-being – the *dolce vita e riposata*, the *bonheur de vivre*, that follows from communal freedom and justice.

We are invited to pause at each of the activities our eyes alight on: the bookshop behind the dancers with a reader in a carrel; the shoeshop, or hosiery; the rapt audience at the lecture; the tavern counter, with its cured hams hanging very much as they do today

84

84 Ambrogio Lorenzetti, detail
from *The Well-Governed City*,
1337–40.

85 Ambrogio Lorenzetti, detail
from *The Well-Governed City*,
1337–40.

above Italian bars. Then our eye may travel upward, catching
a woman looking out of a side window, a vase of flowers, a
birdcage – and high above, the builders at work on the wooden
scaffolding, set against the dark sky. This band of very deep
metallic blue, applied over a crimson underlayer, unifies all three
walls. Outside the tavern a peasant goads his donkey forward;
behind, facing the opposite way, another donkey appears in
profile, its huge head delicately floated on a golden ochre ground.
Everywhere we notice Ambrogio's relish in chance overlappings:
the play of partial donkeys, as headless hindquarters disappear
behind houses; the incongruous appearance of a sheep's head
jutting forward over a young girl's shoulder, as a shepherd and
his flock pass her by.

The city itself is conceived as a compressed mass of irregular 85
buildings. Ambrogio's preparations must have involved a great deal
of architectural drawing, far more than most modern painters
would stoop to. The details of the building types are precise, and
they can still be recognized in modern Siena, though today much
of the painted stucco has been stripped away. Ambrogio was able
to dispose of a varied palette of contrasted greys, pinks and
browns; modern Siena is a more uniform brick landscape. But
he avoids literal topography – there is no trace, for example, of

Siena's most striking feature, the Campo. It is as though Ambrogio picked up his entire city and redistributed it, elided and concertina'd, across the spread of a single wall.

'The Space of Vernacular Style'
But who is the winged woman flying to the right of the gate? Beside her is inscribed the word '*SECURITAS*', yet the cartouche she displays seems also to identify her as sovereign Justice. And

why would Security be nude? I believe Ambrogio's figure may represent an echo of a once familiar prophecy – the 'Just Virgin' of Virgil's fourth Eclogue, 'The Golden Age Returns', the most famous throughout the Middle Ages of all his poems:

Time has conceived and the great Sequence of the Ages starts afresh.
Justice, the Virgin, comes back to dwell with us

That conception of a New Age under the sign of the Just Virgin, in which 'the waving corn will slowly flood the plains with gold', and 'Golden Man inherit all the world', was well attuned to Ambrogio's theme. It was also timely: in 1347 Cola di Rienzo would use the same Virgilian imagery to rally all Italy to the cause of liberty; while Dante, both in *De Monarchia* and in his *Purgatorio*, had invoked the same figure of the rule of the Just Virgin to embody his Ghibelline hopes. What makes Ambrogio's imagery unique in all Western art, however, is that he dares to affirm the possibility of a perfected society, a Golden Age, not as a pre-urban pastoral, but within the complexity of a contemporary city-state.

Once we pass through the gate, the whole atmosphere changes. There is less overlap, and space moves more freely around several complete figures: the falconer and his squire, the amazon seated side-saddle in her bright red skirt – the head of her horse perfectly framing the blind beggar, painted with extraordinary economy. The beggar's hat may identify him as Chinese – perhaps a Mongolian slave or prisoner. Ambrogio shows here a 'Franciscan'

87

87 **Ambrogio Lorenzetti,**
A Blind Beggar, detail from
The Well-Governed City, 1337–40.

88 **Ambrogio Lorenzetti**,
On the Road, detail from *The
Well-Governed City*, 1337–40.
Peasants and half-comical mules
toil up to market, while field work
and coney-catching unfold behind
them. His loving observation
of man and beast is without
precedent; it would have a vast
progeny in French and Flemish
calendars and Books of Hours.

attention to the unregarded: juxtaposing the rich and the destitute
as part of his own canticle 'of all created things'. Across the entire
wall, fifty-six humans and as many animals can be counted. There
are fewer women than men, but anonymous peasants register
vividly as they pass on the road: one, rope in hand, is led by his
saddlebacked pig to market; two stumpy *contadini* lower down,
are deep in conversation, legs fused in amity. When we recall the
steep road of Duccio's *Entry into Jerusalem* of thirty years earlier,
we marvel at the distance Ambrogio has travelled.

88

21

The scale is not constant. The falconers are much bigger than the peasants at work in front of them. As we move down the paved highway, figures diminish in size more or less 'correctly', and distance is powerfully felt between road and field. But when we examine the distant figures more closely, it becomes apparent that the foreground threshers are smaller than the harvesters behind. Such inconsistencies create a sequence of compartments; the effect is of our loosely hovering over the landscape, passing from one focus to another, invited to take a journey through an ideal land of both spring and summer – where sowing and harvesting take place simultaneously.

The landscape is unmistakably Sienese territory, with its villas and vines, its *crete* and distant towers. This huge vista, so unlike any other known medieval painting, has prompted much speculation. Perhaps the wildest, but too persistent to be ignored, is that Ambrogio may have seen Chinese landscape scrolls. The twentieth-century painter Balthus found 'no difference between Far-Eastern painting and that of the Sienese'. In the fifty years after Marco Polo's return from the East in 1298, trade between Italy and Cathay was at its height. The *Merchants' Handbook* of *c.* 1340 declared the Silk Road between the Black Sea and Cathay 'perfectly safe, by day or by night'. Chinese brocaded silks and

89

89 Ambrogio Lorenzetti,
Workers in the Field, detail from
The Well-Governed City, 1337–40.

other fabrics became important European commodities, and the fantastical textiles worn by Ambrogio's dancers, patterned with dragonflies and silkworms, are likely to be of Far Eastern origin. In addition, Tuscan cities are known to have had substantial populations of Mongolian slaves. Thus a Chinese connection cannot be ruled out, even if another possible source for fluid atmospheric landscape illusionism did exist nearer to home, in the Late Antique mural cycles of the Christian basilicas in Rome.

Ambrogio's fresco handling is much looser than any of his contemporaries', more intimate and unplanned. No preliminary design could have anticipated the constant play of calligraphic mark across this enormous surface: the wisps of vegetation, the percussion of a cornfield's stubble, the featheriness of a cockerel's multicoloured tail... Even after so much damage, it survives as one of the greatest 'touch paintings' in European art, an astonishing feat of sustained improvisation.

Only one later artist would offer an itinerary quite like this – landscapes of cosmic breadth, crowded cityscapes, executed in a comparable 'drawing/painting'; whenever I see Ambrogio's peasants I think of Pieter Brueghel. The hypothesis first put forward by White – that the young Brueghel, passing through Siena twice on his journey to Rome, Naples and the South in 1552–53, would have encountered Ambrogio's still famous fresco – seems to me persuasive. Early Netherlandish landscape of the fifteenth century had owed much of its spatial idiom – its detailed naturalistic vignettes strung together – to Sienese painting, transmitted by the Limbourg Brothers and other International Gothic miniaturists. Yet as Mark Meadow tells us, the Antwerp that Brueghel returned to was now being invaded by a new landscape convention. Classicizing, idealized, unified by Albertian perspective, it came with all the prestige of Italian humanist culture, and threatened to sweep away the earlier tradition. Brueghel, in Meadow's phrase, 'defended the space of vernacular style'; his art developed into a new panoramic genre, and his *Seasons* became the greatest heirs to Ambrogio's landscape vision.

The Winter Wall

The 'Bad' wall, which happens to be by far the most damaged, is also in general the least compelling pictorially: a rare case where the devil does not have all the best tunes. Yet as I read my way into this scheme, I enjoy Ambrogio's intellectual cunning in the placing of ideas – what might be called his 'zoning'. We are now, as the framework tells us, in winter, presided over by unfavourable

51

90

90 Ambrogio Lorenzetti,
Winter, detail from the framework
of *The Ill-Governed City*, 1337–40.
Siena, Palazzo Pubblico.
Ambrogio was famous for his
representations of weather. Here
the emblematic figure of Winter
is shown holding a snowball with
wonderfully animated strokes and
with flakes falling all around him.
He was probably the source of
Sassetta's snowball-creating angel
in the *Madonna of the Snow*
(ill. 112).

planets – Saturn, Jupiter, Mars – and by tyrants, including the
Emperor Nero. Inherent in the structure of this 'sinister' wall is
that we must read it from right to left – in other words, against the
grain of our customary reading. The throne of Tyranny is flanked
by Cruelty and Deceit (bearing a sheep with a scorpion's tail); by
Fraud, Fury and saw-wielding Division (whose black-and-white
livery is inscribed '*Si*' and '*No*'); by War in black armour. Avarice,

91

91 Ambrogio Lorenzetti,
Tyranny's Court, with the Vices,
and Justice Bound, Her Scales
Broken, detail from *The Ill-Governed
City*, 1337–40.
The opposite of *Ben Comun* is
the Tyrant, embodied here as a
diabolical figure, whose attendant
goat may signify both lust and
capriciousness. Avarice holds a
squeezer of money bags, the same
motif that recurs as an attribute
of the mean nun in Sassetta's
St Francis in Ecstasy (ill. 123).

Pride and Vainglory are airborne above. At the foot of the throne lies Justice, abject – her hands tied, her scales broken. In the words of the inscription:

There, where Justice is bound, no-one is ever in accord with Ben Comun, *nor pulls the cord straight.*

The gate of the Ill-Governed City is aligned exactly opposite that of its Well-Governed counterpart. When we pass through the city itself, we enter a world where, as White puts it, 'nothing fits' – where disharmony is a principle, where every overlap jars. Tyranny's city is falling into ruin: windows have lost their colonettes and gape hollow, and at top centre, two men are demolishing the house they stand in. The only industry to be seen

92

92 **Ambrogio Lorenzetti**, detail of *The Ill-Governed City*, 1337–40.

93 Ambrogio Lorenzetti, detail of *The Ill-Governed City*, 1337–40.

is an armourer hammering at his forge. In the foreground, a kind of sinister clown in motley pulls at the collar of a civilian, drawing his dagger. Close by, two soldiers lay hold of a red-gowned woman; another lies dead at their feet. To the left, a horseman clatters steeply down the deserted street, towards the gate, to join the armed group just emerging. Above them, there flies out from the city into the countryside a terrible dark-skinned figure, sword in hand, teeth bared in a wolf-like grimace; it is *Timor* (Fear), and written in Latin on her scroll, we read: 'Because each sees only his own good, in this city Justice is subject to Tyranny; nobody passes along this road without Fear'.

If the 'Good' space is made up of concentric circles, returning us to *Ben Comun*, the 'Bad' is an endless extension, petering out in a landscape of utter desolation – among the most compelling areas of the entire scheme. This is nature made hideous, the landscape of those 'dark injuries' listed in the inscription: 'Where there is Tyranny, there are great fear, wars, robberies, treacheries...'. The damage this landscape has suffered has only increased its atmospheric power. The two armies advancing towards the green river have been rendered spectral against the blackened vegetation, palely silhouetted close to the burning village. The red flames twist upwards with wisps of grey smoke, towards the hilltop crowned with ruins, under a sky that has lost

93

almost all its blue and is now a mottled crimson. Our nearest modern parallel to this ravaged storm-lit world is in Anselm Kiefer's Holocaust imagery of the 1980s – the burnt heath inscribed with words from Paul Celan's 'Fugue of Death'.

In 1339, as Ambrogio's room neared completion, the Nine embarked on their most ambitious undertaking: the creation of a new cathedral, to whose colossal nave the existing Cathedral was to be merely the transept. As Borsook puts it: 'Siena already possessed the biggest piazza, hospital and altarpiece in all of Italy: why not the biggest cathedral?' Meanwhile in the Campo itself, another massive project was under way: the paving of the entire arena in bricks, cunningly laid in curved section between the nine stone runnels – a solution both decorative, and, on a rainy day, superbly practical. The paving was completed in 1347: the final enterprise of a regime which, in the following year, would be irreversibly crippled by catastrophe.

The Cosmographer
The lost Sienese masterpiece I would most like to have seen is the rotating World Map created by Ambrogio in 1344–45 in the Great Council Hall, a map centred not on Jerusalem, but on Siena itself. With a diameter of sixteen feet, it was twice the size of the famous English twelfth-century *Mappa Mundi* now in Hereford Cathedral. It survived until at least 1752, when a guidebook described it as 'a tattered remnant of a topographical map... set within a hoop, fixed in the middle to a pivot in the manner of a wheel, turning around and around, so as to display close-to whatever region anyone wants to examine.' De Wesselow imagines it in its heyday, in the often crowded Council Hall, 'revolving slowly at the centre of things'. The room is still known as the *Sala del Mappamondo*, though today only the grooves cut by 45
the turntable remain. In Ambrogio's panorama in the next-door room, the city and its territory were seen from a point just above the walls; here he could show them in two concentric circles: Siena itself filling the wooden hubcap, the city protruding forward above the vast expanse of painted cloth all around. It was, Ghiberti tells us, 'a *cosmografia*, that is, the entire habitable world' – as though the imagery of Duccio's *Temptation*, offering 'all the 2
kingdoms of the world', had now proliferated; not seven little citadels, but seventy, radiating outwards from Siena in all directions, ringed by a continuous curved horizon. On the evidence of Giovanni di Paolo's *Creation* of a century later, the 94
continents may have been set within green oceans, and the whole

94 **Giovanni di Paolo**, World Map, detail from *The Creation and the Expulsion*, 1445. New York, Metropolitan Museum of Art. This miniature world probably gives us some sense of Ambrogio's vast tondo of a century earlier. Originally part of a predella panel for the church of San Domenico, it is one of many echoes of Ambrogio's lost map in fifteenth-century Sienese painting. (For the complete painting, see ill. 140.)

microcosm confined within several outer bands, the different-coloured orbits of the fixed planets.

One of Ambrogio's last paintings is an extraordinary landscape, in which unfolds the entire history and fate of mankind, now known as *An Allegory of Sin and Redemption*. The surface is battered and darkened, but we can make out *The Expulsion* high on the left, with Adam and Eve led down into a dusty world by Death, a black figure much like *Timor*. Then Cain murders Abel; and at the centre, corpses are piled high around the cross. Death now flies aloft, armed with a scythe, and about to mow down the crucified Christ. Under the fortified hilltop, a procession of

95

95 Ambrogio Lorenzetti,
An Allegory of Sin and Redemption,
c. 1342. Siena, Pinacoteca.
This panel is sometimes identified
as the predella for Ambrogio's late
Purification of the Virgin (ill. 70),
which is also dominated by
scrolls. Christ's death above a
heap of corpses is an astonishing
invention. This confrontation
of the Living and the Dead echoes
Buffalmacco's enormous fresco
in Pisa; here, the scale seems
oddly miniaturized, perhaps
too small for the epic content.

witnesses – a falconer, two lovers, two dogs – files past, led by
a pair of aged pilgrims, staff in hand. In the foreground, scrolls
unfurl from prophet-like figures. The rocky pathways of this
quintessentially Sienese landscape recall Pietro Lorenzetti's
Dante illumination, though here the roads end in Judgment
and the mouth of hell.

66

Ambrogio Lorenzetti's panoramic and cosmographical
imagination was more radical than either Giotto's or Simone's;
he included more of the world, of everyday life, than any artist
before or since (with Brueghel perhaps the sole rival). It would
be wrong to see Ambrogio's as a 'secular' vision, just as it would
be mistaken to separate Siena's civic culture from its religious
aspiration. Yet *The Well-Governed City* does affirm the accessibility

82

of sensuous, natural experience, open to all classes, all creatures; in Maginnis's words 'the frescoes announce a growing conviction that governance might be defined outside the Church'. Distinct from both the feudal and the Renaissance world-views, the Sienese vision of the free Commune remains a beacon: a short-lived moment of intellectual and political liberty, which found its most poignant expression in Ambrogio's uncentred, fluid space, a truly democratic idiom.

Chapter 5 After the Black Death (1348–1420)

It was all so dreadful and so cruel that I hardly know where to begin to describe the terror which then reigned; one felt that the very sight of so much suffering would drive a man mad. No words can do justice to the horror, and he is fortunate who has never faced such sights... Father fled from son, wife from husband and brother from brother... Loneliness encompassed the dying, for there was no one who would bury the dead either for money or for friendship's sake... I, Agnolo di Tura, called the Fat, buried my five sons in one grave with my own hands. But some there were who were buried too close to the surface, so that the dogs came and scratched them up, devouring the bodies in the open streets ...The city of Siena appeared to be deserted...And no bells tolled, and no one wept at any misfortune, for almost all expected to die...And everyone said and believed, 'This is the end of the world'.

This chronicler has witnessed the Black Death, the first European experience of bubonic plague. It hit Tuscany especially hard, reaching its peak in the summer of 1348. On 9 June Ambrogio Lorenzetti drew up a will; forseeing that he and his entire family would soon perish, he left his estate to a religious fraternity affiliated to the Hospital. By autumn, more than half the Sienese population is estimated to have died. The economic effects of the plague were far-reaching; as taxation increased, the Nine became unpopular, and in 1355 the Holy Roman Emperor Charles IV – lodged in Siena with a large army – supported their overthrow. In a symbolic act, the box from which the Nine had been chosen by lot was thrown out of the Palazzo Pubblico, its shattered remnants tied to an ass and dragged through the streets, the crowd, egged on by the Sienese nobility, crying 'Death to the Nine!'. The new system of the 'Twelve', nominally more accessible to the artisan and shopkeeper class, became in practice open to manipulation by the magnates. Work was abandoned on the 'New Cathedral'; according to Agnolo di Tura, the decision was taken 'because of the few people that remained in Siena, also because of their melancholy and grief'. Certainly the project had come to seem

hopelessly overambitious, and problems in vaulting the vast nave were also looming.

Yet historians now attribute the city's failure to recover mainly to external factors. William Caferro's *Mercenary Companies and the Decline of Siena* details the almost annual raids and extortions suffered by Siena throughout the later trecento. These invaders were not small bands, but armed hordes often of over ten thousand, covertly underwritten by Florence, and led by such pitiless *condottieri* as Sir John Hawkwood, of whom it was rhymed: *un inglese italianato é un diavolo incarnato* ('an Englishman Italianate is a devil incarnate'). The Via Francigena became unsafe for months on end; Siena's agriculture was ravaged. Huge sums were paid out to the besiegers at the gates. Ambrogio's visionary landscape of the Ill-Governed City had become a terrible reality. In the last months of the fourteenth century, the helpless republic – by then under the rule of upper class *Priori* – gave Siena into the possession of the great Milanese warlord, Giangaleazzo Visconti. One of his immediate edicts was to forbid the use of the word *popolo*.

Bartolo and Taddeo: 'Patent Mediocrities'?

No painter trained under Pietro or Ambrogio Lorenzetti has ever been identified. It is assumed that all their workshop members, the best of a future Sienese generation, died beside the brothers in 1348, leaving Lippo Memmi almost the only surviving established master. The most successful Sienese painter of the

96 **Bartolo di Fredi**, *The Creation*, 1367. San Gimignano, Collegiata. At the beginning of Bartolo's Old Testament fresco cycle, Christ as Creator is carried by seraphs as he brings forth from the void the still unpeopled Earth, orbited by the stars. Much of this image, including the green ocean, must reflect Ambrogio Lorenzetti's lost World Map of 1345, which Bartolo would later be commissioned to repair in 1393. The red ground, so dominant today, was once overlaid by a deep turquoise blue, of which only a few fragments remain.

97 **Andrea di Bartolo**, *Madonna and Child (Madonna of Humility)*, 1394. Washington, National Gallery of Art.
In this beautifully crafted image, the Madonna is probably closely based on a lost original by Simone Martini. A diminutive white-mantled nun kneels at her feet; along the base of the frame is inscribed the *Ave Maria* prayer.

98 **Bartolo di Fredi**, *The Adoration of the Magi*, c. 1395. Siena, Pinacoteca.
Bartolo's composition would influence many subsequent *Adorations*, including Gentile da Fabriano's Florentine masterpiece, now in the Uffizi (ill. 110). The princely monkey riding in procession would be echoed by Sassetta (ill. 115); while the face of the groom, so strongly individuated, would return in many of Giovanni di Paolo's wiry heads, as much as fifty years later.

later fourteenth century was Bartolo di Fredi (*c.* 1330–1410) whose entertaining, complex narratives at San Gimignano – *The Crossing of the Red Sea, The Earthquake in the House of Job* – are crammed with invention, but remain spatially inchoate. From as early as 1353, Bartolo shared a workshop in Siena with Andrea Vanni (known for his later friendship with St Catherine). Bartolo's son, also named Andrea, ran a reliable workshop himself, and was commissioned in 1394 to turn out a large number of more-or-less identical *Virgins of Humility* – one for each nun's cell of a newly built Dominican convent in Venice. Bartolo, now in his sixties, completed his finest altarpiece at about the same time – an *Adoration of the Magi* for a Sienese confraternity. The Virgin, squeezed into the lower right corner, is almost under assault by the eager press of the Magi and their followers. As our eye moves left, the scene becomes more and more animated, culminating in an extraordinary ballet of camels and high-spirited horses, tossing their heads, grinning and snorting, barely under the control of the

96

97

98

99 Taddeo di Bartolo,
The Assumption of the Virgin,
c. 1398–1401. Montepulciano,
Cathedral.
In one of the largest polyptychs ever
painted, Taddeo strains to combine
Assumption with Annunciation and
Coronation. The very 'Sienese'
theme of the *Assumption* was
probably chosen to confirm the city's
domination over Montepulciano.
By the time Taddeo's work was
complete in 1401, however, Siena
had been swallowed by the Visconti,
and Montepulciano's allegiance had
switched to republican Florence.

solitary groom, a comical russet hound skulking under their
hooves. Above, there stretches a zone of barren olive green rocks;
higher still, we see the retinue of the Magi, tiny figures wending
their way around the mountains, entering a walled city by one gate
and leaving by another.

Bartolo's 'Jerusalem', its striped cathedral rising from burnt
sienna castellations, is unmistakably a further instalment of Sienese
civic imagery. A few years later the outstanding painter of the next
generation, Taddeo di Bartolo (*c.* 1362–1422), returned from Pisa 99
and Genoa to work on a giant altarpiece with an equally 'Sienese'
theme, commissioned for the hilltown of Montepulciano, disputed
between Siena and Florence. The Assumption of the Virgin had
become one of the defining feasts of the Sienese year, ever since
the Hospital, glutted with the bequests of plague victims, had
purchased in Byzantium in 1359 a piece of the Virgin's girdle, let
fall as she ascended into heaven. Taddeo's polyptych, with its shifts
of scale and discontinuous space, is difficult to read. But the eye is
caught – among the small, intensely realized apostles gathered
around the tomb in the central panel – by a bearded face looking
directly out. Inscribed 'ST THADDEUS', this is surely Taddeo's self- 100
portrait, one of the earliest to come down to us: the prototype of
the self-aware Renaissance painter, regarding himself as far more
than a provincial journeyman. The picture as a whole can be seen
as his vision – the Virgin billowing vast above him, and the saints,
more than life-size, piled up all around. At top right, St Antilla 102

100 Taddeo di Bartolo,
St Thaddeus, detail from
The Assumption of the Virgin,
c. 1398–1401.

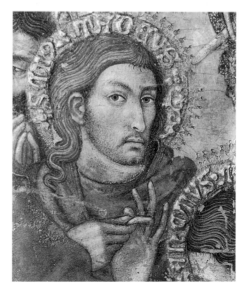

(Montepulciano's patron saint) elevates a votive model of her walled town; a fence leading up to one of the gates dangles as a kind of bracelet beside her wrist.

In 1404, after Giangaleazzo's sudden death, Siena regained independence. A new and (in Carl Strehlke's phrase) 'ferociously republican' government embarked on a civic overhaul. For the chapel of its powerbase in the Palazzo Pubblico, Taddeo created a complex fresco cycle of *The Last Days of the Virgin*. In one striking image, an airborne Christ gently lays hold of his mother to aid her ascent, while, high above, we see the towers of 'Jerusalem', instantly recognizable as Siena, silhouetted against a sunset gold. Yet as in Montepulciano, we register a kind of thwarted sublimity, a linear congestion, that renders his grand conception graceless. The Latin inscription on Taddeo's tomb records an artist 'both refined and ingenious', whose works are 'elaborate and totally perfect... worthy of immortality'. Roberto Longhi, however, characterized both Bartolo and Taddeo as 'patent mediocrities'; while Enzo Carli, doyen of Sienese art historians, dismissed Taddeo as 'ingenuously academic'. Subsequent commentators

101

have offered a more nuanced account: Maginnis writes of 'artists who first homogenized the achievements of their great predecessors, and then grew indifferent to maintaining meaningful links with the past'. Certainly, in those seventy years, no painter in Siena matched the stature of Altichiero in Padua, for example. Yet as Diana Norman and others have shown, the tradition did continue to surface, even if in a coarser and less convincing idiom.

The Fountain and the Font: Jacopo della Quercia
From early in the trecento, a focus of civic Siena had been the *Fonte Gaia* (Fountain of Joy) set on the rim of the Campo, facing the Palazzo Pubblico. It was a triumph of medieval hydraulics, with water being brought through miles of tunnels and aqueducts. In 1327 a statue was dug up close by, inscribed with the name of the Greek sculptor Lysippus. Ghiberti wrote of it in his *Commentaries* in the middle of the fifteenth century:

It had one leg raised, resting on a dolphin. This statue I have seen only in a drawing by Ambrogio Lorenzetti... All the experts, and those learned in the art of sculpture, the goldsmiths and the painters ran to see this statue of such wonder and art. Everyone admiring praised it; to each of the great painters that were in Siena at that time it appeared of the greatest perfection. All flocked to place it with great festivities and honours, and they set it magnificently on their fountain. In that place it reigned for a short time. As Siena had met with much adversity in a war with the Florentines, the flower of the citizenry assembled in council. One citizen arose... 'Consider how idolatry is forbidden by our faith... Ever since we have honoured this statue, we have gone from bad to worse... I am one of those who would advise taking it down, destroying it entirely, and burying it in Florentine territory.'

Ghiberti's tale is true: the Twelve made their act of symbolic cleansing in 1357, just two years after taking power. Half a century would pass before another newly founded regime dared to commission another statue. Jacopo della Quercia (c. 1374–1438) was an outsider, born in Siena, but trained possibly in Lucca and Dijon; in Florence in 1401, he had competed for the Baptistery Doors commission alongside Brunelleschi and the eventual winner, Ghiberti. His new fountain, although nominally centred on the Madonna, was surmounted by a female nude to either side, unmistakably of pagan inspiration. Rhea Silvia and Acca Larentia were mother and foster mother to Romulus and Remus, legendary founders of Rome, emblems also of the Sienese republic. Even today, kept as an eroded fragment in the loggia of

103

103 **Jacopo della Quercia**,
Fonte Gaia, 1408–19. Formerly in
the Campo, fragments now in the
loggia of Siena's Palazzo Pubblico.
A nineteenth-century photograph
shows Jacopo's fountain before
its removal – much worn, but
with the nude figures still in place:
Acca Larentia on the left, and Rhea
Silvia on the right, possibly by a
collaborator. The entire surface
was originally enlivened with colour.

104 **Jacopo della Quercia**
(with Ghiberti, Donatello and
others), Baptismal Font, 1416–30.
Siena, Cathedral Baptistery.
The tabernacle and most of the
marble saints are by Jacopo; the
massively heavy drapery and slow,
powerful rhythm of his figures
point to early contact with Claus
Sluter in Dijon. Ghiberti's *Baptism*
faces us as we enter. Unfortunately,
today, surrounded by the later
frescoes of Vecchietta, the product
of this collaboration of great
sculptors disappointingly fails
to dominate its space.

the Palazzo Pubblico, Jacopo's life-size Acca Larentia remains a radiantly optimistic sign, a true republican goddess suckling the child of Liberty. One of the first free-standing marble figures since Roman times, she established Jacopo as a new Lysippus: his fountain the most 'advanced' monument of its era.

In 1416 Ghiberti was called to Siena as consultant for the new Baptistery font: a hexagon, with gilded bronze reliefs (Ghiberti's speciality) set into the marble. The project as a whole was given to Jacopo, with Ghiberti, Donatello and others also completing individual reliefs. Both fountain and font may be seen as Siena's attempt to import a new heroic republican idiom. But whereas in Florence Donatello's sculpture would radically influence Masaccio and other young painters, in Siena Jacopo would remain displaced, without any real heirs. As late as the 1450s, Ghiberti tells us the Sienese still considered Simone their greatest artist (though he himself found Ambrogio 'much better and more learned'). Jacopo would carve his supreme works not in Siena, but in Bologna – the San Petronio reliefs so admired by the youthful Michelangelo, and the reason Vasari placed Jacopo at the beginning of the second book of his *Lives*, as instigator of a new era: the ascent to a Florentine–Roman 'High Renaissance', in which Siena had little further part to play.

'Lowliness': Bernardino and the Sienese Saints
The painters who emerged in the 1420s would restore many aspects of the early trecento tradition, but their art would have little of the 'realist' or 'secular' thrust of Ambrogio and the aesthetic of the Nine. A succession of Sienese religious reformers had shaped a new artistic climate, more febrile, less affirmative. The fall of the Nine in 1355 had coincided with the dramatic conversion of the rich merchant Giovanni Colombini (1304–67). Giving away his possessions, he performed menial tasks at the Palazzo Pubblico, was ridden about the streets on an ass, and had himself publicly whipped for his earlier financial dishonesty. Eventually he and his troublesome followers were cast into the wilderness, becoming known as the *Gesuati* (Jesus-People), or 'God's Drunkards'. Only when the plague struck again in 1363 were they called back, and given official sanction. Their devotional songs became popular: the hymn 'Come Down O Love Divine' by Colombini's follower Bianco da Siena (d. 1434), familiar to Anglicans in the setting by Vaughan Williams, declares 'Let Holy Charity mine outward vestment be / And Lowliness become mine inner clothing'.

105 **Sano di Pietro**, *Gesuati Polyptych*, 1444. Siena, Pinacoteca. In his early masterpiece, Sano shows the founder of the Gesuati, Giovanni Colombini, kneeling at the feet of the Madonna. He is unhaloed, but radiates light; his beatification would only be confirmed twenty years later in 1464. The beautiful predella, now in the Louvre, shows scenes from the life of another penitent self-flagellant in the wilderness, St Jerome, who is shown at the Madonna's right hand, along with Francis, Augustine and Dominic.

104

105

133

St Catherine of Siena (Caterina Benincasa, 1347–80) was also a reformer – a visionary even in childhood, experiencing a mystical wedding with Jesus and, later, the stigmata of his wounds. Loosely attached to the Dominican lay order, she first became prominent as leader of a group who fearlessly nursed victims of yet another outbreak of the plague in 1374. Soon after, she was summoned to Florence to be tried for heresy; acquitted, she embarked on a tireless campaign to bring the Pope back from Avignon to Rome.

106 **Sano di Pietro**, *San Bernardino Preaching in the Campo in 1427*, 1445. Siena, Museo dell'Opera del Duomo. Painted immediately after Bernardino's death, this is the right-hand panel of a triptych commissioned by the Confraternity of the Virgin. They insisted on a faithful likeness of the wizened ascetic they knew so well and pronounced that if they were dissatisfied with it, Sano would 'be obliged to ruin it and do it over and over'. Standing outside the Palazzo Pubblico, fronted by his popular teaching aid, the 'Jesus-monogram' *IHS*, Bernardino speaks to a kneeling audience, carefully separated by gender. He would be canonized in 1450.

Praying in Rome in 1380, beneath Giotto's mosaic of *The Navicella* (The Ship of the Church), she experienced its terrible weight fall upon her, and never fully recovered. Too disruptive a figure to be easily assimilated into the litany of saints, she was canonized only in 1461, at the special intervention of the Sienese Pope, Pius II Piccolomini.

Within the Franciscan order, the split between the Conventuals and the Spirituals continued far into the trecento. But from 1368, a compromise was reached in the new, more strictly 'observant' communities, and it was from the Siena Osservanza that the most influential of all preachers of the early fifteenth century, San Bernardino (1380–1444) emerged. If Francis had been a 'Second Christ', Bernardino was hailed as a 'Second Francis', drawing enormous audiences all over Italy. In 1427, he delivered a Lenten sermon in the Campo, taking Ambrogio's frescoes as his text: 106
81–2

I have preached, beyond Siena, of the Peace and War you Sienese have painted here – and which, besides, is a very beautiful invention... Up there, in your Palazzo Pubblico, to see Peace painted is a joy... I see merchants buying and selling, I see dancing... the workers busy in the vineyards or sowing in the fields, while on horseback others ride down to swim in the rivers...And for the sake of all these things men live in peace and harmony with one another....

Bernardino then turned to Ambrogio's imagery of Bad Government: 92–3

One sees only man destroying man... No fields are ploughed, no harvest sown, no riders go down to bathe in the river, nor is the fullness of life in any way enjoyed. Beyond the gates I see no men, women, only the slain or the raped... Man kills man in mutual betrayal.

For Bernardino, Ambrogio's frescoes of nearly a century earlier could still provide a key to understanding the present. Strehlke sees the saint as 'promoting' trecento painting, describing him as 'the man who had most affected artistic life in Siena' during the twenty years prior to his death. Through such reformers as Colombini, Catherine and Bernardino – each of them depicted in at least one major altarpiece – Sienese painters were drawn into a culture of 'lowliness', of lyrical penitence. In Bernardino, especially, the type of the Holy Man was given a fresh, almost familial intimacy, that certainly fed into the greatest single Sienese work of the fifteenth century, Sassetta's *St Francis* cycle. 116

Chapter 6 Second Flowering: Sassetta

Although Sassetta (Stefano di Giovanni, *c.* 1392–1450) constantly pays homage to the grand frescoes and altarpieces of a century earlier, his own greatness is most evident on a smaller scale. His art is gentle, offering not monumentality, but intimacy: colour pitched to the subtlest intensity, figures that are almost flimsy, set in fluid, intricate architecture. This synthesis of a heightened flat colour and an abstracted space renders his painting often unexpectedly 'modern' – closer to Bonnard and Matisse than to Masaccio.

Growing up in Cortona, Sassetta would have known the lost fresco cycle by Ambrogio Lorenzetti in which the miracles of the Franciscan mystic, Margherita, were set within an elaborate local topography. As Joanna Cannon suggests, Ambrogio 'appears to have relished the opportunity to show a series of structures, or spaces, often of differing depths, in a single scene': precisely Sassetta's own project a century later. Reaching Siena as an adolescent, and probably apprenticed to Benedetto de Bindo, he emerged in the 1420s into an era of recuperation and revival. The city's population was now reduced to about 20,000 – less than half the figure before the Black Death. The restored Sienese republic fostered a reverence for the glorious years of the Nine – and, by extension, for the art of Simone and the Lorenzetti brothers; while the preaching of Bernardino also harked back to a lost era, to the simplicity of the primitive Franciscan gospel. Sassetta's first altarpiece, with its combination of innovation and conscious archaism, embodied this moment of mingled nostalgia and hope.

For this artist, suspension, hovering, soaring would become a kind of signature. The lost large central panel of his *Arte della Lana* altarpiece showed a ciborium – the liturgical vessel in which the Eucharistic wafer is displayed – carried aloft by angels, floating above a cosmic landscape. Among its ingredients were 'fortifications with many fine towers and two domes', as well as 'two castles with battlements'. Several scholars, including Christiansen, believe two famous little Sienese bird's-eye views – *City by the Sea* and the

4

3

107 Attributed to Sassetta, c. 1425 (also attributed to Ambrogio Lorenzetti, c. 1340, and Simone Martini, c. 1310), *Castle by a Lake*. Siena, Pinacoteca. If the author of this little panel really is Sassetta, then its stylistic qualities must be ascribed to his conscious invocation of trecento 'simplicity'. The boat, its planked interior fanning out in the most elementary perspective, appears especially 'childlike'.

equally enchanting *Castle by a Lake* – may be related to this lost panorama. In *Castle by a Lake* we look down, past the bare Sinai-like rock pinnacles, to walled fields, a road, a red-roofed farmhouse and, nearer to us, the compact fort and curved shore fringing the green water. Not a person in sight. This miniature world seems made only for each one of us to climb aboard the open boat moored to the bank: a true 'Invitation to the Voyage'.

The altarpiece as a whole was made for the feast of Corpus Christi. It upheld the doctrine of transubstantiation (a central topic in the Church Council held in Siena in 1423–24) according to which bread and wine is changed at the Eucharist into the actual Body and Blood of Christ. In *A Miracle of the Sacrament*, an unbelieving monk reels back as the Eucharistic wafer explodes in blood; a devil draws the tiny naked soul out of his mouth. The shocked, marionette-like gestures of his Carmelite brothers may at first appear naive, but they prove to be extraordinarily moving and memorable. The complex architecture, with its convergent lines incised into the gesso, could suggest Sassetta's precocious awareness of Florentine perspective, but that is probably misleading. His construction, here as elsewhere, is more a play

108 **Sassetta**, *A Miracle of the Sacrament*, from the *Arte della Lana Altarpiece*, 1423–25. Barnard Castle, County Durham, Bowes Museum.

This and ills 109 and 111 are small panels cut from the predella of a polyptych commissioned by the *Arte della Lana*, the Sienese Wool Guild. These panels were strongly influenced by the predella of Pietro Lorenzetti's *Madonna del Carmine* (ill. 63), though Sassetta's altarpiece was not, as once thought, painted for the same church. As Machtelt Israels has shown, the altarpiece, although some ten feet wide, was portable, intended to be set up under a canopy in the piazza.

of space than a system. His delight is in composing – in the frieze of flat gold altarpieces, the wall suddenly plunging into depth, the arcade trapping the distant monk; in polarizing the laity's blues and reds against the Carmelites' whites and blacks.

Fifteenth-century Sienese painting teaches us that figures resembling dolls or puppets may be closer to our imaginative life than those prodigies of musculature so admired in contemporary Florence. In *St Thomas Aquinas in Prayer*, the figure is minimal: a black pedestal, surmounted by a haloed egg. The real emotional

109

109 **Sassetta**, *St Thomas Aquinas in Prayer*, from the *Arte della Lana Altarpiece*, 1423–25. Budapest, Museum of Fine Arts.

vehicle is the spatial setting, juxtaposing interior and exterior, inviting us out into the garden, as well as deep into the monastic library. Only when we register the grey dove of the Holy Spirit descending does this space take on full significance. Aquinas's writings provided the foundation for the liturgy of Corpus Christi; kneeling before the altarpiece of the Virgin, he receives divine inspiration. The natural beauty, the waters of the well, the books on the reading desks, on all this Thomas has turned his back to embrace instead devotional solitude, the concentrated silence of an emptied world.

An Alternative Renaissance

In 1425, as Sassetta was bringing his polyptych towards completion, a supremely gifted master arrived in the city. Gentile da Fabriano (c. 1370–1427) had just unveiled in Florence his great *Adoration of the Magi* – a splendidly elaborated retelling of

110 **Gentile da Fabriano**, *The Adoration of the Magi*, 1425. Florence, Uffizi.

110

111 **Sassetta**, *St Anthony Beaten by Demons*, from the *Arte della Lana Altarpiece*, 1423–25. Siena, Pinacoteca.
Anthony, another solitary renunciant, is cudgelled by demons and lashed with serpents' tails. The flaking-away of the glaze has revealed Sassetta's beautiful underdrawing incised into the gold ground: an enormous scrotum, and an anus face. The atmospheric landscape is radiant, the woodland and monastery dark against what is probably the first naturalistic cloud-streaked sky in Italian painting.

Bartolo's painting but with the composition reversed: the culminating work of International Gothic painting. At every point, most evidently in the horses' heads and the procession through the landscape, Gentile takes up Sienese tradition and surpasses it in descriptive intensity. For both Sassetta and Giovanni di Paolo, the impact of their encounter with Gentile would be lifelong. Within a year of Gentile's arrival, however, the Florentine master Filippo Lippi had also visited Siena; and soon after, Sassetta stood before the frescoes of Masaccio and Masolino in Florence's Brancacci chapel, becoming one of those whom Longhi calls 'the dazzled'. Longhi likes to imagine 'noisy arguments' between the two Florentine painters on their scaffold – with Masaccio (translated by Browning as 'Hulking Tom') often terrorizing the far older Masolino ('Little', or perhaps 'Delicate', Tom). Those conflicts may have been internalized by Sassetta; from this point on his art would have to negotiate a difficult path: between the heroic, stark humanism of Masaccio, and Masolino's gentler idiom; but also between the breadth of the trecento Sienese, and Gentile's courtly detail.

In 1430 Sassetta was commissioned to paint an altarpiece for Siena Cathedral. The *Madonna of the Snow* represents yet another 'commentary' on Duccio's nearby *Maestà*. She shares in the same

98

112

16

Sassetta, *Madonna of the Snow*, 1430–32. Florence, Uffizi, Contini-Bonacossi Collection. Placed near the door into the Cathedral, Sassetta's altarpiece was damaged by wind and weather early on. It had been dismantled by 1580, and since its restoration in 1999, has hung in an annexe of the Uffizi seldom open to the public. The halo of St Francis is embossed 'PATRIARCHA PAUPERUM': 'Patriarch of the Poor'.

civic programme, her halo embossed in Latin, 'If you trust in Me, Siena, you will be full of Grace'. The continuing dominance of the Virgin, in contrast to the heroic male figures who now begin to populate Florentine art, helps to establish fifteenth-century Sienese imagery as non-aggressive, almost 'effeminate'. Sassetta's is a quiet image, demanding intimate attention, figure by figure. The Virgin is a diffidently smiling queen; her son a wonderfully robust, naked boy, whose foreshortened leg hangs in mid-air with extraordinary physicality. To either side of the throne stand angel attendants. One, smiling broadly, proffers a salver of snow;

the other kneads it tenderly into a snowball. The motif is unprecedented, and may be Sassetta's own invention: it carries overtones of childhood pleasures, of a game to be played between the infant and his devotees. Snow is for purity, and cleanses the penitent of sin. The text open in St Peter's hands includes the words: 'You are children newborn and all your craving must be for the soul's pure milk' (1 Peter 2: 2). Snow also quenches thirst: the Christ Child's Latin scroll translates, 'Come unto me, all ye that travail, and I will refresh you'.

Two more angels crown the Virgin, their wings folding neatly behind the 'wings' of her throne. And four saints complete this reprise of Duccio's 'idyll of the nursery': Peter and Paul behind, but more prominently, Francis and John the Baptist, whose veined leg takes on a three-dimensional presence even more compelling than the Christ Child's. The patterned, heraldic flatness of the throne is reinforced by the weave of the carpet, rendered as line after line deeply incised into the gesso. These emphatic repeated diagonals serve to create space (especially at the lower right edge) and yet simultaneously assert a raised decorative ground in which all the figures are embedded. With near life-size figures posed in an undivided space, almost as statues, Sassetta's idiom here is, in Christiansen's phrase, 'an authentically Sienese dialect of the new Florentine language'. Even if individual limbs detach themselves, modelled with a conviction worthy of Masaccio, the special qualities of Sienese tradition – warmth, refinement, fantasy, charm – have not been betrayed: the overall atmosphere has been characterized by Van Os as 'sumptuous' and 'dreamy'.

The predella recounts the miraculous midsummer snows that in the year 325 laid out the groundplan for Santa Maria Maggiore in Rome – the first church ever dedicated to the Virgin. Here, even more than in the main panel, we become aware of Sassetta as a great 'touch painter'. In the second episode (sadly, the most damaged) the snow falls softly, each flake touched in with exquisite, tremulous delicacy. In the final scenes, the church rises from its foundation in three stages, against a repeated backdrop of tower-topped hills, but with each sky powerfully contrasted. Above the red cardinals spading earth, swallows fly up into the mackerel sky. Next, as the pink walls take shape, Sassetta assembles stone-carrier and gravel-scatterer, mason and carver, as well as the patient donkey, all set against wild cloud plumes racing upwards like flames. Finally, at the right edge, the basilica stands complete under a clear blue sky.

113

112

113 **Sassetta**, The Construction of Santa Maria Maggiore, detail from the *Madonna of the Snow*, 1430–32.
All the trecento altarpieces for the Cathedral were public commissions, but Sassetta's quattrocento masterpiece was paid for by a private patron, Donna Ludovica, widow of the *capomaestro* of the Cathedral Works. This may explain the emphasis, in this predella, on the detailed processes of building.

The *Madonna of the Snow* establishes Sassetta as a key figure in Italian painting, the oldest of a loose grouping of Umbrian-born masters including Fra Angelico and Piero della Francesca: all of them painters of light and atmosphere, each offering an alternative to Florentine linearity. William Hood believes Sassetta and Fra Angelico (c. 1395–1455) were in close contact by the early 1430s, sharing 'a deep commonality of spirit'. Both had been influenced by Masaccio, yet neither was prepared to sacrifice the gold-ground splendour of pure colour traditional to Christian art. Specifically, both rejected Masaccio's tonal modelling by the admixture of black or white – and here, Hood suggests, Fra Angelico 'took his cue from Sassetta's example'. Both would make a conscious choice, to retrieve and rekindle the achievement of the early trecento masters within a fresh synthesis. Sassetta's great altarpiece signposts a path, divergent from Vasari's relentless highway, towards an alternative renaissance.

If his *Adoration of the Magi* is later than the *Madonna of the Snow*, it suggests Masaccio's impact was now wearing off, with some loss to his figures of weight and dignity. Sassetta is in some ways even more courtly, more 'precious' than Gentile; but also

114

110

more painterly, more 'poetic'. His cavalcade incorporates a menagerie typical of International Gothic: a monkey riding alone among embroidered saddlebags (picked out in points of light like a Vermeer), a dog straining at the scent, two black camels, and just out of sight of the Christ Child, a dog with a bone, anxiously eyeing his rival. Everyone is decked out in the most extravagant contemporary court dress, including the diminutive pageboy and the court jester with ass's ears. The two magpies are, like the two

114 **Sassetta**, *The Adoration of the Magi*, c. 1435. Reconstruction of the original panel, now cut in two. Above, Metropolitan Museum, New York (prior to the restoration of 1987); below, Siena, Chigi-Saracini Collection.

115 **Sassetta**, The Journey of the Magi, detail from *The Adoration of the Magi, c.* 1435.
Conscious of the precedents of Bartolo (ill. 98) and Gentile (ill. 110), Sassetta achieves an even more lucid imagery. Painted with the most refined touch, this exquisite miniature fragment has nevertheless been cut down on all sides, but nevertheless creates a mood and a world entire unto itself: a visionary winter journey beyond time.

tall birds on the crown of the hill opposite, beautifully observed, and the squadron above may carry echoes of Dante:

E come i gru van cantando lor lai
Facendo in aer se lunga riga...
[And as the cranes go, chanting their lays / Making a long streak of themselves in the air...]

Yet all this finery moves through a wonderfully still and pared-down winter landscape, among bare trees, as the riders, led by the star suspended against the white hill, pick their way along a path of bright stones, and pass the pink gate of Jerusalem – unmistakably Siena's Porta Camollia, with the city's towers rising above.

Francis, Jester of God
Sassetta's reputation rests above all on eight scenes, grouped around a central icon of St Francis. Reconstruction shows the complete double-sided polyptych was originally made up of

116

forty-eight main images: the front centred (like Duccio's *Maestà*) on the Madonna; and the back – the only part discussed here – conceived as a *vita icon*, with Francis surrounded by episodes from his own life. What is immediately apparent in all these narrative scenes is an upward motion, echoing the levitation of Francis at the centre.

Gothic architecture had always been about soaring verticality; and one model for these compositions surely lies in the tracery of Gothic windows, where the verticals are tensely extended ever upwards until, at the top, they explode into a kind of sunburst within the arch. That is the pattern all through Sassetta's St Francis narrative: the figures standing on solid earth, the architecture rising in exaggeratedly vertical accents, until at each summit it passes into an unpeopled emptiness. Whether gold or sky, this upper region within the half circle becomes a kind of second reality, a metaphysical or abstract emblem, juxtaposed to the narrative below. In no other painter's work is the juxtaposition of the social and the metaphysical, the real and the abstract, so explicit, and so integral: it is as though we are made to see the metaphysical emerging from the natural world.

The opening image fuses two episodes into a single vertical transition. In the left half, the young Francis dismounts on the road to give his cloak to a poor knight. Immediately to the right we see him again as, in bed that night, he dreams of 'a fair and great palace... adorned with the sign of the cross'. A path leads up past the wood, deep into the atmospheric landscape, to the little grey-walled town, where a distant peasant is silhouetted as he drives his donkey in at the gate. Behind, the sky is palest primrose yellow: it changes to white and then, as it reaches the level of the white balcony, to palest blue, until, by the time it arrives at the flying palace, it is deepest ultramarine. This graded ascent accomplishes through colour alone a depth of spatial excavation unmatched by any previous painter. And startlingly, we realize that Sassetta has shifted us, not just from earth to heaven, from yellow to deepest blue, but also from the day, up into the night. An alteration of consciousness – the story of a few hours that forever changed Francis – has been marvellously compressed within a structure of pure colour.

The Francis of Sassetta is utterly different from the Francis of the Assisi frescoes. That first cycle had been based on St Bonaventura's official *Life of St Francis*, suitable for the headquarters of the Conventuals; written in dry church Latin, it was expressly intended to suppress, supercede and render

117

118

119

146

116 Reconstruction of the central panels on the reverse of **Sassetta's** *Altarpiece of St Francis*, by Dillian Gordon. The exact placing of the narratives (all but one now in the National Gallery, London) remains controversial. The complete altarpiece, painted between 1439 and 1444 for the church of San Francesco in Borgo San Sepolcro, would have been some twelve feet across.

heretical every previous or alternative account. But by 1350, a very different Francis had come into circulation. In the anonymous *Fioretti* (*Little Flowers*), a literary masterpiece in the Tuscan vernacular, the Franciscan legend is recast as a sequence of folk tales, full of humour and charm: the adventures of a Holy Fool by whose antics worldly values are turned upside down. Francis called himself a '*Giullare di Dio*' – the phrase taken up by Rossellini in 1950 as the title for his great film *Francis, Jester of God* (a neo-realist *Fioretti* performed by actual friars, with the 'simple' Brother John being played by a man similarly afflicted). The *Little Flowers* provided the text for one of the most moving episodes of Sassetta's altarpiece, *The Wolf of Gubbio*. More generally (perhaps mediated by Bernardino) this Francis would take on a vulnerability and comic pathos entirely absent in the Upper Church of Assisi. 123

The central image of *St Francis in Ecstasy* shows the saint suspended above the curved horizon, displaying the stigmata of the 'Second Christ', arms outstretched, fingertips touching the edge of the frame. He wears the habit of his order – the poor man's single garment of brown sackcloth, belted by a rope, its three knots signifying his vows of poverty, chastity and obedience, whose winged personifications hover above: Chastity in white, Obedience haltered, Poverty in patched brown shift. Below, floating like islands in the waves, we see their opposites: Lust

117 **Sassetta**, detail from *St Francis Renounces his Father's Earthly Goods,* from the *Altarpiece of St Francis.* London, National Gallery.

118 **Sassetta**, detail from *St Francis Asks the Pope to Recognize his Rule of Poverty,* from the *Altarpiece of Poverty.* London, National Gallery.

119 **Sassetta**, *St Francis Gives his Cloak to a Poor Knight; and Dreams of a Celestial Palace,* from the *Altarpiece of St Francis.* London, National Gallery. More than any Italian painter before Giovanni Bellini, Sassetta makes us aware that space can be created, not just by linear or 'perspective' construction, but through the less measurable effects of colour and light. The young Francis seems so delicate a figure that many viewers would mistake him for a woman.

riding astride a black pig, preening herself in a mirror; Pride, an armoured man with drawn sword, trampled under Francis's wounded feet (the attendant lion looking pained) and most comical of all, Avarice, a nun accompanied by her wolf-familiar, screwing her moneybags through a press. Set within a halo once again stamped with 'Patriarch of the Poor', the saint's foreshortened head is an almost geometrical circle, centred on his enormous almond eyes – the deep light-filled wrinkles radiating

120 **Sassetta**, Head of St Francis, detail from *St Francis in Ecstasy*, Settignano, Villa i Tatti.

121 **Sassetta**, *St Francis Asks the Pope to Recognize his Rule of Poverty*, from the *Altarpiece of St Francis*. London, National Gallery.
Francis and his companions appear at the papal court, asking to live out their way of poverty without fear of persecution as heretics. Sassetta stages a social comedy, derived from Ambrogio's *Investiture of St Louis of Toulouse* (ill. 73) with even more sly pictorial wit, juxtaposing the poor brothers' tonsures against the cardinals' hats. Crammed into a narrow space is a whole society, evoked mainly by fragmentary heads – a slice of profile, a quarter of an eye behind a column.

122 **Sassetta**, *St Francis Proves his Faith to the Sultan*, from the *Altarpiece of St Francis*. London, National Gallery.
As Francis steps into the fire we are plunged into deepest space behind him, towards a tiny distant hill crowned with a tree, and even further away, pale towers. The graded blue excavates the deep vignette. Above the cornice, however, a shock awaits us – not blue, but a shift into flat gold.

outwards in loving kindness: Francis as true and smiling sage, exalted and joyous.

An Agglomeration of Glimpses

Documentation published by James Banker in 1991 has revealed the complicated story of the altarpiece. A group of lay Franciscans in Borgo San Sepolcro had an elaborate wooden structure built in 1426, commissioning a local painter, Antonio d'Anghiari, in 1430; his young assistant, gessoing the panels in 1432, was none other than Piero della Francesca (c. 1415–92). But progress was so slow that in 1437 they reassigned the altarpiece to Sassetta. He may – with his home town of Cortona less than a day's walk from Borgo San Sepolcro – have had local connections. Not wanting to leave

120

Siena, he agreed to replicate the carpentry in his own workshop. After a debate in chapter in 1439, two friars journeyed to Siena 'to order and to compose the images and narratives of the altarpiece, as it seems to us and the master together'. They returned with drawings and the final list was read out in chapter.

Pictorial precedents for the friars' conception have been found in Taddeo di Bartolo and Spinello Aretino, but the language Sassetta arrives at is very much his own, perfectly adapted to the poet of the *Canticle of the Sun*. From the first episode, the action of light upon colour is felt at its purest, in the conjunction of two greens in the platform under the sleeping Francis, in the two yellows below, in the delicate greys of the bedchamber. Each is exquisitely judged, with an even greater subtlety than his trecento forbears. The white arcaded balcony, receding in an abstract and fantastical logic, hits the pale blue at perfect pitch. In the next scene, Francis renounces his father's merchant caste, stripping himself naked before all, and crossing into the porch to place himself in the bishop's embrace. Francis is again a strikingly 'girlish'

119

124

123 **Sassetta**, *St Francis in Ecstasy*, from the *Altarpiece of St Francis*. Settignano, Villa i Tatti. St Bonaventura tells of Francis 'praying by night, hands stretched out after the manner of a cross, his whole body uplifted from the earth'. The green waters below, ringed by little hills, probably depict Lake Trasimeno, visible from Sassetta's home town of Cortona; Francis is known to have fasted forty days on one of its islands.

figure, who folds his arms over his breast in a gesture usually associated with feminine *pudeur*. Compared to the monumental drama of the Assisi cycle (with Francis separated from his angry father by a great gulf of blue) this staging may seem almost feeble. Yet the setting articulates meaning with superb inventiveness, the pink, impossibly slender columns allowing us a glimpse of cloistered serenity before we ascend to the segmented circle of flat gold. ₁₁₇

In both these opening compositions, Sassetta puts together a kind of collage of mutually irreconcilable spaces, somehow harmonized into a unity. The effect is to structure the picture, not with the steely web of systematic perspective, but with an agglomeration of glimpses, of framed vignettes. One needs to explore each in terms of an itinerary, a sequence of pictures within pictures; transitions certainly assisted by the artist's manipulation of his panels' shape, to shift us through space. As the narrative unfolds – The Twelve Companions at the Papal Court, 121

124 **Sassetta**, *St Francis Renounces his Father's Earthly Goods*, from the *Altarpiece of St Francis*. London, National Gallery.

Francis's Ordeal before the Sultan – we experience each 122 composition as itself a vertical 'unfolding'.

Perhaps the most revelatory of all is the Chantilly *St Francis* 125 *Marries Poverty* – the single panel not in London. It is based on a strange passage from St Bonaventura's *Life of St Francis*, when, on the road through southern Tuscany towards Siena, Francis meets three girls who hail him: 'Welcome Lady Poverty'. The 'seraphic' Francis is a eunuch of God, and has become the female embodiment of a virtue. By the time of Dante, 'Lady Poverty' had become the saint's courtly beloved:

Ai frati suoi, si com' a giust' erede,
Raccommandà la sua donna piu cara
É commandà che amassero a fede.
[Unto his friars, as his rightful heirs / he commended his dearest lady /
and bade them to love her faithfully. (Paradiso XI: 172–4)]

125 **Sassetta**, *St Francis Marries Poverty*, from the *Altarpiece of St Francis*. Chantilly, Musée Condé.

126 **Sassetta**, detail from *St Francis Marries Poverty*. Chantilly, Musée Condé.

In Sassetta's panel, the encounter on the road surely carries an echo of Paris and the Three Graces: except that Francis must choose here not between Wisdom, Beauty and Wealth, but between red Obedience, brown Poverty, and in the foreground, white Chastity. These high-waisted smiling girls are taller than he is: modestly, he steps forward, arm outstretched, to place the ring on Poverty's finger. And then, in a wonderful use of continuous narrative, the girls fly up; and Poverty looks, smiling, back at him. (In the overall design of the polyptych, this upwards motion was

127 Monte Amiata seen from Pienza. Although Pope Pius II had not yet built his famous loggia, this spot was already cherished as a 'belvedere'.

yet further extended, with the same girls making a third 116 appearance, as the Virtues in the main panel hovering above the head of St Francis in Ecstasy.) Opening behind them is a huge gulf of empty sky, filling almost half the picture surface. While the fortified town in the foreground still resembles those schematic city-signs of Duccio's *Temptation*, Sassetta's snaking pathways and 2 chessboard fields convey a compelling sense of place – of a natural world freshly experienced. Many years after I had first seen the Chantilly *Marriage*, I was looking out from the loggia of Pienza when I felt a sudden jolt of recognition. This dark silhouette of 127 Monte Amiata cut against the pale sky was unmistakably the same view; the artist must have observed and drawn it here, integrating the mountain with great fidelity into his visionary narrative, without any jarring of idiom.

128 **Sassetta**, *St Francis and the Wolf of Gubbio*, from the *Altarpiece of St Francis*. London, National Gallery.
In the words of the *Little Flowers*: 'The wolf lifted up his right paw before him, and laid it gently in the hand of Francis, giving thereby such sign of good faith as he was able... And thereafter the same wolf lived two years in Gubbio; and went like a tame beast from door to door... and was courteously nourished by the people.'

When Van Os writes of Sassetta's 'perfect balance between the natural and the supernatural, between the world of imagination and reality', he touches the core of his achievement. In perhaps the best-loved of all the London panels, we also register, in the spirit of the *Little Flowers*, the artist's humour and charm. The Umbrian town of Gubbio had been ravaged by a man-eating wolf, and Francis called in as a kind of troubleshooter; he was, in Bernardino's words, 'compassionate not only with men but with beasts'. Outside the familiar city gate (the womenfolk peering anxiously down from the battlements) we see a terrible path, strewn with human bones and bleeding remnants. But here is Francis – his diminutive stature again emphasized – making a notarial contract with the beast. Behind, the crowd recedes to fragments of heads and hats, counterpointed with coronets of distant citadels. Three birds glide towards us. Higher and to the right, the sudden apparition of a squadron of geese, brilliantly observed in curved formation, echoes not only the turn in the bone-strewn path, but also the swing of the ogee frame. And this upper region becomes once again a vastness of empty space; as though for the gold ground of earlier Sienese art Sassetta has substituted a new infinitude, a pale blue atmospheric depth. At the National Gallery in London, these blond tonalities are closely echoed in the pale whites and blues of Piero della Francesca's early *Baptism* hanging nearby. The link between Sassetta's *St Francis in Ecstasy* and Piero's *Madonna of Mercy*, begun in 1445, is widely acknowledged. But Piero would soon come under the sway of a very different, and ultimately opposed, idiom – the Albertian classical ideal, centred on the court of Urbino.

129 **Sassetta**, *Blessed Ranieri Liberates Poor Men from a Debtors' Prison*, from the *Altarpiece of St Francis*. Paris, Louvre.

130 **Sassetta**, *The Damnation of the Miser of Citerna*, from the *Altarpiece of St Francis*. Paris, Louvre.
This predella panel, rediscovered only in 1987, depicts Blessed Ranieri twice as he demonstrates to his fellow friars the evils of avarice. Through the open door we glimpse the naked soul of a notorious miser being carried off by airborne demons. Both panels emphasize Francis's doctrine of poverty, as 'Patriarch of the Poor', more than any Assisi equivalent.

Verticality

The predella below *St Francis in Ecstasy* was dedicated to a local disciple of the saint, Blessed Ranieri, whose relics lay beneath the altar. For these small panels Sassetta reverted to a simpler spatial construction, strongly recalling Simone Martini's *Blessed Agostino* of more than a century earlier. Blessed Ranieri is another cloud-borne miracle man, swooping into the contemporary street to release ninety poor debtors who had written to him from a Florentine prison. But where Simone had sought a new urban realism, Sassetta abstracts the architecture into two flat greenish grey planes – the blank walls of the gaol, through which the poor are making their breakout. A foreground figure, kneeling in still prayer at this miraculous intervention, acts as foil to the almost streamlined flight out of the left edge. In a fine example of

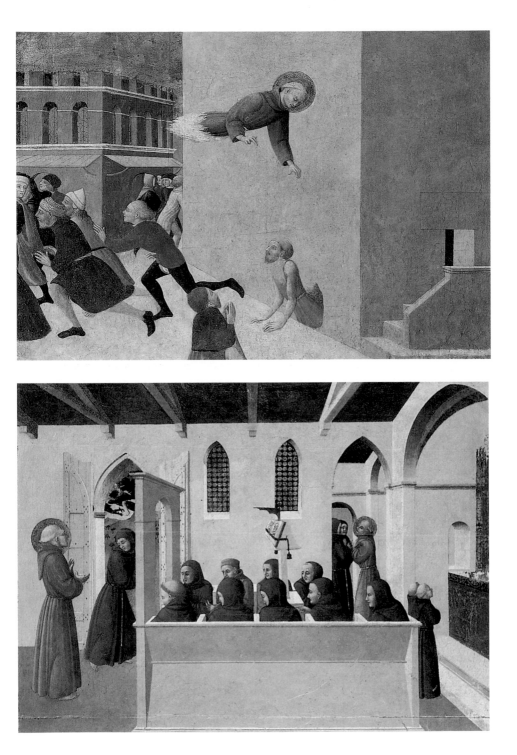

Sassetta's witty overlap, beneath the black tunic of one elderly runner (whose cap seems speckled with snow) appear the bare toes of the old man behind.

Sassetta's great altarpiece had taken over five years of his life, and he was now in his early fifties. He had made a late marriage to the daughter of a butcher in 1440; all three of his children (one of whom would become a sculptor) had godparents from a leading Sienese family, the Petrucci. Among his former assistants were some of the most successful artists of the next generation, including Vecchietta. In 1447, he accepted an ill-fated commission, a fresco on one of the city gates. Simone Martini had painted a famous *Assumption* (now lost) on the Porta Camollia, and Sassetta's counterpart on the Porta Romana was probably designed as a combination of the Assumption and the Coronation of the Virgin – a visionary cloud pageant, set high above a cosmic panorama. The fascinating *Assumption* now in Esztergom in Hungary by Sassetta's close disciple Pietro di Giovanni d'Ambrogio, with its magical seascape of islands and boats under a curving horizon, may reflect aspects of the Porta Romana's original design. By 1450 however, Sassetta seems to have completed only the upper vaults; the surviving fragments,

131

131 **Pietro di Giovanni d'Ambrogio**, *The Assumption of the Virgin*, c. 1450. Esztergom, Kereszeteny Museum.
An angel prepares to let fall the Virgin's girdle, to be caught by the solitary figure of Doubting Thomas, standing by the empty tomb in this poignant landscape. Like Sano, Pietro di Giovanni was closely associated with San Bernardino, creating a series of striking images of the aged Franciscan standing on the curvature of the globe.

phalanxes of angel heads simpering down at us, appear mannered and unconvincing. In March, while at work on the scaffold one windy day, he caught a chill and died of pneumonia two months later. Although the earlier payment of 510 florins for his Borgo San Sepolcro altarpiece – the highest recorded for any single fifteenth-century work – ought to have left him rich, a petition from the artist's widow to the Sienese government shows the family destitute, deep in debt, barely able to afford him burial.

The three greatest Sienese narrative cycles of the fifteenth century would all depict saints of renunciation – Francis, Anthony, John the Baptist – whose journey takes them away from the city, from trade and community and settled luxury. Redeployed, the trecento street-language now creates an imagery of wilderness, of solitude. The new constellation of Sienese painters remains difficult to assess. Sassetta's *Madonna of the Snow* and his *Altarpiece of St Francis*; Giovanni di Paolo's *Creation* and *John the Baptist* series; 142–7 the Master of the Osservanza's *St Anthony* cycle, as well as the 155–9 Asciano *Birth of the Virgin* – all these would amount to a second 160 flowering of Sienese painting almost as resplendent as the first. Yet because their panels have been scattered so widely across Europe and the United States, with very little from those thirty years now visible in Siena itself, any overview demands an act of the imagination. We need to cram back into the little city all those pictures encountered in Chicago or Chantilly, in Berlin or Boston (and then multiply them at least seven times over), before the workshops of quattrocento Siena are recognized in all their astonishing achievement.

Sassetta's works were unmentioned by Vasari: they could not be integrated within any 'progressive' narrative. In Christiansen's words, his art 'resists classification as Gothic or Renaissance', and by the time of his *St Francis* sequence, 'a completely original post-Gothic idiom has been created'. The city-signs we first encountered in Duccio's *Temptation* – those compressed essences 2 of urban fabric which were stitched by Ambrogio into an entire enclosing world – are now transformed once more. Ambrogio's *Well-Governed City* was the most complete expression in Western 82 art of the horizontal, carrying the impulse of a world-affirming vision, the everyday embodied within an all-encompassing vernacular. Sassetta's art is far narrower, and its verticality points towards a more personal language: a metaphysical fantasy of architectural space, an inward ascent.

Chapter 7 Giovanni di Paolo: The Chessboard Journey

First documented in 1417, working as a miniaturist for the Sienese Dominicans, Giovanni di Paolo (c. 1395–1482) would eventually contribute four large altarpieces to their vast basilica. His earliest surviving work is, however, tiny and thoroughly secular: an exquisite marriage box, inscribed with the date 1421. Around the 132 box itself rushes a circuit of dogs chasing deer and wild boar; but on the lid another kind of hunt is in progress. As red-gowned girl-musicians sing and play in a flowering meadow, there floats slowly into sight above the rim of the hill, the Goddess of Love. She looms directly above her devotees, magnificent against the golden sky; an archer, unsmiling as one blind naked boy gives her the bow, another the arrow. Giovanni's authorship is confirmed by the masterly spatial design. Within the tondo, the dip of the meadow (a reversal of all those curved horizons in Sienese art) is poised against the down-turned arc of dark cloud, setting all in motion towards us – the cupids on their little cloud-chargers, Venus on her thunderous juggernaut throne: Love Conquers All.

A *Madonna of Humility* painted some fifteen years later is of the 133 same sisterhood – the same small features under a tall brow and

132 **Attributed to Giovanni di Paolo**, *Marriage Box: The Triumph of Venus*, 1421. Paris, Louvre. Millard Meiss was the first to ascribe this box to Giovanni di Paolo, followed more recently by Strehlke and others. It is shown today in the rather miscellaneous *objets d'art* section of the Louvre.

133 **Giovanni di Paolo**,
Madonna of Humility, c. 1435.
Siena, Pinacoteca.
The Virgin is painted in a
surprisingly thick impasto; the
band of blue at the top is more
'impure' than its equivalent in
Sassetta. The fields, darker below,
rise to catch the light. These tonal
transitions are less compelling in
the near-replica now in Boston,
though its colour is generally
better preserved.

turban. She is at play with her child on the flowering summit of
a little hill, seated on a brocade cushion and enclosed within a
tightly packed orchard, bursting with fruit. The theme of the Virgin
in the Garden (familiar among Giovanni's International Gothic
predecessors) is given a new dimension by the cosmic panorama
that rears up behind as a tilted plane. With its emphatically
curved horizon ringed by mountains, it suggests a segment from
Ambrogio Lorenzetti's circular World Map of a century before,
yet here transformed by a more fantastical imagination into a kind
of patchwork microcosm. Paths and boundaries are mapped out
by microscopic trees and tiny white-dotted stones, painted with a
miniaturist's precision. From the right, a river curves through the
chequered fields, past the dark rock that guards the steep-walled
city, and down into the lake.

Variations on this chessboard panorama recur throughout
Giovanni's long career. It becomes, of course, a formula – yet so
effective, so magical in its conjuring of the vast patterned space to

be traversed, that its spell never wears thin. 'Few experiences in Italian painting are more exciting', writes John Pope-Hennessy, 'than to follow Giovanni di Paolo as he plunges, like Alice, through the looking-glass.' In the *Madonna of Humility*, the chessboard panorama establishes the world beyond the *hortus conclusus*, and its role in all his work is to create an abstraction of space, whose appeal is not to the fixed optics of the spectator, so much as to the winged flight of the dream-voyager. What is conveyed is a child's wonder at the immensity of the world, of life's quest as a game to be played across it.

Giovanni's artistic formation remains mysterious. Taddeo di Bartolo was probably his master, and they share a similar toughness of line. But there is also a Northern component; the orchard below the Madonna recalls the little woods of the *Très Riches Heures* by the Limbourg Brothers, who Giovanni may have met in Siena in 1413. There is also evidence that he may have worked in Lombardy. Certainly he was, even more directly than Sassetta, affected by Gentile da Fabriano's stay in Siena in 1425 – an influence visible not only in the beautiful six-foot *Branchini Madonna* (Norton Simon Foundation) painted for San Domenico in 1427, but in pictures completed decades later. It has become clear that Giovanni possessed a sketchbook filled with details from Gentile's *Adoration of the Magi*, as well as other compositions, which he made use of again and again. Although no drawings survive by any of the principal Sienese painters, Maginnis and other art historians are convinced they did once exist: paper was certainly available, since by 1330, at least twenty paper mills were already flourishing in the town of Fabriano. In Giovanni di Paolo's *Presentation in the Temple* of about 1442, the ragged beggar and the old woman, as well as the two fashionable young ladies, are all lifted straight from Gentile's composition of seventeen years earlier. Yet his colour is far more atmospheric and decorative, and the architecture is compressed, steepened, destabilized. The strangest note is on the right-hand side, where the patterned paving suddenly gives out to a gaping hole: as though for Giovanni the crust of civilization were really very thin.

The two maids accompanying the Holy Family in *The Flight into Egypt* are likewise borrowed from Gentile (the same girls employed by Sassetta on the right of his *Adoration of the Magi*). The picture as a whole embodies another wondrous travel fantasy. Papyrus is growing on the stony shores of the Nile, with pyramidal hills carved out of the gold ground; all conflated, of course, with the watermill, towers and hilltowns of contemporary Tuscany, the

134 Giovanni di Paolo,
The Presentation in the Temple,
c. 1442. New York, Metropolitan
Museum. The last of five now
widely dispersed panels from
the predella of an unidentified
altarpiece.

135 Giovanni di Paolo,
The Flight into Egypt, c. 1435.
The sun at the top left corner is
the source of all the shadows.
Those beyond the green river are
authentic, but the shadows cast by
the foreground palms on the left
are probably a later addition.

sky alive with skimming and swooping swallows. This higgledy-piggledy landscape has become famous above all for its late-afternoon shadows – unprecedented, and scarcely to be encountered again in painting for another two centuries. In an essay of 1906 entitled 'Art and Sunlight', the Nabi painter Maurice Denis recalls a discussion with Pissarro, 'telling him about a certain picture in the Museum of Siena, by Giovanni di Paolo, who back in the fifteenth century represented sunlight by a golden ground laced with long grey shadows'. Strikingly, however, none are cast by the foreground figures, leading Victor Stoichita to contrast the Holy Family, 'typical of the medieval image', with the much more innovative landscape, charged with Giovanni's 'revitalized experience of the real'. Charles Lock finds in this contrast a more conscious theological argument – the 'substance' of the sacred figures distinguished from the more ephemeral 'foreshadowing' of the natural world they pass through. Either way, *The Flight into Egypt* remains one of those many fifteenth-century Sienese images whose perceptions are so fresh and experimental that even the artist himself never returned to them.

136 **Giovanni di Paolo**,
The Triumph of Death, 1437.
Berlin, Kunstgewerbemuseum.
One of the shields in this
Biccherna panel bears the arms of
the Piccolomini family, indicating
that not every branch of this
troublesome clan was exiled.

Death and the Dante Illuminations

In 1437, following yet another severe outbreak of plague in the city, Giovanni di Paolo painted perhaps the most monumental of all those little *Biccherna* panels that served as covers for collections of official documents – a civic tradition that already went back over a hundred years. Black Death gallops in on his 'night mare' – victims heaped under the horse's hooves, its black head terrifyingly elongated to become a kind of weapon – and bursts bat-winged into a room crammed with young men and women dressed in vivid red, all playing dice, four of them already pierced by Death's shafts. Some have seen Giovanni's image as a response to the contemporary sermons of Bernardino, railing against the sin of gambling. But five years later, Death reappears in a very different context: a miniature illuminating the Office of the Dead, painted for the Augustinian hermits of Leccetto. The solitary man has been surprised by Death, trapped on a ledge between a dark wood and a foreground chasm. The terrible archer rides again bareback, scythe in belt – but covered now in grey hair (rather like the 'wild man' of Alpine tradition), his steed breathing red flames.

Giovanni was appointed rector of the painters' guild in 1441. As the outstanding miniaturist of his generation, he was an obvious choice to illuminate Dante's *Paradiso*, completing the

136

137

137 **Giovanni di Paolo**, *Death in a Landscape*, 1442. Siena, Biblioteca Comunale (Cod. 9.1.8, fol. 162). From an antiphonary, with many other illuminations by Giovanni di Paolo, made for the monastery at Leccetto, set deep in the forest. Here the screen of miniature trees is again reminiscent of the work of Northern artists such as the Limbourg Brothers. Stooped in prayer, wringing his hands, the figure of Everyman quite literally 'gets it in the neck'.

138 **Unknown Sienese artist**, *Dante and Virgil are Rowed across the River Acheron* (*Inferno*, Canto III), *c.* 1440–44. London, British Library (The Yates Thompson Dante, MS36, fol. 6r.). The manuscript was probably presented by the city to King Alfonso of Naples at a peace conference in Siena in 1444 (the occasion at which Alberti and Federico da Montefeltro first met). It has 115 illuminations, the first 54 by an artist sometimes identified either as Niccolo d'Ulisse or as Vecchietta.

manuscript today known as 'The Yates Thompson Dante', in which *Inferno* and *Purgatorio* were painted by another, probably younger artist. The great vernacular poem had by now become part of Sienese life; ever since 1396, the grammarian Giovanni da Spoleto had been under contract to read aloud from the *Commedia* on feast days outside the church of San Vigilio. Every Sienese citizen would have heard this public recitation – more familiar perhaps with Dante than most of us with Shakespeare.

The two artists respond very differently. *Inferno* is the work of a great colourist. Under black skies sometimes flecked with red flames, the unidentified painter deploys a gorgeous nocturnal

138

palette. Blue-gowned Dante and pink Virgil are shown repeatedly, sometimes three or four times in the same image, as they tread their path through each long-format composition, past multicoloured mountains in chords of brown, purple and deep blue. Their jouney through hell becomes a chromatic progression across each page. In Canto III, they cross the bright green waters of the river Acheron; it triggers a speckling with minute points of white – wave foam on the shore, Virgil's hair, Charon's 'woolly cheeks'. The horizon has been tilted upwards, pushing the narrative forward. At the left, boyish Dante waits beside his white-bearded mentor on the 'joyless strand'. But the centre is given over to Charon, who is shown three times: as he fends off the damned souls with his great oar; as he disembarks others; and in the foreground as he ferries the two poets. Throughout these *Inferno* miniatures, the large childlike heads contrast with a surprisingly sophisticated and sensual mastery of the nude; the busty woman climbing awkwardly out of the boat and the naked tonsured cleric standing with his back to us seem almost improper.

The illuminations become fewer in *Purgatorio*. But as soon as *Paradiso* is reached – where Dante is now airborne, ascending ever upward with Beatrice – the very different hand of Giovanni di Paolo establishes a much fresher, light-filled sky world. Below

139 **Giovanni di Paolo**, *Dante and Beatrice Leave the Heaven of Venus and Approach the Sun* (*Paradiso*, Canto X), *c.* 1440–44. London, British Library (The Yates Thompson Dante, MS36, fol. 146r.). Dante and Beatrice are about to encounter the planetary souls of Thomas Aquinas and the Dominican saints as the horizon tilts again. Canto X includes the line 'Leva dunque, lettor, all'alte rote' ('Lift then your sight with me, reader, to the lofty wheels') and also refers to the planets orbiting 'aslant' – that is, elliptically. Below the figures, the six almost uniform city-signs are exceptionally schematic and abbreviated.

139

Dante and Beatrice, the panorama that unfolds is unmistakably Tuscan, pierced and fractured by the sun's arrow-like golden rays. This is a gloriously buoyant image of soul-flight, and the ultimate fulfilment of one aspect of Sienese tradition – of the imaginative possibilities that were already implicit a hundred-and-thirty years earlier in the bird's-eye panorama of little citadels spread out in Duccio's *Temptation*. In later episodes, Dante is shown moving into a deeper blue, an outer space beyond sight or consciousness of the earth. But the sublime is not Giovanni di Paolo's natural territory, and the mismatch between his essentially earthy, literal vision and the poem's dematerialized soul-flight sometimes appears almost comical. Dante himself declares his experiences in paradise to be 'unimaginable'; it would be left to Botticelli, in his great cycle of drawings from the 1480s, to achieve an almost miraculous visual equivalence.

2

Pope-Hennessy sees Giovanni's work on these sixty-one images as a watershed that 'formed the background of his development and influenced the course of his whole subsequent career'. His *Creation* dates from a year later, with the earth seen as one of Dante's 'lofty wheels'. The image has also been aligned with Canto XXII of *Paradiso* (lines 133–5):

140

Col viso ritornai per tutte e quante
le sette spere, e vidi questo globo
tal ch'io sorrisi del suo vil semblante
[I looked back through all the seven spheres / and saw this globe in such a way / that I smiled at its worthless semblance.]

Yet if the earth is miniaturized here, it is also radiant, held by the Creator as a living thing, pulsing within its rings of light; we look into it as into a dark mirror, its mountains and rivers felt as a shadowed mystery. Ambrogio's World Map had perhaps already been inspired by these lines of Dante, but Giovanni gives the image a compelling new context, setting his wheel *within* the landscape of Eden and its four rivers. The Garden is stocked with lilies, strawberries, carnations – as well as two little rabbits, perhaps emblems of fertility. Adam and Eve are loosely taken from Jacopo della Quercia's *Expulsion* on the *Fonte Gaia* in the Campo – figures that every Sienese would have known. But the nakedness of the angel (a narcissus covering his genitals) is without precedent, and has yet to be satisfactorily accounted for. A gold ground underlies the entire sky area, the golden fruit and foliage scratched through; all reflect the light of the Creator, emanating from deeply incised ruled lines.

103

140 Giovanni di Paolo, *The Creation and The Expulsion,* 1445. New York, Metropolitan Museum, Lehman Collection.
This small panel was cut from the predella of the *Guelfi Altarpiece,* originally in the Sienese church of San Domenico. Above was a large *Madonna and Saints* that included both Thomas Aquinas and Dominic himself, now in the Uffizi, Florence. The blue cherubim are associated with Dominican knowledge, as opposed to the red seraphim of Franciscan ardour.

In another superb fragment from the same predella as *The Creation,* mankind is redeemed and returns to the Paradise Garden after the Last Judgment. The same flowers are under foot, and this time with four identical rabbits. At top right, along the curving crest of the hill, a young man is led by a kind of radiant Beatrice; below, a pope clasps hands with an angel and a cardinal chats with his nephew. Siblings and old friends, male and female, are reunited. St Augustine greets his mother, St Monica, while to their left, the Sienese Blessed Ambrogio Sansedoni (the dove of the Spirit always at his ear) is welcomed by an angel. In the foreground, the brown-mantled St Anthony makes contact with two Dominican sisters, followers of St Catherine; behind, two friars of the same order embrace, one identified by his head wound as St Peter Martyr. Thus Giovanni's lovely meadow, once the realm of Venus,

141 Giovanni di Paolo, *Paradise*, 1445. New York, Metropolitan Museum. The Guelfi predella included *The Creation* and *The Flood* (now lost); both flanking the long central panel of *The Last Judgment* (based on Fra Angelico's famous composition in San Marco, Florence). This scene of paradise is cut from the left of the design; on the right was hell, now also lost.

is now a christianized Parnassus; and those purified souls who, in Dante's scheme, climbed to the summit of Mount Purgatory, have here become (in Pope-Hennessy's phrase) 'guests at some idyllic garden party'.

The John the Baptist *Cycles*

The six panels now in Chicago, the single most impressive grouping anywhere of Giovanni di Paolo's work, were discovered

145–7

142 **Giovanni di Paolo**, *John the Baptist Goes into the Wilderness*, 1454. London, National Gallery. One of four scenes surviving from the predella of a large *Madonna and Saints* perhaps painted for the church of Sant' Agostino in Siena (now in the Metropolitan Museum, New York). Once owned by Pierpoint Morgan, the predella panels were acquired for the National Gallery in London in 1944: their present curved surface is not intentional, but the result of warping. Giovanni's interest in flowers is evident throughout his work.

only in 1907, and acquired by the Art Institute in 1933. Pope-Hennessy characterizes the *John the Baptist* series as 'perhaps the finest expression of visual individualism in the whole body of Italian painting'. These emphatically vertical compositions originated, however, in a sequence of much smaller horizontal images painted several years earlier, now in the National Gallery in London. The most famous of these earlier paintings shows the Baptist as a child, carrying his few needs on his shoulder, leaving the familiar city gate to make his way up into the wilderness. Just to his right we see him again, several miles away, but not reduced at all in scale: a giant walking up the steep mountain path. The head and torso of the two figures are almost identical, but as John climbs he slings his bundle over the other shoulder. Thus the

142

143 **Giovanni di Paolo**, detail from *John the Baptist Goes into the Wilderness*, 1454. London, National Gallery.

144 **Giovanni di Paolo**, detail from *John the Baptist Goes into the Wilderness*, 1454. London, National Gallery.

spectator has moved with St John, and the foreground landscape becomes the vista opening up below as the child climbs; I take the little pink-towered city to be the same one he set out from, warmed by the setting sun. The picture is about renouncing the city, leaving behind the man-made grid of cultivated fields, its beautiful patchwork of contrasted greens, for a world of wilder forms. Higher up, we glimpse a yet further region – a blue-and-white ice realm, across a dark river, extending to the curved rim of the horizon – all laid in with a scintillating economy of mark.

143

144

Some of this compression is lost in the Chicago version, which adopts a vertical format and is more than twice as tall. For the earlier harmonies of greens and blues, Giovanni here substitutes a harsher palette of red, brown and grey. The boy Baptist wears yellow instead of brown boots; his bundle stays on the same shoulder as he climbs the mountain. However, this version too is full of wonderful invention. Tiny figures are inserted on the pale paths, drawing us down into yet another shift of scale. The climb is felt more acutely, and at the top of the picture we pass into a kind of map, with another tiny city at the right margin, and a ragged crimson coastline that might conceivably be the Red Sea. What he constructs here is not 'perspective', but a 'herringbone' projection of space, made up of repeated parallel diagonals – the boundaries

145

145 Giovanni di Paolo, *John the Baptist Goes into the Wilderness*, c. 1460. Chicago, Art Institute. The Art Institute has six of the original twelve panels from this later series. They were not originally part of an altarpiece, but would have been set in four vertical rows to form cupboard doors roughly seven feet high. They were probably made for Siena Cathedral – to enclose the niche for Donatello's statue of the Baptist, or for the reliquary of the saint's right arm, presented by Pope Pius II.

Opposite:
146 Giovanni di Paolo, *Ecce Agnus Dei*, c. 1460. Chicago, Art Institute.
At the beginning of his ministry, Jesus comes to the Jordan to be baptized by John, who recognizes him as the Messiah. 'The next day he saw Jesus coming toward him, and said, "Behold, the Lamb of God, who takes away the sin of the world!"' (John 1: 29–30).

147 Giovanni di Paolo, *The Beheading of John the Baptist*, c. 1460. Chicago, Art Institute. The scene immediately preceding this panel in Chicago shows the Baptist in an identical setting, but still alive and speaking through his prison bars. In the *Beheading*, however, the two lower bars have been ingeniously unhooked and dangle down, allowing the window to serve as a convenient executioner's block. In addition, the man in profile beyond the gate, shown walking towards the left in the earlier scene, is now returning to the right.

of fields and pathways extending across the whole surface. They converge just enough to cue recession, but there are no vanishing points, and the relative scale of figure to field, of distant city to mountain, remains always fluid. In both versions, Giovanni's intuitive eliding, his piecing together of spatial units, his miniaturizing and schematizing, all serve the story of the child's journey perfectly.

The chessboard-map continues to be deployed later in the cycle. When the Baptist recognizes Jesus on the other side of the Jordan, pointing out the Lamb of God to his own devotees, the diagonals stretch behind the figures at a very acute angle, the fields scored with tight, repeated ruled lines. Beyond the bridge and the distant city, multiple Mount Sinais wave their peaks wildly to the slanted horizon – a rock convention that seems to hark back explicitly to Siena's Byzantine beginnings. Perhaps the chessboard needs the mountains, to register effectively as distance. When the Baptist is gorily beheaded – the blood spurting horrifically in front of the grey stone Sienese-Gothic prison – we glimpse behind the executioner, through the gate, an exceptionally abstract slice of chessboard stretching to the high horizon, with a little passer-by impaled in its geometry. The cruel details of chains and bars, and Giovanni's metallic line, might remind us, as Adrian Stokes has pointed out, that Siena was 'the capital of the wrought-iron

146

147

148 **Giovanni di Paolo**, *The Adoration of the Magi*, c. 1462. New York, Metropolitan Museum.

industry'. The fearsome intensity of this picture makes it easier to understand why Crowe and Cavalcaselle wrote of Giovanni's 'epileptic vehemence'; or why the artists of Chicago still like to refer to him as 'our Dostoevsky'. St John was Giovanni di Paolo's name saint, and the narrative perhaps elicited a special emotional engagement; the artist would eventually be buried in a chapel dedicated to the Baptist, endowed in his will of 1477.

Giovanni's use of the chessboard pattern retains its freshness even in his final works. *The Adoration of the Magi* takes place high in the mountains; the figures derive once again from Gentile da Fabriano's courtly magi, though a more intimate note is struck when the young King reassures the ever-bewildered Joseph, placing an arm around his shoulders and tenderly taking his hand. Behind the green alpine meadow and its calm pastoral air, however, we plunge suddenly down onto a patchwork plain of almost infinite extension – a quilt of palest blue and khaki, merging with the feathery sky, and painted with an atmospheric touch so delicate and limpid that it challenges the work of his great Venetian contemporaries.

148

The Storyteller

Ever since Duccio's *Maestà*, Sienese painters had found in the 16
two parts of the altarpiece – the large-scale icon, and the small
narrative panels – quite different expressive possibilities. The
predella was the territory of the contingent, of dramatic action
unfolding in time, in the city street or across the landscape. Its
scale was inherently humble, intimate; it became the natural
location for that civic and vernacular imagery most characteristic
of Sienese tradition. Giovanni di Paolo's main altarpieces nearly
always present a Madonna in 'sacred conversation' with her
attendant saints, offering very little opportunity for spatial and
compositional play; after 1450, when the Florentine unbroken
rectangular format became a dominant convention, they are
seldom of much interest. His gifts are released, almost exclusively,
in the predella.

The anthology that follows has been chosen with some
difficulty from at least a hundred of these wonderful small
narrative panels. Giovanni di Paolo's storytelling is entertaining,
pungent, funny and compelling. He is much closer to popular
religion than is Sassetta, who may well have considered him (as
the painter Trevor Winkfield once speculated) a mere journeyman
image-maker. Whether saints or laymen, Giovanni's figures are,
one might say, 'lower-class types' – blobby-nosed, squinty-eyed,
ignoble; but full of wiry nervous energy. Sassetta conveys the
immaterial body, the vulnerable spirit. But when Giovanni's robust
worker-saints become airborne, there is no hovering about; they
fly straight in, and each of their miracles is a job like any other.

Two predella panels tell of the miracles of a new saint, Nicholas
of Tolentino – an Augustinian, canonized only in 1446. When
Giovanni shows him calming a storm at sea, his iconography 149
is borrowed from the far more celebrated St Nicholas of Bari,
the image drawn once again from Gentile da Fabriano – whose
delightful mermaid is transcribed almost without change. But
Giovanni's conception is, characteristically, far wilder and more
dramatic; the greenish black voids of sea and sky meeting in a fiery
horizon; the two smashed masts and the literally mountainous
waves. The image has the simplicity and symmetry of a primitive
ex-voto, and becomes an emblem of man's extremity – the
kneeling figures in the boat helpless, lost. Only the intervention
of the glowing saint, dodging the flying spars and rags of sails, can
save them.

The second panel recapitulates several much earlier Sienese 150
street miracles – the castellated arcades of Duccio's *Healing of*

149 **Giovanni di Paolo**,
*St Nicholas of Tolentino Calms
a Storm*, 1456. Philadelphia,
Museum of Art (John G. Johnson
Collection).

150 **Giovanni di Paolo**, *A Miracle
of St Nicholas of Tolentino*, 1456.
Vienna, Akademie der Bildenden
Künste.

the *Man Born Blind*, as well as the jettied balconies of Simone's
Blessed Agostino Novello – while establishing a space more
compartmented and complex than either. The steep street in the
background, crowded with figures, leads up to a miniature variant
of Brunelleschi's dome of Florence Cathedral silhouetted against
the beautiful ruffled sky – its green and blue streaks rising to a
greenish black, in which the denser black of the flying saint's habit
is embedded. Far below in the street, preparations are being made
for a funeral, with incense and candles carried and a gaunt stooped
figure, hand on hip, bearing on his back the scarlet coffin. The
powerful diagonal of this gabled form (rather like an extended
miniature house) creates a kind of wedge at the picture's crux.
We are witnessing the moment just before the miracle, as
Nicholas flies in to resuscitate the corpse.

151 **Giovanni di Paolo,**
St Stephen Suckled by a Doe, 1450.
Siena, San Stefano alla Lizza.
The opening scene of an
outstandingly fine predella, added
to a dull altarpiece of *The Madonna
with Saints* (Bernardino and Jerome
among them) painted some fifty
years earlier by Andrea Vanni. It
stood in a pilgrimage church on
the outskirts of Siena, whose relics
included one of the rocks with
which St Stephen was stoned.

A similar paved foreground with a steep street behind provides the setting for one of the strangest and most beautiful images Giovanni ever painted. But here, although the doors of the two facing palaces are open, the street is uncannily deserted. Into this spellbound, silent city (so akin to the trance-like piazzas of Giorgio de Chirico and the twentieth-century 'Metaphysicals') has strayed the delicate grey doe, giving her milk to the infant Stephen, already haloed in his swaddling bands. The patterned pavement splays outwards, as though radiating from the semi-heraldic beast herself. Giovanni's colour, limited here almost entirely to white, black, pink and red, is far more wintry than Sassetta's, but attains in this small masterwork a comparable intensity.

Giovanni di Paolo has often been cast as the 'deformed brother' of Sassetta; closely related, yet sour where he is sweet,

152 **Giovanni di Paolo**,
St Thomas Aquinas Confounding Averroes, c. 1445.
Averroes had propounded, about a century before Aquinas, the separateness of faith and reason as alternative paths to truth. Thomas devoted his life's work to refuting this: in his *Summa* (which so influenced Dante) human reason is reconciled with Christian faith.

darker and harsher. This contrast may partly be a result of the respective orders each served: Sassetta worked mainly for the Franciscans, associated with prayer, while Giovanni's Dominican links brought him closer to doctrine, to the inquisitorial workings of the faith. When Giovanni depicts Thomas Aquinas, the great 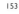 152 Dominican philosopher, he shows him not in solitary prayer – as Sassetta had done twice in the 1420s – but triumphant in dispute. The adversary lying at his feet is Averroes (Ibn-Rushd), the Spanish-Arabic Aristotelian. Giovanni depicts the *doctor angelicus* enthroned in his pulpit among the schoolmen who include a Dominican and a Franciscan. The Christians all share eager childlike faces; aged Averroes alone is bearded, asleep in his heresy, his book laid open upside down.

The artist was already in his mid-sixties when he embarked on ten scenes from the Life of St Catherine, commissioned by 153 the Hospital immediately after the Sienese Pope Pius II had secured her controversial canonization in 1461. As Strehlke points out, Giovanni would have known her story intimately: working at San Domenico as a young man, he must have met many of her surviving friends and followers. Catherine had prayed to Christ to give her a new, pure heart; a few days later, 'elevated in rapture... her heart leapt out of her body, entered Christ's side, and was made one with his heart'. Here, Catherine levitates outside her greenish grey convent with its pink roofs; the operation is under way, as she holds her left hand to her bosom, and stretches forth her right, her scarlet heart spurting blood. Christ rears up behind his own image as the Man of Sorrows above the open church door.

A year later, Giovanni di Paolo was invited to contribute a large altarpiece to the most prestigious Sienese project of his time – the cathedral built by Pope Pius II for his native village of Corsignano, now to be renamed 'Pienza'. But the resulting *Madonna and Child with Saints* is, by general consent, a dispiriting failure. Painting on well into his eighties, though threatened by increasing blindness, Giovanni would make figures that frequently border on the grotesque. Pope-Hennessy calls them 'debased'; 'they offer the imagery of fear, not of consolation'. (He nevertheless far prefers Giovanni's peculiarities to 'the complacency and sometimes exasperating tenderness of Sano di Pietro'.) Among such late images, the sainted Pope Fabian in his 154 crimson cope, his veined hand raised in blessing, and Sebastian, an amazing human pincushion holding his martyr's palm, do achieve a kind of knobbly majesty. The expanse of flat gold in which they are

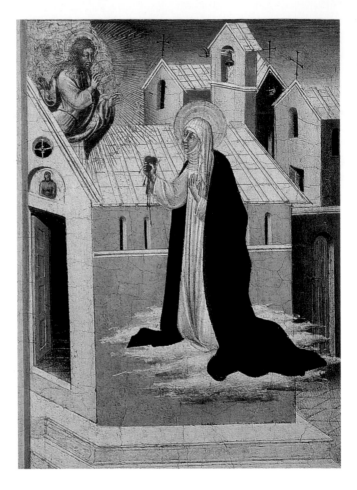

embedded would have been a rarity by 1475, but it allowed Giovanni to achieve a taut, metallic silhouette in his awkward drawing of the nude. The full unsettling strangeness of this late votive image is startlingly apparent when we register, kneeling at their feet, the two tiny hooded Brothers of the Misericordia, companions of the dying, whose collecting spoons dangle from hands raised in prayer.

According to Andrew Ladis, the Pienza altarpiece exposed 'a mentality unsuited to the challenge of the moment. Giovanni confronted a world of clarity, rationality and measure, but his was an art given to irresolution, irrationality and the immeasurable'. That 'challenge of the moment', that 'world of clarity', was of course the Albertian Renaissance. Our assessment of Giovanni's stature must partly hinge on whether we condemn his failure to

154 **Giovanni di Paolo**, *St Fabian and St Sebastian with Two Devotees*, c. 1475. London, National Gallery. The two saints share the same feast day – 20 January. In the nineteenth century, most of Sebastian's arrows were painted out, but they have recently been restored. The painting was purchased for ten guineas by Robbie Ross, Oscar Wilde's executor and loyal friend, and was eventually presented to the National Gallery.

adapt his art to the new aesthetic. Thirty years earlier, his magpie pictorial intelligence had borrowed from many sources to construct his distinctive idiom – from his trecento forebears, as well as from contemporaries such as Gentile da Fabriano and Fra Angelico. The 'renaissance' he and others had hoped for in the 1420s was the rebirth not of Classical Antiquity, but of a civilization closer to hand – the Siena of the Nine. And even if his art seems to 'lead' nowhere, it nevertheless becomes part of what may be called the 'matter' of Siena – that body of cultural material which today evokes nostalgia for a lost society. For Giovanni's generation the Siena of the Nine had already become something of a mythical or ideal city, whose forms embodied a specific raft of civic and ethical aspirations. In this sense, he is perhaps the most 'Sienese' painter of them all.

Chapter 8 The Lost Cause:
From the Master of the Osservanza to
Francesco di Giorgio

155

In 1940, several panels, until then universally attributed to Sassetta, were reassigned by Longhi to another hand, today generally known as the Master of the Osservanza (active c. 1430–50). The most striking are scenes from the Life of St Anthony. In the first, the fashionably dressed rich boy comes into church just as the priest reads aloud the gospel: 'If you would be perfect, go, sell what you possess and give to the poor, and you will have treasure in heaven; and come, follow me' (Matthew 19: 21–2). The setting is Siena's own striped Cathedral, its Gothic interior recreated as a compelling but absolutely unmathematical space – the columns soaring to star-spangled vaults, the lozenged floor plunging towards us, the side pinnacles of Duccio's *Maestà* visible on the right. In a kind of flashback we glimpse Anthony again as a devout child, kneeling beside the distant column. One of the artist's hallmarks (for which there is no parallel in Sassetta's work) is the grey penumbra hatched beside the head of the priest, rendering it almost like a bas-relief.

16

Anthony returns home to his Sienese palazzo: seen first in profile as he comes downstairs, purse in hand, and then out in the street, still in his fur-lined crimson finery, but this time among the needy – the barefoot, the stooped, the widow in her patched gown, begging for her children. Two blind men are about to pass one another, one of them bravely led by a patch-marked, wire-haired smiling terrier (my nomination for the most delightful dog in Western painting). Although the staging of this contemporary street seems so simple, no previous artist had so tellingly choreographed the movement of passers-by, nor the engagement of a patrician with the common people.

156

The real movement of the sequence now begins: a pilgrimage from the city to the desert. (In pictures in Washington and Yale, not illustrated here, a maturer Anthony will be seen taking leave of a hermit at a monastery door, and, a little way down the road, suffering a beating by demons – the same episode earlier depicted by Sassetta.) By the time of his first Temptation Anthony has

157

155 Unknown Sienese painter (The Master of the Osservanza), *St Anthony Hears the Gospel*, c. 1440. Berlin, Gemäldegalerie. The first of eight surviving panels, probably from a *vita icon* of St Anthony, commissioned by the Augustinians. They held Anthony (251–356) in special esteem as the founder of Christian monasticism, whose example converted St Augustine (*Confessions*, Book VIII).

Overleaf:
156 Unknown Sienese painter (The Master of the Osservanza), *St Anthony Distributing his Wealth to the Poor*, c. 1440. Washington, National Gallery. This typical Sienese palazzo, with its colonnetted Gothic windows and colour-washed façade in burnt sienna, is enlivened by constant invention: shutters, plants, metalwork sconces, interior glimpses. To compare this street scene with Duccio's *Healing of the Man Born Blind* (ill. 24) is to recognize both a shift towards naturalism, and a real continuity.

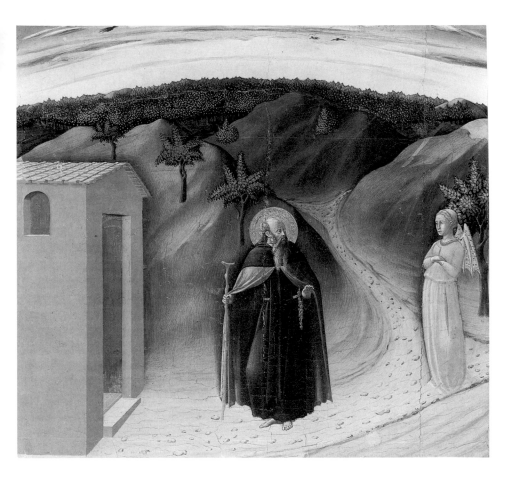

157 Unknown Sienese painter
(The Master of the Osservanza),
*St Anthony Tempted by a Demon
in the Shape of a Woman,* c. 1440.
Yale, University Art Gallery.
This is the closest of all the series
to Sassetta, in its solidity and
evenness of mark. The stones on
the path are constructed with great
lucidity out of a few contrasted
reds, meticulously drawn and
shaded, in contrast to the wild
splatter of the next Temptation.

become a greybeard, standing before his simple hut; a stony path
leads through grey barren hills into the forested wilderness, dark
against the sky. The constrast is vivid between the bright red cell
(constructed so lucidly out of a few flat tones) and the raw nature
beyond. Anthony, dressed as an Augustinian, his wayfarer's staff
in tau-cross form, turns away from the beautiful apparition; she
seems at first an angel, until we register her batwings, her pink
gown slit at thigh and bosom. The subtle oppression of this silent
encounter is reinforced by the streaked clouds and hovering birds
that bound the arc of the horizon.

In his second Temptation, on another rock-strewn path, 158
Anthony's nervous distress is more overt. This deeper wilderness
is more uncanny, punctuated by fire-blasted trees and a sequence
of still beasts – a rabbit, two deer, another rabbit – leading back to
the sinister lake and the dark tower, surveyed by ominous crows.

158 **Unknown Sienese painter**
(The Master of the Osservanza),
St Anthony Tempted by Gold, *c*. 1440.
New York, Metropolitan Museum,
Lehman Collection.
The theme of Anthony's
tribulations has called forth some
of the greatest images in European
art – from Bosch's *Lisbon Triptych*
and Grünewald's *Isenheim
Altarpiece*, to Ensor and Beckmann
(both mediated through Flaubert).
Yet the Sienese images remain
perhaps the most 'schizoid' and
inward of them all.

Anthony, now white-haired, throws up his hands in frozen horror.
The focus of his gaze was originally a heap of diabolic riches,
overpainted in a restoration: 'How very many times in the desert
has Satan not shown before me things like phantoms which
resembled gold, in order that I might bow myself down before
him'. Perhaps this loss of the narrative crux was fortunate: in its
absence, all our attention is concentrated on the landscape, as the
embodiment of Anthony's inner torment. The treatment of the
surface is far more expressive than Sassetta's: the shore speckled
or flicked rather than brushed, the sky flushed with patches of
bright red, and, above the white peak, suddenly rent through to
the gold ground. The sixteenth-century artist Albrecht Altdorfer
comes to mind, or even the Germans of the twentieth century,
such as Otto Dix; Italian painting has rarely, if ever, penetrated

159 Unknown Sienese painter
(The Master of the Osservanza),
*St Anthony Goes in Search of St Paul
the Hermit, c.* 1440. Washington,
National Gallery.
This panel was rediscovered in
1931 by the British art historian,
Ellis Waterhouse, in a bathroom
in Piccadilly. Anthony moves
from solitude, back into human
companionship. The two old men
(whose heavily veined hands and
feet receive special emphasis)
have cast down their yellow staffs
at the moment of meeting.

so deeply into the subjective state. The association of the saint
with a gangrenous fever known as 'St Anthony's Fire' (ergot
poisoning), as well as with the plague, may have helped to elicit
this hallucinatory wildness.

In the final episode, it is revealed in vision to the ninety-year-
old Anthony that an even older hermit exists – 'one more
excellent than thou art'. He sets out to find him, his passage
through the landscape charted in the final panel. At top left,
mantle slung over his shoulder, he comes into sight along the path,
which then vanishes behind a mountain, emerging again from the
trees on the right. At the next turn, Anthony, wearing his mantle,
asks directions from a centaur who seems to be a kind of guardian
of the forest. The path plunges on into a wood, whose foliage is
patterned in small clusters of dotted marks, until, at last, it arrives

159

at the mouth of a cave, where Anthony is lost in the embrace of St Paul the Hermit, their overlapping haloes a kind of consummation. In one small panel, barely eighteen inches tall, an epic journey has been encompassed – one of those many Sienese 'quest pictures' that recount a pilgrimage through both space and time. Here, the passage through the dark wood may also carry half-conscious echoes of Dante. Like Sassetta in his Franciscan legend, this artist tells a story from a distant era whose thrust is towards purity and simplicity; a kind of history painting that allows him to invoke an already 'archaic' language.

Asciano and the Shared Idiom
The paintings today ascribed to the Master of the Osservanza still seem too disparate to be the work of a single artist. The most likely hypothesis is that they are the products of a collaborative workshop in which various masters were employed, including the young Sano di Pietro and Sassetta himself. This *compagnia* was probably led by an as yet unidentified figure; the name of Vico di Luca, active between 1426 and 1445, is one of several contenders. Certainly the altarpiece of *The Birth of the Virgin*, painted for the small agricultural town of Asciano, suggests a very different artistic personality from the painter of the *St Anthony* panels. It is a surprising elaboration of Pietro Lorenzetti's own *Birth of the Virgin*, painted over a century earlier. The groin vaults and the tiled floor remain, as does the antechamber to the left, where Joachim is again told of the birth by a little boy. But Anne's bed has been shifted to the right margin, so that the central panel is given over to the newborn baby and the dainty young women who tend her. Pietro's 'heavy grace' here gives way to a more self-conscious charm, a refinement bordering on preciosity, barely redeemed by the surprisingly down-to-earth domestic contingencies.
The infant has been bathed, and although it is still late summer, a maidservant airs a towel at the open fire – the grey stone chimney piece constructed with admirable conviction. A girl in brocaded dress is passing in from the courtyard, bearing a boiled fowl and some broth. At the very centre of the composition, a tiny angel flies in like a sunbeam, bringing little Mary's crown straight from heaven. The surface is far more decorative than Pietro's, the deep space flattened by the deployment of gold, and by the repetition of a few surprising colours: the rose of the garden wall on the left is echoed in the well and the child below, then infiltrates the main space in the beautiful rose gown of the girl pouring water for Anne.

160

71

160 Unknown Sienese painter
(attributed to The Master of the
Osservanza), *The Birth of the Virgin*,
c. 1445. Asciano, Museo d'Arte
Sacra.
Painted for the Collegiata di
Sant'Agata, the altarpiece would
have had flanking saints to either
side, while scenes of the Funeral
and Death of the Virgin would
probably have been balanced by a
predella of episodes from her life.
A beautiful miniature variant of the
Asciano *Birth of the Virgin* exists as a
portable triptych in the National
Gallery, London.

In the Asciano museum, the elegance of this palace nativity
stands in startling contrast to a more wayward masterpiece.
Pietro di Giovanni d'Ambrogio (*c.* 1410–49) was capable of at
least equal refinement and sophistication, but in his large *Adoration* 161
of the Shepherds he adopts a rustic idiom, as though entering into
the experience of the Asciano *contadini*. The bright button-eyed
child so cosily wrapped in his swaddling-cylinder looks out under
the kindly gaze of the beasts, the ox's horn companionably placed
behind the ass's ear. The nocturnal panorama extending beyond
the crèche, leading across chessboard fields to a dark lake and
dominated by the great owl perched on the roof, is among the
most astounding landscapes in all Italian painting.

Until at least the mid-fifteenth century, several Sienese painters continued to create highly original works within their broadly shared pictorial language. Even in a collection as fine as the Fogg, the Master of the Osservanza's *Descent into Limbo* stands out, above all by its weird colour. No reproduction can quite convey the peculiar radiance of Christ's aureole – palest yellow with hints of pale violet – pressing into the utter blackness of the cave. Christ is here the 'great light' of Isaiah's prophecy, seen by 'all they

162

164 **Sano di Pietro**, *The Annunciation to the Shepherds*, c. 1450. Siena, Pinacoteca.

that walk in darkness'. The surface is oddly enamel-like, smooth and dense. In *The Resurrection* from the same sequence, a similar 163 use of deepest flat black recurs, the silhouetted hill rising to a dark tower. Behind, the dawn sky – a vermilion-streaked arc with rags of cloud hovering in stillness – is a feat of imaginative observation without precedent or heir.

Yet the limitations of this Sassetta-derived idiom become evident in the most prolific of all his followers, Sano di Pietro (1405–81). His first securely dated work, the *Gesuati Polyptych* 103 with its noble portrait of the kneeling Colombini, was painted when he was already almost forty. But over the next few decades, Sano's workshop would turn out repetitive assemblies of stereotyped saints (the Siena Pinacoteca alone counts more than forty altarpieces of this kind). Only in his delightful small predella scenes does some vestige of his earlier poetic invention surface again. *The Annunciation to the Shepherds* is a typically charming 164 predella panel from a typically dull and disappointing altarpiece. The landscape, with its fortified farms set high in the stark Sienese countryside, owes much to Ambrogio Lorenzetti. White-and-black sheep are packed tight in the fold, and their two brown-mantled pastors seated on the ground, warming their hands at the campfire. Suddenly, high in the sky, a bright red angel appears – and most surprised of all is their dog, straining upwards on the right-hand side. For all the sweet charm of this and many other little panels, Sano remains a disappointing artist; in Pope-Hennessy's cruel judgment, 'too stupid and too commercial to

develop any one of the germinal ideas with which Sassetta's work was filled'.

Towards Pienza

Young 'progressive' painters were already looking elsewhere. Sassetta's pupil Vecchietta (Lorenzo di Pietro, 1412–80) went north in the mid-1430s, to assist Masolino on his frescoes at Castiglione d'Olona – an outpost of Florentine taste in remote Lombardy. Returning to Siena, he began his lifelong association with the Hospital (by now the richest of all the city's institutions), overseeing the ambitious fresco cycle for the *Pellegrinaio,* or Pilgrim Hall, which served both as men's dormitory and as a setting for public festivities. The cycle depicts events from the history of the Hospital, as well as its charitable works – feeding the hungry, taking in pilgrims, bringing up orphans. The basic format of each large bay was fixed from the beginning: a lower zone of figures, dwarfed by an elaborate architectural backdrop converging on a central vanishing point.

To carry out the first trial fresco, Vecchietta selected a master several years his elder, Domenico di Bartolo (*c.* 1403–45). The *Care of the Sick* is arguably his masterpiece – a witnessing of

165 **Domenico di Bartolo**, *Care of the Sick*, 1440. Siena, Ospedale di Santa Maria della Scala.

164

contemporary life with a raw verism that can make the idiom of Sassetta appear suddenly cloying and escapist. Throughout the cycle, Domenico created a series of extraordinarily moving encounters between the fortunate and the broken: expensively gowned patricians ministering to the naked and the dying. Here, on the left, one of them leans over an emaciated patient, clasping him with fierce intensity; the doctor behind, examining his urine, gestures in alarm. Next, a benefactor kneels to wash the feet of a bleeding boy, while another places a cloak about his shoulders. To the right, at the bedside of a stricken elderly man, an immensely fat monk props himself in pensive pose, as two hospital porters enter from the right, bearing on their shoulders a black-draped object – perhaps a coffin, or an altar for last rites. Domenico brings the same wiry line and astringent eye to bear on the bubbles in a basin as on a horrifying wound; on a pomegranate on a shelf as on the shutters of a window; on the encounter of a dog and cat, as on the dispensing of medicine in the hospital pharmacy. All are encompassed within a rational and even 'clinical' depiction, in sober, cool colour.

166

According to Vasari (who praises his 'fertility' and 'ingenuity') Domenico was a nephew of Taddeo di Bartolo. This has often been questioned, but seems stylistically plausible, since they share an overwhelmingly linear emphasis. Domenico also seems to have had links with Jacopo della Quercia (whose brother Priamo would work on the *Pellegrinaio* frescoes), and he carried out several commissions in Florence. Disappointingly, Domenico's later frescoes in the cycle were more congested, and Vecchietta's own *Vision of St Sorore*, with the Hospital's founder-saint kneeling to recount his apparition of the Virgin letting down her ladder, is even more awkward, its antiquarian classicism ludicrously overdone. In practice, Vecchietta's would-be 'progressive' architecture and 'correctly constructed' perspective turned out less convincing than the fluid but unsystematic space that Sassetta was employing elsewhere in Siena at the same time. A few years later, Vecchietta seems more at ease working on the hinged doors commissioned for the Hospital's reliquary cupboard. The tiered portraits present a recapitulation of all the familiar local heroes of Siena's religious history, from Blessed Andrea Gallerani and Blessed Agostino Novello, through to the more recent, still unsanctioned cults of Catherine and Bernardino.

167

168

Had Domenico developed more consistently, and Sassetta lived longer, Sienese painting of the mid-fifteenth century might have played out an interesting debate. In Vecchietta, we have instead a

167 **Vecchietta**, *The Vision of St Sorore*, 1441. Siena, Ospedale di Santa Maria della Scala.

168 **Vecchietta and Pietro di Giovanni d'Ambrogio**, Reliquary Cupboard, *c.* 1445. Siena, Pinacoteca.

compromise between Sienese tradition and the new Florentine humanism, which allowed him to act as intermediary when the cultural climate shifted decisively in 1458 with the election of a Sienese Pope. Pius II (Aeneas Silvius Piccolomini, 1405–64) came of exiled Sienese nobility, growing up in Corsignano, 'a town', as he tells us, 'of small repute'. He first rose to prominence as a humanist and Latin poet. But in 1446 he took orders, serving as papal legate in Scotland and Austria, before becoming Bishop of Siena. In his *Commentaries*, written in Latin in his final years, his political sympathies are entirely anti-republican: 'to serve legitimate and natural lords is the only true liberty'. He harboured a deep resentment against a Sienese government that had set 'the nobles under the yoke like slaves', and by which 'the house of Piccolomini was humbled with the rest'. Pius set out to transform humble Corsignano into the Ideal City of 'Pienza' – constructing alongside his own palace a bizarrely eclectic cathedral. Its facade was Albertian (built by the Florentine Bernardo Rossellino on the pattern of a Roman triumphal arch), but its open bright interior was imported from a Gothic hall-church he had admired in Austria. Vecchietta was commissioned to oversee a series of altarpieces, all of them renouncing the polyptych form of Sienese tradition in favour of the regular rectangle, the Florentine *pittura quadrata*, to which – as seen in the previous chapter – the aged

169

169 The Palazzo Piccolomini and the apse of the Cathedral of Pienza, 1460–64.

Pius II had a great love for Monte Amiata, where he records 'holding consistories with the cardinals under the chestnuts'. The massive palace backed onto 'a most delightful view of Monte Amiata' (see ill. 127), and he constructed a loggia, 'three porticoes raised one above the other on stone columns', to frame it.

Giovanni di Paolo failed to adapt. A papal bull ordained, however, that the high altar should remain empty in perpetuity; as Van Os writes, 'the function of the Sienese High Altarpiece dissolved, as it were, in the light of Pius's "House of Glass"'.

Francesco di Giorgio and 'Mathematical Humanism'
In Siena, as the city swirls around the Campo, the distribution of space seems to respond to the rhythms of our walking, of our breathing; and for over a century and a half, Sienese painting shared in that free play of space. Perhaps this irregular experience of space is specific to the hilltown; on the flattened stage of Florence, a very different conception of the city had begun to

170 **Francesco di Giorgio**,
In the Time of Earthquakes, 1467.
Siena, Archivio di Stato.
Serving as cover for the city's tax accounts of 1466–67, this tiny *Biccherna* panel also includes the names and heraldry of those holding office. De Wesselow believes this and similar views of Siena originated in the emblematic image painted on the hubcap of Ambrogio Lorenzetti's lost World Map of 1345.

ALTENPO DETREMVOTI

A DI PRIMO · DIGIENAIO · M·CCCC·LXVI ·
ALTENPO·DEVENERABILI·HVOMINI·LONARDO·D
ANDREA·K·D·B·EDIGVLIARDO·DICONE·FORE·G
VRI·BARTALOMEIO·IDPAVOLODIGABRIELO·GIOVANI
DANTONIO·DINERI·GIOVANI·DI·SAVINO·SAVINI·FRARAL

171 **Francesco di Giorgio**,
The Annunciation, c. 1470.
Siena, Pinacoteca.

take shape – a city of grid and geometry, which embodied the aspirations of reason and intellect.

Beginning as a talented young painter, fully integrated within Sienese tradition, Francesco di Giorgio Martini (1439–1501) ended as the most famous architect, engineer and 'universal man' of his era. His beautiful little *Biccherna* cover, painted in his late 170
twenties, draws effortlessly on an accumulated imagery of the city that goes back to the early trecento (as does the *Biccherna* form itself). Towers and palaces rise up, surmounted by the striped Cathedral and the tower of the Palazzo Pubblico, all contained within the circuit of the wall, its brick transformed to a hotter pink, as though lit by a setting sun. Shaken by earthquakes, the inhabitants have moved outside into a tented camp. But the ever-protective Virgin (who resembles earlier Madonnas by Francesco's master Vecchietta, and whose angel-attendants recall in turn those of Vecchietta's teacher, Sassetta) still keeps covenant with her city. In the long lineage of Sienese civic images, Francesco's is perhaps the last that is truly memorable.

Many elements in his *Annunciation,* painted a few years 171
later, suggest an artist now more aware of his Florentine

172 **Francesco di Giorgio**,
The Coronation of the Virgin,
1472–74. Siena, Pinacoteca.

contemporaries. This Virgin is a close relative of similar figures in Verrocchio and Botticelli; the doorway behind, with its grey pietra serena surround, is Albertian. The landscape is also far removed from Sienese tradition, dotted about with Roman reminiscences and flanked by a fantastical crag such as we might find later in the work of Piero di Cosimo. Yet the impossibly slim pink columns rise as weightlessly as in any picture by Sassetta, the floor tilting steeply, the angel stepping forth ungrounded, the lectern about to slide.

In his far more ambitious *Coronation of the Virgin*, painted for 172 the aristocratic monastery of Monte Oliveto, Francesco strives beyond such intimacy of setting. Heaven is here conceived as a structure of marble terraces, crowded with saints like figurines on some elaborate mantelpiece; in their midst, supported by a kind of seraphic clockwork mechanism, Christ crowns his mother. The circling rhythms confirm his closeness to the young miniaturist Liberale da Verona, resident in Siena in these years. At the top, a foreshortened God the Father spirals down through a hole in the empyrean, his force field settling above his son's head. The sublimity of this wild-haired Jehovah, with huge feet and squat body, prefigures not so much Michelangelo as William Blake.

By the early 1470s, Francesco's interests had already expanded way beyond mere picture-making. In his youth he had known Mariano da Jacopo (1381–c. 1458), an engineer known as '*Il Taccola*' (The Jackdaw). A friend of Brunelleschi, Il Taccola, 'the Sienese Archimedes', had devoted himself to the study of hydraulics. Francesco inherited and annotated at least one of his notebooks, but soon brought to bear a more comprehensive vision: machinery of all kinds, churches and fortifications. This 173 quest for universal knowledge drew him inevitably towards the current of thought known as 'mathematical humanism' centred on Urbino. As general of the papal army under Pius II Piccolomini, Federico da Montefeltro (1422–82) had conceived of a new palace that would have some of the character of the 'Ideal City' imagined by his mentor, Leon Battista Alberti (1404–72). In 1435 Alberti had first codified single-point perspective and, a year later, completed his treatise *On Painting* (*Della Pittura*). It was he who had recommended the architect Laurana, and who created at Urbino a brilliant court circle that included Flemish and Spanish masters, as well as, from 1469, Piero della Francesca; all at work in the rapidly growing palace.

Francesco's first commission for Urbino was a bronze relief, in which the influence of Donatello is evident. Much earlier, between

1457 and 1462, the great Florentine sculptor had made several visits to Siena, declaring his purpose 'to live and die there'; his late style, with its vibrant surface and tormented figures, left a permanent impact on the sculpture both of Vecchietta and his young pupil. In Francesco's *Lamentation*, the cross stands bare against the expanse of naked bronze 'sky' – a heavily patinated brown plane, only lightly ruffled by darting angels. Far below, the crowd is modelled in much deeper relief, tremulous forms of hair and drapery reflecting a broken light; while the beautiful corpse of Christ is a fully three-dimensional classical nude, a Pentheus among the Maenads. The two wild women at the foot of the cross seem almost to dance their rhythmic grief. Yet the Sienese

174

173 **Francesco di Giorgio,**
*Groundplan of a Basilica in the
Image of Man, c.* 1475. Florence,
Biblioteca Nazionale (Codex
Maglia Becchianus, C. 42 verso).
This image is from one of several
beautifully drawn manuscripts;
another would eventually be
acquired and annotated by
Leonardo da Vinci. Francesco's
Opusculum, presented to Federico
da Montefeltro of Urbino, has
been described by Paolo Galazzi
as 'a luxurious promotional
brochure, showcasing the technical
performances provided by the
Sienese engineer and his workshop'.

174 **Francesco di Giorgio,**
The Lamentation, 1476. Venice,
Chiesa del Carmine.
Always represented in profile
(the other side of his face having
been mutilated in a tournament)
Federico da Montefeltro kneels
at the foot of the cross, together
with his nephew and young son.
The Lamentation hangs today as
an unframed plaque, oddly placed
against a battered church wall.
Adrian Stokes was probably
thinking of this relief when he
wrote of Francesco di Giorgio's
bronze as 'foam-like'.

**175 Possibly designed by
Francesco di Giorgio**, *Intarsia*
from the Gubbio *Studiolo, c.* 1480.
New York, Metropolitan Museum.
The *trompe l'oeil* panelling of the
Duke's inner sanctum for his
secondary palace at Gubbio
discloses cupboards in virtuoso
perspective, crammed with faceted
objects, emblematic of both martial
and intellectual achievement. The
design was carried out in Florence,
in the workshop of Giuliano da
Maiano, employing a 'palette' of
some thirty-three different woods.

trecento is also still present, most obviously in the veiled
matrons seated in mourning; and when the open-mouthed
Magdalene flings up her arms, we may suddenly recognize in
her a wonderful 'modernization' of Simone Martini's Magdalene 28
of 150 years before.

I would identify this *Lamentation* of 1476 as the last, albeit
sculptural, manifestation of the continuous tradition which is the
subject of this book. Was it cast in Siena, or at Urbino? Behind
St John, traced in lowest relief of all at the right margin, is the
familiar profile of Federico da Montefeltro. Francesco would serve
the Duke as master builder for the next twelve years, designing
fortresses and engines, windows and doors. Several paintings
often attributed to him, as well as the beautiful inlaid-wood
Gubbio *Studiolo*, may be better understood as part of a collective 175

176 Francesco di Giorgio, *An Allegory of Discord*, c. 1480. London, Victoria and Albert Museum.

Albertian project. In Urbino, classicism is at its most radiant; we feel the plasticity of each architectural element – each leaf or scroll, pediment or column – remade as emblem. But when we encounter Francesco again, in the plaster relief now known as *An Allegory of Discord*, the Albertian prescription already tends towards academicism. The subject – perhaps Lycurgus, who ordered the slaughter of the Maenads – seems mainly an excuse to display nude figures in as many contortions as possible, set against a perspectival backdrop of the Ideal City. Francesco has abandoned his birthright, the common tongue of the Sienese republic, as a lost cause; he has learnt to compose in the court Latin of the Florentine humanists.

176

Discarding the 'Humble Style'

From Simone Martini and the Lorenzetti brothers, the early fifteenth-century Sienese had inherited a wit of composition not found in their Florentine counterparts: an overlapping of borders, a juxtaposition of compartments. Very often, this play of wit was achieved through an architectural setting, which allowed each

177 **Unknown artist** (Circle of Piero della Francesca), *The Ideal City*, c. 1470. Urbino, Palazzo Ducale (National Gallery of the Marches).
Sometimes attributed to the architect Luciano Laurana, or to Francesco di Giorgio himself, this eight-foot panel was probably placed above a door in the palace at Urbino. It derives ultimately from the famous *prospetti* (demonstrations of perspective) known to have been painted by Brunelleschi and Alberti, but here given a compelling intensity as an image of human perfectibility.

painter to segment or 'zone' the pictorial field in a hundred inventive ways. Ideas about liberty had been bound up with the Sienese project from the beginning; both Simone and Ambrogio had conferred new freedoms on colour and space. But in the Sienese of the early fifteenth century, those liberties appear more like echoes, last vestiges of pictorial freedoms already half lost. The painter of the great *Ideal City* at Urbino – whoever he was – designed his cityscape in a manner fundamentally incompatible with Sienese tradition. Sienese painters had loved bouquets of reds and greens and blues; the Albertian painter subscribed to what Paul Hills has called the 'Renaissance cult of whiteness... the valorization of austere colours as opposed to florid ones'. Gold had been essential to the Sienese palette; Alberti condemned gold as tonally unstable, immeasurable. Many of the other expressive means essential to Sienese art – continuous narrative, disparities of scale, the irregular shape of polyptych panels – were outlawed by the unities of Albertian doctrine. The Sienese experience of the city had been, in Michel de Certeau's phrase, 'a practice of everyday life', a 'blind wandering'; the Ideal City of Albertian perspective claimed knowledge and control. Sienese painting had pioneered the integration of figures within city and landscape; Florentine Renaissance painting would take its cue from sculpture, reaching its apogee in a master whose art is *only* figure – in Michelangelo, for whom the natural world would almost cease to exist.

The prose narrative of the Christian gospel has been seen by Erich Auerbach as having 'conquered the classical rule of styles' in the early Middle Ages, establishing the validity of the everyday or 'humble style' in which 'the most deep-seated preoccupations of the people found expression'. I have tried to suggest a comparable development in Sienese painting. But the Florentine Renaissance

177

enacted a reconquest; as Jacob Burckhardt wrote in *The Civilization of the Renaissance*:

...the worst that can be said of the movement is that it was anti-popular, that through it Europe became for the first time sharply divided between the cultivated and the uncultivated classes.

The story of Siena and its painters could be told as that of a community exceptionally committed to the vernacular in the fourteenth century; which proved, in the early fifteenth, exceptionally resistant to the Latinate reconquest; only to be eventually overwhelmed by it.

* * *

In 1460, Pope Pius II appointed his twenty-three-year-old nephew to the newly instituted archbishopric of Siena. Over the next few years, members of the Piccolomini clan would build a series of Albertian white marble palaces in the heart of the city. Francesco di Giorgio returned to Siena in the late 1480s; for the influential Bichi chapel in Sant' Agostino, he collaborated with a young Umbrian painter he had met in Urbino, Luca Signorelli. Soon after, the magnate Pandolfo Petrucci would take control of a now merely nominal republic; full citizenship and participation in government would be legally reserved to 350 named families – the 'Noble Regents'. In 1506, on Petrucci's orders, Duccio's *Maestà* was removed from the high altar of the Cathedral. 16
The despot's favourite painters were Pinturicchio and Signorelli, whose frescoes for the Palazzo del Magnifico (now in the National Gallery, London) were commissioned in 1509 to celebrate the marriage of the oldest Petrucci boy into the Piccolomini clan. Thus, in the words of Van Os, 'the sweet classicism of the Umbrian school conquered Sienese painting'.

Although several native painters of distinction were at work in Siena after 1476 – Matteo di Giovanni, Pietro Orioli, the Griselda Master – none was heir to the tradition set forward in this book. A sole exception may be Domenico Beccafumi (1486–1565) whose eccentric imagination often seems to preserve unexpected 178 echoes of Siena's 'humble style'. In the puppet-like innocence of his large-headed figures, in their intimate relation to architectural space, the world of Catherine and Bernardino still lives. Beccafumi would serve the Sienese republic for its brief restoration, before a final succession of catastrophes extinguished all independence: Spanish rule, popular rebellion, the terrible seven-month siege of

1554–55, and the eventual sale of the broken city (by Philip of
Spain and Mary of England) to Cosimo I of Florence. For almost
four hundred years, the achievements of Sienese painting would
become invisible.

In the final paragraph of John Ruskin's autobiography, *Praeterita*,
he and his American friend, Charles Eliot Norton, go down to
Fontebranda. I have always associated this passage with the image
of Siena painted by Francesco di Giorgio in his *Biccherna* panel – 170
itself a kind of valediction. Ruskin was writing in 1890, in another
'time of earthquakes', when his own attempt to fuse art and ethics
had come to seem a lost cause. In Siena, 'to have drunk the waters
of Fontebranda' signifies madness, and as *Praeterita* breaks off,
Ruskin enters his long, final insanity. But his criticism had been
crucial to the shift of taste that would lead to the rediscovery
of Sienese painting – a process that still continues today.

*We drank of it together and walked together that evening on the hills
above, where the fireflies among the scented thickets shone fitfully
in the still undarkened air. How they shone! moving like fine-broken
starlight through the purple leaves. How they shone! through the sunset
that faded into thunderous night as I entered Siena three days before,
the white edges of the mountainous clouds still lighted from the west,
and the openly golden sky calm behind the gate of Siena's heart, with
its still golden words, Cor Magis tibi Siena pandit [The Great Heart of
Siena welcomes you], and the fireflies everywhere in sky and cloud rising
and falling, mixed with the lightning and more intense than the stars.*

Epilogue The Rediscovery

The rekindling of critical interest in Sienese painting coincided
with the birth of modernism – with the moment when art's five-
hundred-year impetus towards naturalism faltered; when Roman
antiquity lost its aesthetic primacy. Of course, Vasari's High
Renaissance values had been challenged long before. In the 1840s
Lord Lindsay had been among the first to make the now familiar
opposition of Florentine/active to Sienese/contemplative. The
German Nazarenes (precursors of the English Pre-Raphaelites) had
become enthusiasts in the same years, the Cologne-based painter
J. A. Ramboux purchasing some thirty-five *Biccherna* panels from
Sienese street-vendors. He eventually collected more than a
hundred Sienese works, including Giovanni di Paolo's *Triumph of* 136
Death and *St Catherine Exchanging her Heart with Christ*. Ruskin, in his 153
influential writings on trecento painting, had valued the 'primitives'
above all later art for their religious humility and moral purity.

But by the time the first art-historical studies of Sienese
painting began to appear, critical taste had shifted towards
art-for-art's sake, and issues of narrative had become very much
secondary to those of 'form'. Hence Bernhard Berenson's
strictures in 1897: 'the Sienese school fails to rank among the
great schools of art because its painters never devoted themselves
with the requisite zeal to form and movement'; they 'deal in that
perniciously popular article, expressive illustration'. Although
he admired Duccio, Berenson castigated Pietro Lorenzetti for
having sunk 'to the rubbish of his Passion scenes at Assisi'. He was
equally critical of Ambrogio, who 'could think of nothing but vast
panoramas overshadowed by figures powerless to speak for
themselves, and obliged to ply us with signs and scrolls'; ending
with a judgment that today seems at least trebly erroneous,
'At his worst, he hardly surpasses the elder Brueghel'!

In his *Central Italian List*, Berenson made no mention of Sassetta,
attributing the Chantilly *St Francis Marries Poverty* to Sano di Pietro. 125
The crucial years of rediscovery were the 1900s. Robert Langton
Douglas (one-time Anglican chaplain in Livorno, turned Catholic

and art dealer) was the first to publish on Sassetta in 1903; followed closely by Berenson, writing of his 'soaring spaces of silvery sky', of an art that 'lightens, uplifts, and dematerializes you'. The first substantial exhibition of Sienese art was held in the Palazzo Pubblico in 1904. At last the field began to be mapped – though well into the twentieth century, Andrea di Firenze's Spanish Chapel in Florence would still be ascribed to Simone, the Pisa *Triumph of Death* (by Buffalmacco) to Ambrogio. Scholarship remained centred on Florence, with Siena at best a charming sideshow. Within a framework that conflated a residual Vasarian notion of progress with the modern theory of the avant-garde, the fifteenth-century Sienese were bound to appear 'provincial conservatives'. Only with the young John Pope-Hennessy – whose pioneering monographs *Giovanni di Paolo* (1937) and *Sassetta* (1939) were published at his own expense – did they at last begin to be viewed not as uncomprehending backward children, but as having made their own informed choice against the values of the Florentine Renaissance.

After the Second World War, in the heyday of formalist criticism, the Sienese tended to be admired chiefly as colourists – prefiguring the clean flat purity of contemporary French and American painting. I would date the full critical rehabilitation of the Sienese to the 1980s; modernist orthodoxy needed to fade before 'expressive illustration' could be unashamedly enjoyed. The writings of the new generation of scholars conveyed some of the freshness of a newly excavated culture. As Henk Van Os, director of Amsterdam's Rijksmuseum, observed, 'It is a rather exciting experience to witness the end of the oldest tradition in art history: Vasari's Florentinocentrism'. New historical research by William Bowsky and others clarified the political and civic underpinnings of Sienese art; values that were, to a late twentieth-century audience, far more sympathetic than the nascent despotism of Medici Florence. Ambrogio Lorenzetti was no longer seen as 'proto-Renaissance', but an artist as definitive, and unsurpassed, as Dante.

Among painters as well, the passion for the Sienese had become a late twentieth-century phenomenon. Illustrated here 179 are three works from the same decade, by artists of the same 180 generation, yet of utterly contrasted background, each paying 181 homage to a Sienese source. When the Indian Bhupen Khakhar visited Europe for the first time in 1976, he spoke of how the Sienese 'faced certain problems which I face as a painter: how to include the narrative aspects in a painting without destroying its

179 **R. B. Kitaj** (b. 1932, American), *Land of Lakes*, 1975–77. Private collection.
The most overtly 'literary' painter of his generation, Kitaj embarked (with Ambrogio's frescoes of the *Well-Governed and Ill-Governed Cities* in mind) on a contrasted pair of altarpiece-sized pictures. His 'optimistic scenic view', with its red flag and cross in the foreground, embodies 'the "Historic Compromise" between Christians and the Left'. The 'Bad' companion piece to this picture is *If Not, Not*, (Scottish National Gallery of Modern Art, Edinburgh).

181 **Ken Kiff** (1935–2001, English), *The Pilgrimage*, 1978–79. Private collection.
Kiff emerged as a key artist in the 'refigured painting' of the 1980s. He had long felt attracted to the continuous narrative of Sienese quest-pictures. Later, as artist-in-residence at London's National Gallery in 1992–93, he made several explicit homages to Giovanni di Paolo's *St John the Baptist Goes into the Wilderness* (ill. 142).

180 **Bhupen Khakhar** (b. 1934, Indian), *Celebration of Guru Jayanti*, 1980. Private collection.
The leading painter of the 'Baroda school', Khakhar shared with several other Indian contemporaries a 'discovery' of the Sienese. The sense of community, and the penetration of the urban landscape, were linked to an instinctive understanding of Siena's 'humble style', which Khakhar characterized as 'diffident'. 'They are trying to evolve a language for the first time... A kind of meekness... If you see the work of Lorenzetti and Simone Martini, you realize their modesty in comparison with Michelangelo.'

structure'. As an art student, I had feared my own falling in love with Siena was mere nostalgia, only to recognize, much later, that it was part of a shared project. Like so many painters of the 1960s and 1970s, I was 'beginning again'. Those first solutions of the Sienese have come to seem ever more relevant; their ideas for spatial construction, for example, far nearer to present needs than Albertian perspective. And in this book I have tried to put forward Sienese painting as a great reservoir of pictorial language for the future.

Siena has aroused an almost comical devotion in its scholars. Pope-Hennessy recalled that 'Sienese pictures spoke to me in accents so seductive and so intimate... one had the illusion of responding to a message no one else could hear'. Bowsky attests to 'a twenty-year love affair; to 'the love for Siena that has seized me'. Christiansen declares that 'Sienese painting has given me more pleasure than any other', and Van Os confesses 'I lost my heart to Siena 25 years ago, and since then I have found nothing that gives me greater joy than researching Sienese art'. To conclude, then, with my own avowal: these are the pictures that have moved me most, jolting me into a wonder I have felt impelled to share: the good news, long lost, now found again.

Bibliography

Among the few texts in English to cover both trecento and quattrocento are the two volumes of *Sienese Altarpieces* by Henk Van Os (Groningen, 1984 and 1990). *Five Centuries of Sienese Painting*, ed. Giuletta Chelazzi Dini (London, 1998), has many magnificent plates. Eve Borsook's *The Mural Painters of Tuscany* (2nd edition, Oxford, 1980) provides a helpful overview. Both volumes of the Open University's *Siena, Florence and Padua: Art Society and Religion 1280–1400*, ed. Diana Norman (London, 1995), are packed with information and have useful bibliographies. For the general context, John White's *Art and Architecture in Italy 1250–1400* (The Pelican History of Art, 3rd edition, New Haven and London, 1993) remains the most eloquent account.

The Italian City-Republics by Daniel Waley (London, 1969) provides a compact political introduction. But by far the outstanding work of history is William Bowsky's *A Medieval Italian Commune: Siena Under the Nine 1287–1355* (Berkeley, 1981). His emphasis on the anti-aristocratic character of the Nine has been challenged: see, among others, Daniel Waley's *Siena and the Sienese in the Thirteenth Century* (Cambridge, 1991). For a popular account, written for the general reader, I recommend *Siena: A City and its History* by Judith Hook (London, 1979).

The pioneering work of John Pope-Hennessy and other pre-war scholars on the quattrocentro painters will be listed under the relevant chapters. But far and away the best modern book is the splendid exhibition catalogue of the Metropolitan Museum's *Painting in Renaissance Siena 1420–1500* by Keith Christiansen and Carl Strehlke (New York, 1988). Two more specialist catalogues are *Il Gotico a Siena* (Florence, 1982) and *Le Biccherne* (Rome, 1984).

Introduction

Two recent books by Hayden B. J. Maginnis, *Painting in the Age of Giotto:*

An Historical Re-evaluation (University Park, Pa., 1997) and *The World of the Early Sienese Painter* (University Park, Pa., 2001) are strongly recommended; parts are in the author's own words 'rather heavy going', but together they build a new sense of trecento Siena that has influenced my entire text. Bowsky (op. cit.) is the main source for my account of the Nine. Thomas de Wesselow's powerful arguments for Simone Martini as painter of *City by the Sea* were given at a National Gallery, London seminar in 2002. Vasari's *Lives*, dedicated to a Medici Grand Duke, are weak on the Sienese; nevertheless they remain essential reading.

Chapter 1 Duccio

The best picture book is *Duccio: La Maestà* by Luciano Bellosi (Milan, 1998). For the complete works, *Duccio di Buoninsegna* in the Classici d'Arte series (Milan, 1972) is useful. But the role of Duccio and his assistants remains fiercely contested. John White's *Duccio: Tuscan Art and the Medieval Workshop* (London, 1979) is one possible starting point. James Stubblebine in *Duccio di Buoninsegna and his School* (Princeton, 1979) is particularly tendentious. My account of the *Rucellai Madonna* owes much to Maginnis (op. cit.).

For earlier Sienese painting, Van Os (op. cit.) is helpful. Stubblebine's *Guido da Siena* (Princeton, 1964) remains a standard work. Among several writings by Hans Belting that touch on the relation of Sienese to Byzantine, *Likeness and Presence* (Chicago, 1994) is recommended. For Nicola and Giovanni Pisano see John White's *Art and Architecture in Italy* (op. cit.) and John Pope-Hennessy's *Italian Gothic Sculpture* (3rd edition, London, 1986.) Cennino Cennini's late trecento *The Craftsman's Handbook* is easily available in Dover Books (New York, n.d.).

Chapter 2 Simone Martini

The standard monograph remains Andrew Martindale's *Simone Martini* (Oxford, 1988). *Simone Martini: Catalogo Completo delle Dispinti* by P. de Castris (Florence, 1989) is useful. Enzo Carli's

Simone Martini: La Maestà is a handsome picture book; while beautiful details, especially of the *Blessed Agostino* miracles, are in *Simone Martini: Atti del Convegno*, ed. L. Bellosi (Florence, 1988). Elvio Lughi's guide book *The Basilica of St Francis at Assisi* (London, 1996) is recommended. *The Light of Early Italian Painting* by Paul Hills (New Haven and London, 1987) has influenced my writing on Simone and especially on Assisi.

For the Guidoriccio controversy, my chief source has been Thomas de Wesselow's work on the wall of the Mappamondo, first published in *Art, Politics and Civic Religion in Central Italy 1261–1352*, ed. Joanna Cannon and Beth Williamson (Aldershot and Brookfield, 2000). His further conclusions await publication. For the importance of the vernacular on the early trecento see Gabriel Josipovici's fine essay 'Dante: Trusting the Mother-Tongue', included within *On Trust* (New Haven and London, 1999).

Chapter 3 Pietro Lorenzetti

The standard monograph is Carlo Volpe's *Pietro Lorenzetti* (Milan, 1989). But the most useful text in English is Chiara Frugoni's *Pietro and Ambrogio Lorenzetti* (Florence, 1988). Volpe's *Pietro Lorenzetti ad Assisi* (Milan and Geneva, 1965) has excellent large colour plates. For Franciscanism and the 'Humble Style' see Erich Auerbach's classic *Mimesis* (New York, 1953); as well as his *Literary Language and its Public in Late Antiquity and the Middle Ages* (Princeton, 1965). In *Margherita of Cortona and the Lorenzetti* (University Park, Pa., 1998) Joanna Cannon and André Vauchez reconstruct the lost fresco cycles of Santa Margherita.

Chapter 4 Ambrogio Lorenzetti

As a brief general account in English, Chiara Frugoni's *Pietro and Ambrogio Lorenzetti* (op. cit.) is again recommended; the same author's *A Distant City: Images of Urban Experience in the Modern World* (Princeton, 1991) is also illuminating. For detailed colour plates, *Ambrogio Lorenzetti: Il Buon*

Governo, ed. E Castelnuovo (Milan, 1995) is unsurpassable; it includes a fine essay by Maria Monica Donato. Eve Borsook's Ambrogio Lorenzetti (Florence, 1966) is an excellent brief monograph in Italian. Ambrogio Lorenzetti: La Sala della Pace (Milan and Geneva, 1969) has long folding plates. Nicolai Rubinstein's essay on 'Political Ideas in Sienese Art' was published in the Warburg Journal in 1958; Quentin Skinner's Ambrogio Lorenzetti: The Artist as Political Philosopher first appears in the proceedings of the British Academy, 1986. See also R. Starn and L. Partridge in Arts of Power (Berkeley and Oxford, 1992). The male gender of the dancers was established by Jane Bridgeman in Apollo no. 133 (London, 1991). I owe the Chinese suggestion mainly to the painter Gabriel Laderman; it was touched on by George Rowley (a scholar also of Chinese art) in his Ambrogio Lorenzetti (Princeton, 1958). Frances Yates in her Astraea (London, 1975) offers some fascinating insights. John White writes interestingly on Ambrogio in The Birth and Rebirth of Pictoral Space (3rd edition, London, 1972); see also James Elkins's The Poetics of Perspective (Ithaca, 1996). For my reconstruction of Ambrogio's lost World Map, and for this chapter as a whole, I owe much to Thomas de Wesselow (op. cit.).

Chapter 5 After the Black Death

Although many of Millard Meiss's conclusions have been set in question, his Painting in Florence and Siena after the Black Death (Princeton, 1951) remains essential reading. My account of Giovanni Colombini is based partly on Meiss, augmented by Van Os (op. cit.). In Siena and the Virgin: Art and Politics in a Late Medieval City State (New Haven and London, 1999), Diana Norman argues for a reconsideration of artists such as Bartolo di Fredi; it includes fine plates. The story of the Lysippus statue is based on Ghiberti's Third Commentary, in Holt's A Documentary History of Art, volume I (New York, 1957). William Caferro's Mercenary Companies and the Decline of Siena (Baltimore and London, 1998) details some 37 raids between 1342 and 1399. For Jacopo della Quercia see James Beck's two-volume

study (New York, 1991). Carl Strehlke writes well on the influence of San Bernardino in Painting in Renaissance Siena (op. cit.).

Chapter 6 Sassetta

The best modern writing on Sassetta is by Keith Christiansen, in Painting in Renaissance Siena (op. cit.). But the only full-length monograph in English remains John Pope-Hennessy's Sassetta (London, 1939); many of his attributions are now doubtful. Enzo Carli's Sassetta e il Maestro dell'Osservanza (Milan, 1957) also came out in French; it has many fine black-and-white details. Large colour reproductions are in the 'Maestri di Colori', Sassetta (A. Monferini, Milan, 1965); later reissued in the English series 'The Masters', with a text by St John Gore. Berenson's A Sienese Painter of the Franciscan Legend first appeared in the Burlington Magazine in 1903, and was republished as a monograph (London, 1909). Roberto Longhi's essay 'Masaccio and Masolino' has been translated in Three Studies (Riverdale on Hudson, 1996). I recommend William Hood's Fra Angelico at San Marco (New Haven and London, 1993). Dillian Gordon's reconstruction of the St Francis altarpiece came out in The Burlington Magazine CXXXV, 1993; and Machtelt Israels's article on the Arte della Lana altarpiece was in the same magazine, CXLIII, 2001. James Banker's documentation of the Borgo San Sepolcro contract was published in I Tatti Studies, 1991. St Bonaventura's Life of St Francis and the Fioretti (Little Flowers of St Francis) were both published in ' The Temple Classics' (London, 1899 and 1904). My chapter owes much to discussions with the painter Trevor Winkfield.

As this book goes to press, two further important discussions of Sassetta have appeared: Machtelt Israels's monograph on Sassetta's Madonna della Neve (Leyden, 2003) and Dillian Gordon's catalogue of The Fifteenth Century Italian Paintings, vol. I (National Gallery, London, 2003), where the seven St Francis panels occupy several pages. Both works incorporate many fine colour plates and details.

Chapter 7 Giovanni di Paolo

I recommend Carl Strehlke's 80-page catalogue section on Giovanni di Paolo, incorporated within Painting in Renaissance Siena (op. cit.). But the only full-length monograph is, once again, by John Pope-Hennessy (London, 1937) who returned to the subject in 1988 in the Metropolitan Museum's Bulletin, printed as a separate small monograph, Giovanni di Paolo (New York, 1988). Pope-Hennessy also wrote twice about the Dante illuminations in A Sienese Codex of the Divine Comedy (London, 1947) and in Paradiso (London, 1990). For The Lost Sketchbooks of Giovanni di Paolo, a detailed study by Andrew Ladis, which also includes his comments on the Pienza altarpiece, see The Craft of Art, ed. A. Ladis and C. Wood (Athens, Ga., 1995). I recommend Keith Christiansen's monograph on Gentile da Fabriano (London, 1982). Maurice Denis's essay 'Art and Sunlight' appears in a Wildenstein catalogue, Maurice Denis (London, 1964). Charles Lock discusses The Flight into Egypt in A Returning of Shadows (Literary Research, Spring 1998); he incorporates Victor Stoichita's remarks in A Short History of the Shadow.

Chapter 8 From the Master of the Osservanza to Francesco di Giorgio

The works now attributed to the Master of the Osservanza are often discussed or illustrated under Sassetta, as in the monographs by Pope-Hennessy and Enzo Carli (op. cit.). Keith Christiansen discusses the St Anthony series and other panels in Painting in Renaissance Siena (op. cit.) with fine colour plates; Pietro di Giovanni d'Ambrogio and Sano di Pietro also have separate sections. For excellent reproductions of the Pellegrinaio cycle in the Siena Hospital see Italian Frescoes: The Early Renaissance by Steffi Roettgen (New York, 1996). The Commentaries of Pius II are abridged and translated as Memoirs of a Renaissance Pope (London, 1960). Paolo Galluzzi discusses and illustrates the work of 'The Sienese Engineers' in The Art of Invention (Florence and London, 1999). A recent account of

the culture of Federico of Urbino appears in *The Gubbio Studiolo and its Conservation*, ed. Olga Raggio (New York, 1999). Among several books on Franceso di Giorgio as sculptor and painter the monograph by F. Toledano (Milan, 1987) provides one starting point. A useful summary is the 'Art Dossier' by Pietro Torriti, *Francesco di Giorgio Martini* (Florence, 1993). See also Adrian Stokes in *The Quattrocento* (London, 1932 and New York, 1968). Among numerous editions of Burckhardt's *The Civilisation of the*

Renaissance in Italy, see London, 1958. For Signorelli, see *Luca Signorelli: The Complete Paintings* by Kanter and Henry (London, 2002). Ruskin's *Praeterita* was included in the 'Library Edition' (London, 1903–12) but has been reissued separately several times.

Epilogue

The early chapters of Maginnis's *Painting in the Age of Giotto* (op. cit.) summarize the historiography of Sienese painting. Berenson never revised his essay on the central Italian school, which continued to be republished several times. The autobiography of John Pope-Hennessy, *Learning to Look* (London, 1993), has some revealing glimpses of Sienese art scholarship. As examples of late twentieth-century painters engaging with the Sienese, see: *R. B. Kitaj: A Retrospective*, ed. R. Morphet (London and New York 1994); *Bhupen Khakhar* by T. Hyman (Bombay, 1998); and *Ken Kiff* by A. Lambirth (London, 2002).

Acknowledgments

A painter who ventures into a territory so full of pitfalls as Sienese painting needs all the help he can get. Many art historians and scholars have contributed to this book. Professor Paul Hills read the trecento chapters in draft, as did Professor Gabriel Josipovici; in both cases, our Sienese dialogue goes back many years, and I am grateful for their friendly comments. At a later stage, Dr Thomas de Wesselow generously read the entire text, and I have incorporated much of his advice; he has constantly challenged any received ideas with his own fresh insights, and my eventual understanding of Simone and Ambrogio particularly was transformed by our contact. Over several years, I have benefited from stray conversations with individual scholars, among them Professor Joanna Cannon, Professor Keith Christiansen, Professor Marvin Trachtenberg, Professor Nicolai Rubinstein and Professor John White. To all these, as well as to the authors cited in my bibliography, I am grateful.

A grant from the H. H. Wingate Foundation in 1998 enabled me to travel and to see or revisit many of the pictures discussed here; earlier, in 1993, a Leverhulme award helped to fund a more extended stay in Siena. An Honorary Research Fellowship from University College, London gave me the resources of a fine library, and I was able to browse also at the Warburg Institute. Invitations to lecture on the Sienese at many British universities and art schools, including The Slade and The Royal College, have clarified my thoughts over a twenty-year period. Public lectures at the Institute of Fine Arts, New York in 1998 and at the National Gallery, London in 2001 were particularly useful in eliciting responses from both scholars and fellow artists. Parts of my text incorporate ideas first formulated in two review-articles published in the *Times Literary Supplement*.

My own responses to the Sienese have often been nurtured by those of fellow painters. I want especially to single out G. M. Sheikh and Trevor Winkfield, both revelatory companions in Siena. Among many artists who have given me both insights and practical help, I want to thank Margherita Abozzo, David Carbone, Ronald Cohen, Elizabeth Collins, Dexter Dalwood, Peter de Francia, Josef Herman, Howard Hodgkin, Merlin James, Derek Jarman, Bhupen Khakhar, Ken Kiff, R. B. Kitaj, Gabriel Laderman, Richard Lannoy, Simon Lewty, Andrea MacLean, Jiro Osuga, Gieve Patel, Sudhir Patwardhan and Nilima Sheikh. Many others have helped in the most various ways, and I am particularly grateful to Professor Jaynie Anderson, Janet Atkinson, Gillian Barlow, Dr Xavier Baron, Dr Kaushik Bhaumik, Professor Hans Belting, Professor David Bindman, Jonathan Blond, Gerard Casey, Dinah Casson, Ray Clark, Professor Caroline Elam, Roger Farrington, Professor Tamar Garb, Dr Dillian Gordon, Michael Hewlings, Dr Philippa Jackson, David Fraser Jenkins, Dr Desirée Koslam, John Lane, Professor Charles Lock, Professor Lorenzo Polizotto, Oliver Probyn, Louis Spitalnick, John Toft, Rosamond Williams and Nicholas Wood. The comradeship of Judith Ravenscroft has been a constant support; she also assisted on the later drafts, especially on Chapter 7, as well as completing the arduous task of indexing the final text. My friend Louise de Brüin, working from a remote Dorset Village, has been midwife-in-chief throughout this book's five-year gestation: typing from manuscript each successive version, and seizing with unflagging acuity upon each lapse or laziness. I owe her an enormous debt. Finally, I want to thank all at Thames & Hudson.

Illustration List

Dimensions are given in centimetres followed by inches, height before width.

1 Duccio, *The Temptation of Christ*, 1308–11 (detail). Tempera on wood panel, 43.2 x 46 (17 x 18 ⅛). The Frick Collection, New York

2 Duccio, *The Temptation of Christ*, 1308–11. Tempera on wood panel, 43.2 x 46 (17 x 18 ⅛). The Frick Collection, New York

3 Attributed to Sassetta, c. 1425 (also attributed to Ambrogio Lorenzetti, c. 1340, and to Simone Martini, c. 1310), *City by the Sea*. Tempera on wood panel, 22 x 32 (8 ⅝ x 12 ⅝). Pinacoteca Nazionale, Siena. Photo Fabio Lensini, Siena

4 Seventeenth-century watercolour, after Ambrogio Lorenzetti's lost fresco cycle of c. 1335, *The Resuscitation and Healing of Suppolino*. Biblioteca Communale, Cortona (watercolour no. X, cod. 429)

5 Aerial view of Siena. Ed. M. Romboni, Siena

6 View of the Campo, Siena. Photo Fabio Lensini, Siena

7 The Palazzo Tolomei, Siena. Photo Fabio Lensini, Siena

8 Attributed to Guido da Siena, *Reliquary Shutters of Blessed Andrea Gallerani* (outer shutters), c. 1275. Pinacoteca Nazionale, Siena. Photo Fabio Lensini, Siena

9 Attributed to Guido da Siena, *Reliquary Shutters of Blessed Andrea Gallerani* (detail of inner panel), c. 1275. Pinacoteca Nazionale, Siena. Photo Fabio Lensini, Siena

10 Attributed to Guido da Siena, *The Annunciation*, c. 1260s. Tempera on wood panel, 35.1 x 48.8 (13 ⅞ x 19 ¼). The Art Museum, Princeton University Museum, Caroline G. Mather Fund

11 Guido da Siena, *Maestà*, c. 1275. 362 x 194 (142 ½ x 76 ⅜). San Domenico, Siena

12 Duccio, *Rucellai Madonna*, 1285. Tempera on wood panel, 450 x 290 (177 ⅛ x 114 ⅛). Galleria degli Uffizi, Florence. Photo Scala

13 Duccio, *Rucellai Madonna*, 1285 (detail). Tempera on wood panel, 450 x 290 (177 ⅛ x 114 ⅛). Galleria degli Uffizi, Florence. Photo Scala

14 Nicola Pisano, *The Nativity*, c. 1265–68. Marble panel. Siena Cathedral

15 Duccio, *Madonna of the Franciscans*, c. 1300. Tempera on wood, 30 x 22 (11 ¾ x 8 ½). Pinacoteca Nazionale, Siena

16 Duccio, *The Virgin and Christ Child Enthroned in Majesty with Angels and Saints*, central panel of the *Maestà*, 1308–11. Tempera and gold on wood panel, 214 x 412 (82 ¼ x 162 ¼). Museo dell'Opera del Duomo, Siena. Photo Scala

17 Duccio, The Christ Child, detail from the *Maestà*, 1308–11. Tempera and gold on wood panel, 214 x 412 (82 ¼ x 162 ¼). Museo dell'Opera del Duomo, Siena. Photo Scala

18 Duccio, *Maestà*, reconstruction of the reverse, by John White. Reproduced by kind permission of John White

19 Duccio, *Scenes from the Passion of Christ*, reverse of the *Maestà*, 1308–11. Tempera on wood panel, 211 x 411 (83 ⅛ x 161 ⅞). Museo dell'Opera del Duomo, Siena

20 Duccio, *Christ's Appearance on the Road to Emmaus*, detail from the reverse of the *Maestà*, 1308–11. Tempera on wood panel. Museo dell'Opera del Duomo, Siena

21 Duccio, *The Entry into Jerusalem*, detail from the reverse of the *Maestà*, 1308–11. Tempera on wood panel, 102 x 53.5 (40 ⅛ x 21 ⅛). Museo dell'Opera del Duomo, Siena

22 Duccio, *Christ before Annas* (above)

and *Peter's First Denial* (below), detail from the reverse of the *Maestà*, 1308–11. Tempera on wood panel, 99 x 53.5 (39 x 21). Museo dell'Opera del Duomo, Siena

23 Duccio, *Christ and the Woman of Samaria*, Predella panel from the *Maestà*, 1308–11. Tempera on wood panel, 43.5 x 46 (17 ⅛ x 18 ⅛). Thyssen-Bornemisza Collection, Madrid

24 Duccio, *The Healing of the Man Born Blind*, Predella panel from the *Maestà*, 1308–11. Tempera on wood panel, 43.5 x 45 (17 ⅛ x 17 ¾). National Gallery, London

25 Giotto, *Ognissanti Madonna*, c. 1305. Tempera on wood, 325 x 204 (128 x 80 ⅜). Galleria degli Uffizi, Florence

26 Ugolino di Nerio, *The Entombment*, 1325. 34.5 x 53 (13 ⅝ x 20 ⅞). Gemäldegalerie, Berlin

27 Simone Martini, *The Entombment*, c. 1312 or c. 1337. Tempera on wood, 22 x 15 (8 ⅝ x 5 ⅞). Gemäldegalerie, Berlin

28 Simone Martini, *The Carrying of the Cross*, c. 1312 or c. 1337. Tempera on wood, 25 x 16 (9 ⅞ x 6 ¼). Louvre, Paris

29 Simone Martini, *Maestà*, 1315, reworked c. 1320. Fresco, 763 x 970 (300 ⅜ x 381 ⅞). Palazzo Pubblico, Siena. Photo Scala

30 Simone Martini, *Maestà*, 1315, reworked c. 1320 (detail). Fresco, 763 x 970 (300 ⅜ x 381 ⅞). Palazzo Pubblico, Siena. Photo Scala

31 Simone Martini, *Maestà*, 1315, reworked c. 1320 (detail). Fresco, 763 x 970 (300 ⅜ x 381 ⅞). Palazzo Pubblico, Siena. Photo Scala

32 Simone Martini, *Altarpiece of St Louis of Toulouse*, c. 1317. Tempera on wood, 200 x 138 (78 ¾ x 54 ⅜) without predella. Museo di Capodimonte, Naples

33 Simone Martini, *Altarpiece of St Louis of Toulouse*, c. 1317 (detail). Tempera on wood, 200 x 138 (78 ¾ x 54 ⅜)

without predella. Museo di Capodimonte, Naples

34 Simone Martini, *Cardinal Gentile da Montefiore Kneeling Before St Martin,* c. 1317–20. Fresco, 330 x 700 (129 ⁷/₈ x 275 ⁵/₈). Montefiore Chapel, Lower Church of San Francesco, Assisi

35 Simone Martini, *St Martin Shares his Cloak with a Beggar,* c. 1317–20. Sinopia underdrawing (above); fresco (below). Montefiore Chapel, Lower Church of San Francesco, Assisi

36 Simone Martini, *Christ Appears in a Dream to St Martin,* c. 1317–20. Fresco, 264 x 201 (103 ⁷/₈ x 79 ¹/₈). Montefiore Chapel, Lower Church of San Francesco, Assisi

37 Simone Martini, East wall of the Montefiore Chapel, Lower Church of San Francesco, Assisi. Photo Scala

38 Simone Martini, *The Investiture of St Martin,* c. 1317–20 (detail). Fresco. Montefiore Chapel, Lower Church of San Francesco, Assisi

39 Simone Martini, *The Investiture of St Martin,* c. 1317–20 (detail). Fresco. Montefiore Chapel, Lower Church of San Francesco, Assisi

40 Simone Martini, *Altarpiece of Blessed Agostino Novello,* c. 1328. Tempera on wood, 198 x 257 (78 x 101 ¹/₈). Pinacoteca Nazionale, Siena. Photo Scala

41 Simone Martini, *Agostino Saves a Falling Child,* detail from the *Altarpiece of Blessed Agostino Novello,* c. 1328. Tempera on wood. Pinacoteca Nazionale, Siena. Photo Scala

42 Simone Martini, *Agostino Heals a Child,* detail from the *Altarpiece of Blessed Agostino Novello,* c. 1328. Tempera on wood. Pinacoteca Nazionale, Siena. Photo Scala

43 Simone Martini and Lippo Memmi, *The Annunciation* (central panel), 1333. Tempera on wood, 184 x 210 (72 ¹/₂ x 82 ⁵/₈). Galleria degli Uffizi, Florence

44 Simone Martini and Lippo Memmi,

The Annunciation, 1333 (detail of central panel). Tempera on wood, 184 x 210 (72 ¹/₂ x 82 ⁵/₈). Galleria degli Uffizi, Florence

45 North wall of the Great Council Hall (Sala del Mappamondo), Palazzo Pubblico, Siena. Photo Fabio Lensini, Siena

46 Unknown Sienese painter, *Fortress Town with Figures,* c. 1331. Palazzo Pubblico, Siena. Photo Fabio Lensini, Siena

47 Unknown Sienese painter, *The Crucifixion,* c. 1335. Fresco, h. 995 (32' 7"). Collegiata, San Gimignano

48 Unknown Sienese painter, *The Mystic Marriage of St Catherine of Alexandria,* c. 1340. Tempera on panel, 138.9 x 111 (54 ⁵/₈ x 43 ³/₄). Museum of Fine Arts, Boston

49 Simone Martini, *The Holy Family,* 1338. Oil on panel, 49.6 x 35.1 (19 ¹/₂ x 13 ³/₄). Walker Art Gallery, Liverpool

50 Simone Martini, frontispiece to Petrarch's copy of Virgil with a commentary by Servius, 1342. Tempera on vellum, 29.5 x 20 (11 ⁵/₈ x 7 ⁷/₈). Biblioteca Ambrosiana, Milan

51 The Limbourg Brothers, *August,* from *Les Très Riches Heures du Duc de Berry,* 1413–16. 21.5 x 14.5 (8 ¹/₂ x 5 ³/₄). Musée Condé, Chantilly

52 Pietro Lorenzetti, *Arezzo Polyptych,* 1320. 298 x 309 (117 ³/₈ x 121 ⁵/₈). Santa Maria della Pieve, Arezzo. Photo Scala

53 Pietro Lorenzetti, *Arezzo Polyptych,* 1320 (detail). 298 x 309 (117 ³/₈ x 121 ⁵/₈). Santa Maria della Pieve, Arezzo. Photo Scala

54 Pietro Lorenzetti, scenes from *The Passion of Christ,* c. 1315–25. South transept of the Lower Church of San Francesco, Assisi. Photo Scala

55 Pietro Lorenzetti, *The Last Supper,* c. 1315. Fresco. Lower Church of San Francesco, Assisi. Photo Scala

56 Pietro Lorenzetti, *The Last Supper,* c. 1315 (detail). Fresco. Lower Church of San Francesco, Assisi. Photo Scala

57 Pietro Lorenzetti, *The Crucifixion,* c. 1320. Fresco. Lower Church of San Francesco, Assisi

58 Pietro Lorenzetti, *The Crucifixion,* c. 1320 (detail). Fresco. Lower Church of San Francesco, Assisi

59 Pietro Lorenzetti, *The Deposition,* after 1320. Fresco, 377 x 232 (148 ³/₈ x 91 ³/₈). Lower Church of San Francesco, Assisi. Photo Scala

60 Pietro Lorenzetti, *The Deposition,* after 1320 (detail). Fresco. Lower Church of San Francesco, Assisi.

61 Pietro Lorenzetti, *The Entombment,* after 1320 (detail). Fresco. Lower Church of San Francesco, Assisi.

62 Pietro Lorenzetti, *The Madonna and Child between St Francis and St John,* c. 1325. Fresco. Lower Church of San Francesco, Assisi

63 Pietro Lorenzetti, *Madonna del Carmine,* 1327–29 (reconstruction by Carlo Volpe). Tempera on wood. Pinacoteca Nazionale, Siena

64 Tino da Camaino, *The Madonna and Child,* 1321. Marble, height 78 (30 ³/₄). Museo Nazionale del Bargello, Florence

65 Pietro Lorenzetti, *Madonna del Carmine,* central panel, 1327–29. Tempera on wood, 169 x 148 (66 ¹/₂ x 58 ¹/₄). Pinacoteca Nazionale, Siena

66 Attributed to Pietro Lorenzetti, *Dante's Path Blocked by the She-Wolf; He Encounters Virgil,* c. 1340. Miniature from the first canto of *Dante's Divine Comedy: Inferno.* Biblioteca Comunale Augusta, Perugia (MS.L. 70, fol.2)

67 Attributed to Pietro Lorenzetti, *Altarpiece of Blessed Umiltà,* c. 1335. Tempera on wood, 128 x 185 (50 ³/₈ x 72 ⁷/₈). Galleria degli Uffizi, Florence

68 Attributed to Pietro Lorenzetti, *Umiltà Leaves the Convent,* detail from the *Altarpiece of Blessed Umiltà,* c. 1335. Tempera on wood. Galleria degli Uffizi, Florence

69 Attributed to Pietro Lorenzetti,

Umiltà Arriving in Florence with Her Companions, detail from the Altarpiece of *Blessed Umiltà*, c. 1335. Tempera on wood. Galleria degli Uffizi, Florence

70 Ambrogio Lorenzetti, *The Purification of the Virgin*, 1342. Tempera on wood panel, 275 × 168 (108 1/$_4$ × 66 1/$_8$). Galleria degli Uffizi, Florence

71 Pietro Lorenzetti, *The Birth of the Virgin*, 1342. 188 × 183 (74 × 72). Museo dell'Opera del Duomo, Siena

72 Ambrogio Lorenzetti, *A Group of Poor Clares*, c. 1329. Fresco, 58.5 × 52 (23 × 20 1/$_2$). National Gallery, London

73 Ambrogio Lorenzetti, *The Investiture of St Louis of Toulouse*, c. 1329. Fresco, w. 410 (13' 6"). San Francesco, Siena. Photo Scala

74 Ambrogio Lorenzetti, *Two Miracles of Nicholas of Bari*, 1332. Tempera on wood, 96 × 52.5 (37 3/$_4$ × 20 5/$_8$). Galleria degli Uffizi, Florence. Photo Scala

75 Ambrogio Lorenzetti, *The Annunciation*, 1334. Sinopia underdrawing, 240 × 344 (94 × 134). Oratory of San Galgano, Montesiepi

76 Ambrogio Lorenzetti and assistants, *Maestà*, 1335. Tempera on wood, 155 × 206 (61 × 81 1/$_8$). Palazzo del Podestà, Museo Civico, Massa Marittima

77 Ambrogio Lorenzetti and assistants, *Maestà*, 1335 (detail). Tempera on wood, 155 × 206 (61 × 81 1/$_8$). Palazzo del Podestà, Museo Civico, Massa Marittima

78 The Sala della Pace, Palazzo Pubblico, Siena

79 Ambrogio Lorenzetti, *Good Government*, 1337–40. Fresco. Sala della Pace, Palazzo Pubblico, Siena. Photo Scala

80 Ambrogio Lorenzetti, *Good Government*, 1337–40 (detail). Fresco. Sala della Pace, Palazzo Pubblico, Siena

81 Ambrogio Lorenzetti, *Good Government*, 1337–40 (detail). Fresco. Sala della Pace, Palazzo Pubblico, Siena

82 Ambrogio Lorenzetti, *The Well-Governed City*, 1337–40. Fresco, c. 770 × 1400 (25' 3" × 46'). Sala della Pace, Palazzo Pubblico, Siena. Photo Scala

83 Ambrogio Lorenzetti, *The Well-Governed City*, 1337–40 (detail). Fresco. Sala della Pace, Palazzo Pubblico, Siena. Photo Grassi, Siena

84 Ambrogio Lorenzetti, *The Well-Governed City*, 1337–40 (detail). Fresco. Sala della Pace, Palazzo Pubblico, Siena. Photo Scala

85 Ambrogio Lorenzetti, *The Well-Governed City*, 1337–40 (detail). Fresco. Sala della Pace, Palazzo Pubblico, Siena. Photo Scala

86 Ambrogio Lorenzetti, *The Well-Governed City*, 1337–40 (detail). Fresco. Sala della Pace, Palazzo Pubblico, Siena

87 Ambrogio Lorenzetti, *The Well-Governed City*, 1337–40 (detail). Fresco. Sala della Pace, Palazzo Pubblico, Siena

88 Ambrogio Lorenzetti, *The Well-Governed City*, 1337–40 (detail). Fresco. Sala della Pace, Palazzo Pubblico, Siena

89 Ambrogio Lorenzetti, *The Well-Governed City*, 1337–40 (detail). Fresco. Sala della Pace, Palazzo Pubblico, Siena

90 Ambrogio Lorenzetti, *The Ill-Governed City*, 1337–40 (detail from the framework). Fresco. Sala della Pace, Palazzo Pubblico, Siena

91 Ambrogio Lorenzetti, *The Ill-Governed City*, 1337-40 (detail). Fresco. Sala della Pace, Palazzo Pubblico, Siena

92 Ambrogio Lorenzetti, *The Ill-Governed City*, 1337–40 (detail). Fresco. Sala della Pace, Palazzo Pubblico, Siena

93 Ambrogio Lorenzetti, *The Ill-Governed City*, 1337–40 (detail). Fresco. Sala della Pace, Palazzo Pubblico, Siena

94 Giovanni di Paolo, *The Creation of the World and the Expulsion from Paradise*, 1445 (detail). Tempera on wood panel, 46.5 × 52 (18 1/$_4$ × 20 1/$_2$). The Metropolitan Museum of Art, New York, Robert Lehman Collection

95 Ambrogio Lorenzetti, *An Allegory of Sin and Redemption*, c. 1342. Tempera on wood panel, 49 × 110 (19 1/$_4$ × 43 1/$_4$). Pinacoteca Nazionale, Siena. Photo Fabio Lensini

96 Bartolo di Fredi, *The Creation*, 1367. Fresco. Collegiata, San Gimignano. Photo Fabio Lensini

97 Andrea di Bartolo, *Madonna and Child*, c. 1415. Tempera on panel, 28.6 × 17.8 (11 1/$_4$ × 7). National Gallery of Art, Washington, Samuel H. Kress Collection

98 Bartolo di Fredi, *The Adoration of the Magi*, c. 1395. Tempera on wood, 195 × 158 (76 3/$_4$ × 62 1/$_4$). Pinacoteca Nazionale, Siena

99 Taddeo di Bartolo, *The Assumption of the Virgin*, c. 1398–1401. 525 × 420 (206 3/$_4$ × 165 3/$_8$). Cathedral of Montepulciano

100 Taddeo di Bartolo, *The Assumption of the Virgin*, c. 1398–1401 (detail). Cathedral of Montepulciano

101 Taddeo di Bartolo, *The Last Days of the Virgin*, 1407 (detail). Palazzo Pubblico, Siena

102 Taddeo di Bartolo, *The Assumption of the Virgin*, c. 1398–1401 (detail). Cathedral of Montepulciano

103 Jacopo della Quercia, *Fonte Gaia*, 1408–19. Marble. Formerly in the Campo, Siena

104 Jacopo della Quercia with Ghiberti, Donatello and others, Baptismal Font, 1416–30. Marble and bronze. Baptistery, Siena Cathedral

105 Sano di Pietro, *Gesuati Polyptych*, 1444. Pinacoteca Nazionale, Siena. Photo Fabio Lensini, Siena

106 Sano di Pietro, *San Bernardino Preaching in the Campo in 1427*, 1445. Tempera on panel, 162 × 101.5 (63 3/$_4$ × 40). Museo dell'Opera del Duomo, Siena

107 Attributed to Sassetta, c. 1425 (also attributed to Ambrogio

Lorenzetti, c. 1340, and to Simone Martini, c. 1310), *Castle by a Lake*. Tempera on wood panel, 23 × 33 (9 × 13). Pinacoteca Nazionale, Siena. Photo Fabio Lensini, Siena

108 Sassetta, *A Miracle of the Sacrament*, 1423–25. Tempera and gold on wood, 24.1 × 38.2 (9 ½ × 15). The Bowes Museum, Barnard Castle, County Durham

109 Sassetta, *St Thomas Aquinas in Prayer*, 1423–25. Tempera and gold on wood, 24 × 30 (9 ½ × 11 ¾). Museum of Fine Arts, Budapest

110 Gentile da Fabriano, *The Adoration of the Magi*, 1425. Tempera on wood, 300 × 282 (118 ⅛ × 111). Galleria degli Uffizi, Florence

111 Sassetta, *St Anthony Beaten by Devils*, 1423–25. Tempera and gold on wood, 24 × 39 (9 ½ × 15 ⅜). Pinacoteca Nazionale, Siena

112 Sassetta, *Madonna of the Snow*, 1430–32. Contini-Bonacossi Collection, Galleria degli Uffizi, Florence. Photo Fabio Lensini, Siena

113 Sassetta, *Madonna of the Snow*, 1430–32 (detail). Contini-Bonacossi Collection, Galleria degli Uffizi, Florence. Photo Fabio Lensini, Siena

114 Sassetta, reconstruction of *The Adoration of the Magi*, c. 1435. Tempera on wood. Metropolitan Museum of Art, New York (top panel); Chigi-Saracini Collection, Siena (bottom panel)

115 Sassetta, The Journey of the Magi, fragment from *The Adoration of the Magi*, c. 1435. Tempera on wood, 21.6 × 29.9 (8 ½ × 11 ⅝). Metropolitan Museum of Art, New York

116 Reconstruction of the reverse of Sassetta's *Altarpiece of St Francis* by Dillian Gordon. Reproduced by kind permission of Dillian Gordon

117 Sassetta, *St Francis Renounces his Father's Earthly Goods* (detail), from the *Altarpiece of St Francis*, 1439–44. Tempera on poplar, 87 × 52.5 (34 ¼ × 20 ⅝). National Gallery, London

118 Sassetta, *St Francis Asks the Pope to Recognize his Rule of Poverty* (detail), from the *Altarpiece of St Francis*, 1439–44. Tempera on poplar, 87 × 52.5 (34 ¼ × 20 ⅝). National Gallery, London

119 Sassetta, *St Francis Gives his Cloak to a Poor Knight; and Dreams of a Celestial Palace*, from the *Altarpiece of St Francis*, 1439–44. Tempera on poplar, 87 × 52.5 (34 ¼ × 20 ⅝). National Gallery, London

120 Sassetta, *St Francis in Ecstasy*, from the *Altarpiece of St Francis*, 1439–44 (detail). Tempera on poplar, 205 × 122 (80 ¾ × 48). Villa i Tatti, Settignano

121 Sassetta, *St Francis Asks the Pope to Recognize his Rule of Poverty*, from the *Altarpiece of St Francis*, 1439–44. Tempera on poplar, 87 × 52.5 (34 ¼ × 20 ⅝). National Gallery, London

122 Sassetta, *St Francis Proves his Faith to the Sultan*, from the *Altarpiece of St Francis*, 1439–44. Tempera on poplar, 86.5 × 53.5 (34 × 21 ⅛). National Gallery, London

123 Sassetta, *St Francis in Ecstasy*, from the *Altarpiece of St Francis*, 1439–44. Tempera on poplar, 205 × 122 (80 ¾ × 48). Villa i Tatti, Settignano

124 Sassetta, *St Francis Renounces his Father's Earthly Goods*, from the *Altarpiece of St Francis*, 1439–44. Tempera on poplar, 87 × 52.5 (34 ¼ × 20 ⅝). National Gallery, London

125 Sassetta, *St Francis Marries Poverty*, from the *Altarpiece of St Francis*, 1439–44. Tempera on poplar, 95 × 58 (37 ⅜ × 22 ⅞). Musée Condé, Chantilly

126 Sassetta, *St Francis Marries Poverty*, from the *Altarpiece of St Francis*, 1439–44 (detail). Tempera on poplar, 95 × 58 (37 ⅜ × 22 ⅞). Musée Condé, Chantilly

127 Photo Timothy Hyman

128 Sassetta, *St Francis and the Wolf of Gubbio*, from the *Altarpiece of St Francis*, 1439–44. Tempera on poplar, 86.5 × 52 (34 × 20 ½). National Gallery, London

129 Sassetta, *Blessed Ranieri Liberates*

Poor Men from a Debtor's Prison, 1392–1450, Predella panel from the *Altarpiece of St Francis*. Tempera on poplar, 43 × 63 (17 × 25). Louvre, Paris

130 Sassetta, *The Damnation of the Miser of Citerna*, 1392–1450. Predella panel from the *Altarpiece of St Francis*. Tempera on poplar, 45 × 58 (17 ¾ × 22 ⅞). Louvre, Paris

131 Pietro di Giovanni d'Ambrogio, *The Assumption of the Virgin*, c. 1450. 92 × 50.5 (36 ¼ × 19 ⅞). Kereszteny Muzeum, Esztergom, Hungary

132 Attributed to Giovanni di Paolo, *Marriage Box: The Triumph of Venus*, 1421. Painted wood. Louvre, Paris. Photo © RMN – Arnaudet

133 Giovanni di Paolo, *Madonna of Humility*, c. 1435. Tempera on wood, 62 × 47.5 (24 ⅜ × 18 ¾). Pinacoteca Nazionale, Siena. Photo Fabio Lensini, Siena

134 Giovanni di Paolo, *The Presentation in the Temple*, c. 1442. Tempera and gold on wood, 39.4 × 46 (15 ½ × 18 ⅛). Metropolitan Museum of Art, New York, gift of George Blumenthal, 1941

135 Giovanni di Paolo, *The Flight into Egypt*, c. 1435. Pinacoteca Nazionale, Siena. Photo Fabio Lensini, Siena

136 Giovanni di Paolo, *The Triumph of Death*, 1437. Biccherna panel, 43 × 28 (16 ⅞ × 11). Kunstgewerbemuseum, Berlin

137 Giovanni di Paolo, *Death in a Landscape*, 1442. Tempera, gold, and ink on vellum, 15 × 26.5 (5 ⅞ × 10 ½). Biblioteca Communale degli Intronati, Siena (Cod.9.1.8, fol.162)

138 Unknown Sienese artist, *Dante and Virgil are Rowed across the River Acheron* (Inferno, Canto III), c. 1440–44. 8.5 × 16.9 (3 ¼ × 6 ¾). The British Library, London (The Yates-Thompson Dante, MS36, fol.6r)

139 Giovanni di Paolo, *Dante and Beatrice Leave the Heaven of Venus and Approach the Sun*, (Paradiso, Canto X), c. 1440–44. 9 × 20 (3 ½ × 7 ⅞). The

British Library, London (The Yates-Thompson Dante, MS36, fol.116r)

140 Giovanni di Paolo, *The Creation of the World and the Expulsion from Paradise*, 1445. Tempera on panel, 46.5 x 52 (18 ¼ x 20 ½). The Metropolitan Museum of Art, New York, Robert Lehman Collection

141 Giovanni di Paolo, *Paradise*, 1445. Tempera on canvas, transferred from wood, 46.5 x 40.3 (18 ½ x 16). Metropolitan Museum of Art, New York

142 Giovanni di Paolo, *John the Baptist Goes into the Wilderness*, 1454. Tempera on poplar, 31 x 38.8 (12 ¼ x 15 ¼). National Gallery, London

143 Giovanni di Paolo, *John the Baptist Goes into the Wilderness*, 1454 (detail). Tempera on poplar, 31 x 38.8 (12 ¼ x 15 ¼). National Gallery, London

144 Giovanni di Paolo, *John the Baptist Goes into the Wilderness*, 1454 (detail). Tempera on poplar, 31 x 38.8 (12 ¼ x 15 ¼). National Gallery, London

145 Giovanni di Paolo, *John the Baptist Goes into the Wilderness*, c. 1460. Tempera on panel, 68.5 x 36.2 (27 x 14 ¼). The Art Institute of Chicago, Mr and Mrs Martin A. Ryerson Collection

146 Giovanni di Paolo, *Ecce Agnus Dei*, c. 1460. Tempera on panel, 68.5 x 39.5 (27 x 15 ½). The Art Institute of Chicago, Mr and Mrs Martin A. Ryerson Collection

147 Giovanni di Paolo, *The Beheading of John the Baptist*, c. 1460. Tempera on panel, 68.6 x 39.1 (27 x 15 ⅜). The Art Institute of Chicago, Mr and Mrs Martin A. Ryerson Collection

148 Giovanni di Paolo, *The Adoration of the Magi*, c. 1462. Tempera and gold on wood, 27 x 23.2 (10 ⅝ x 9 ⅛). The Metropolitan Museum of Art, New York, The Jack and Belle Linsky Collection

149 Giovanni di Paolo, *St Nicholas of Tolentino Calms a Storm*, 1456. Philadelphia Museum of Art, John G. Johnson Collection

150 Giovanni di Paolo, *A Miracle of St Nicholas of Tolentino*, 1456. Tempera on wood, 50 x 42.5 (19 ⅝ x 16 ¾). Akademie der Bildenden Künste, Vienna

151 Giovanni di Paolo, *St Stephen Suckled by a Doe*, 1450. San Stefano alla Lizza, Siena

152 Giovanni di Paolo, *St Thomas Aquinas Confounding Averroes*, 1445–50. Tempera and gold leaf on panel, 24.8 x 25.9 (9 ¾ x 10 ¼). The Saint Louis Art Museum

153 Giovanni di Paolo, *St Catherine Exchanging her Heart with Christ*, c. 1475. Tempera and gold on wood, 28.6 x 22.9 (11 ¼ x 9). Private collection, New York

154 Giovanni di Paolo, *St Fabian and St Sebastian with Two Devotees*, c. 1475. Tempera on wood, 84.5 x 54.5 (33 ¼ x 21 ½). National Gallery, London

155 Unknown Sienese painter (The Master of the Osservanza), *St Anthony Hears the Gospel*, c. 1440. Tempera, gold, and silver on wood, 46 x 32.5 (18 ⅛ x 12 ¾). Staatliche Museen Preussischer Kulturbesitz, Gemäldegalerie, Berlin-Tiergarten

156 Unknown Sienese painter (The Master of the Osservanza), *St Anthony Distributing His Wealth*, c. 1440. Tempera and gold on wood, 47.1 x 34.6 (18 ½ x 13 ⅝). Painted surface 46 x 33.6 (18 ⅛ x 13 ¼). National Gallery of Art, Washington

157 Unknown Sienese painter (The Master of the Osservanza), *St Anthony Tempted by the Devil in the Guise of a Woman*, c. 1440. Tempera and gold on wood. Painted surface 37.9 x 40.2 (14 ⅞ x 15 ⅞). Yale University Art Gallery, New Haven

158 Unknown Sienese painter (The Master of the Osservanza), *St Anthony Tempted by a Heap of Gold*, c. 1440. Tempera and gold on wood, 47.8 x 34.5 (18 ⅞ x 13 ⅝). The Metropolitan Museum of Art, New York, Robert Lehman Collection

159 Unknown Sienese painter (The Master of the Osservanza), *St Anthony Goes in Search of St Paul the Hermit*,

c. 1440. Tempera and gold on wood, 47.8 x 34.5 (18 ⅞ x 13 ⅝). Painted surface 46.4 x 33.4 (18 ¼ x 13 ⅛). National Gallery of Art, Washington

160 Unknown Sienese painter (attributed to The Master of the Osservanza), *The Birth of the Virgin*, c. 1445. Museo d'Arte Sacra, Asciano

161 Pietro di Giovanni d'Ambrogio, *The Adoration of the Shepherds*, c. 1445. Museo d'Arte Sacra, Asciano

162 Unknown Sienese painter (The Master of the Osservanza), *The Descent into Limbo*, c. 1445. Tempera and gold on wood, 38 x 47 (15 x 18 ½). Fogg Art Museum, Harvard University Art Museums, Cambridge, Massachusetts

163 Unknown Sienese painter (The Master of the Osservanza), *The Resurrection*, c. 1445. Tempera and gold on wood, 36.9 x 45.9 (15 ¾ x 18 ⅛). Painted surface 36 x 44.3 (14 ⅛ x 17 ½). The Detroit Institute of Arts

164 Sano di Pietro, *Annunciation to the Shepherds*, c. 1450. Pinacoteca Nazionale, Siena. Photo Fabio Lensini, Siena

165 Domenico di Bartolo, *Care of the Sick*, 1440. Fresco, h. 450 (177). Ospedale di Santa Maria della Scala, Siena. Photo Grassi, Siena

166 Domenico di Bartolo, *Care of the Sick*, 1440 (detail). Fresco. Ospedale di Santa Maria della Scala, Siena. Photo Fabio Lensini, Siena

167 Vecchietta, *The Vision of St Sorore*, 1441. Fresco, h. 450 (177). Ospedale di Santa Maria della Scala, Siena. Photo Fabio Lensini, Siena

168 Vecchietta and Pietro de Giovanni d'Ambrogio, Reliquary Cupboard (Arliqueria), c. 1445. Pinacoteca Nazionale, Siena

169 Pienza, Piccolomini Palace and Cathedral. Archivio Pubbli Aer Foto, Aerocentro Varesino, Varese

170 Francesco di Giorgio, *In the Time*

of *Earthquakes*, 1467. *Biccherna* cover, 54 x 41 (21 ¹/₄ x 16 ¹/₈). Archivio di Stato, Siena. Photo Fabio Lensini, Siena

171 Francesco di Giorgio, *The Annunciation*, c. 1470. Tempera on wood, 73 x 47 (28 ³/₄ x 18 ¹/₂). Pinacoteca Nazionale, Siena. Photo Fabio Lensini, Siena

172 Francesco di Giorgio, *Coronation of the Virgin*, 1472–74. Tempera on wood, 337 x 200 (132 ³/₄ x 78 ³/₄). Pinacoteca Nazionale, Siena

173 Francesco di Giorgio, *Groundplan of a Basilica in the Image of Man*, c. 1475. Biblioteca Nazionale, Florence (Codex Maglia Becchianus, C.42 verso)

174 Francesco di Giorgio, *The Lamentation*, 1476. Bronze, 86 x 75 (33 ⁷/₈ x 29 ¹/₂). Chiesa del Carmine, Venice

175 Possibly designed by Francesco di Giorgio, *Studiolo* from the Ducal Palace in Gubbio, c. 1480. Executed by Giuliano da Maiano. Walnut, beech, rosewood, oak and fruitwoods on walnut base. h. 485 (15' 11"); w. 518 (16' 12"); d. 384 (12' 7"). Metropolitan Museum of Art, New York. Rogers Fund, 1939 (39.153)

176 Francesco di Giorgio, *An Allegory of Discord*, c. 1480. Stucco relief, 49.5 x 67.3 (19 ¹/₂ x 26 ¹/₂). Victoria and Albert Museum. V&A Picture Library

177 Unknown artist (Circle of Piero della Francesca), *The Ideal City*, c. 1470.

Panel, 60 x 100 (23 ⁵/₈ x 78 ³/₄). Palazzo Ducale, Urbino

178 Domenico Beccafumi, *The Birth of the Virgin*, 1540–43. Oil on wood, 233 x 145 (91 ³/₄ x 57 ¹/₈). Pinacoteca Nazionale, Siena

179 R. B. Kitaj, *Land of Lakes*, 1975–77. Oil on canvas, 152.4 x 152.4 (60 x 60). Private collection. Photo courtesy Marlborough Gallery Inc. © the artist

180 Bhupen Khakhar, *Celebration of Guru Jayanti*, 1980. Oil on canvas, 170 x 246 (66 ⁷/₈ x 96 ⁷/₈). Private collection. © the artist

181 Ken Kiff, *The Pilgrimage*, 1978–79. Pencil on paper, 21.5 x 45.5 (8 ¹/₂ x 8). Private collection. © the artist's family

Index

Page numbers in **bold** refer to primary entries, and numbers in *italic* refer to illustrations.